Masterworks
from
Stuttgart
The Romantic Age
in German Art

Masterworks
from
Stuttgart

The Romantic Age
in German Art

Essay by
Elizabeth Pendleton Streicher

Catalogue by
Jeremy Strick

THE SAINT LOUIS ART MUSEUM
1995

Masterworks from Stuttgart: The Romantic Age in German Art has been made possible by the generous support of Daimler-Benz and its corporate units Mercedes-Benz, Deutsche Aerospace, AEG Daimler-Benz Industrie, and Daimler-Benz InterServices.

It is supported by an indemnity from the Federal Council on the Arts and Humanities.

Editor: Mary Ann Steiner
Designer: Judy Schmitt, Cracom Corporation
Printer: Garlich Printing Company

Sponsor's Greeting

We at Daimler-Benz are proud to contribute to the realization of this exhibition which should serve as a stimulating "reciprocation" for the Beckmann treasures from Stuttgart, the sister city of St. Louis.

The art-loving and industrious people of St. Louis, with their significant German heritage, will appreciate the fact that Stuttgart has traditionally been home to both artists and artisans. During the first half of the nineteenth century, this city's newly founded Staatsgalerie made a name for itself as an art school and museum. Just a few decades later, Gottlieb Daimler realized his dream of creating the world's first automobile.

While Stuttgart has remained the headquarters of our corporation, Daimler-Benz, as you may know, is a very different company from just a few years ago. Today, we are involved in transportation and systems for land, sea, air, and space. Once we were mainly a car and truck company, today our mission is better described by the word "mobility."

There is, in this mission, a powerful suggestion of the romantic. To move forward, to change, to explore, to seek, to experience new ideas and even new worlds—these are romantic impulses. So, in this sense, it is appropriate that Daimler-Benz sponsor an exhibition of paintings from the romantic school.

Part of mobility, of course, is the movement of information and ideas from one place to another, from one person to another. The capacity to be moved is also part of mobility; to be open to change and also to be able to be stirred emotionally and spiritually. Art gives us the gift of an experience that is completely new, brought to us through an artist's vision. We, as human beings, need such visions for inspiration. I am certain Masterworks from Stuttgart will prove to be inspirational in its own way.

More simply, this exchange of two collections of artworks between two fine institutions will have a number of good effects. St. Louis will have a chance to view an aspect of German culture that may afford a richer sense of the German character and people. Stuttgarters will have the pleasure of seeing this extraordinary range of Max Beckmann's great talent. Best of all, perhaps, this exchange will bring St. Louis and Stuttgart a bit closer together.

EDZARD REUTER
Chairman
Daimler-Benz AG

Stuttgart, January 1995

Foreword

Museum visitors in North America have had many occasions to enjoy European art of the nineteenth century. Opportunities to view masterpieces of French nineteenth-century painting, for example, have abounded in numerous retrospectives of Monet, Renoir, van Gogh, Gauguin, and Pissarro. The Saint Louis Art Museum itself hosted a grand exhibition of works by the Impressionists in 1990. It is, however, much rarer for American audiences to have access to exhibitions of German masterworks from the nineteenth century. And yet many German artists enjoyed the highest international reputations in their time, and artists from around Europe and many from America traveled to Germany to pursue their artistic educations. Indeed, one of the best-known paintings of American history, *Washington Crossing the Delaware,* was painted by Emanuel Leutze, who came to America from Stuttgart. It is therefore fitting that we look to some of the best examples of the great German artistic tradition that has included such masters as Johann Heinrich Dannecker, Caspar David Friedrich, Adolph von Menzel, and Max Slevogt.

This impressive selection of paintings, drawings, watercolors, and sculpture from the Staatsgalerie Stuttgart comes from one of the keystone collections of German and Swiss art in Europe. This exhibition is part of a unique exchange between our two museums. In the fall of 1994, The Saint Louis Art Museum lent its entire collection of paintings by the twentieth-century German master Max Beckmann to the Staatsgalerie, in order to form the core of a small but nearly perfect retrospective of the artist's work. Thereby Germany's greatest modern painter, who lived in St. Louis in his late life, could be seen by enthusiastic crowds in his native country for the first time in a decade. For our part, we are able to present a special exhibition that is an almost complete survey of central European art from about 1770 to 1920. This is the first time most of these works have been shown in North America.

The cities of Stuttgart and St. Louis have many links, not the least of which is our sister-city relationship of long standing. The many nineteenth-century immigrants who came to Missouri and Illinois from Baden and Wurttemberg established commercial and cultural ties between our regions that still flourish. Our two museums have enjoyed many years of collegial relations that have prepared the way for such an exchange to be carried out with grace and ease. We are grateful to Professor Dr. Peter Beye, Emeritus Director of the Staatsgalerie, and to his able successor, Professor Dr. Christian von Holst, who have been our respected partners in this. We thank their exceptional staff who have assisted us throughout the project including Dr. Ulrike Gauss, Director of the Graphische Sammlung; Dr. Karin von Maur, Deputy Director and Curator of Twentieth-Century Art; and Karin Hämmerling, Registrar. We thank the photographers in Stuttgart who so ably managed to photograph many of the works in this publication.

At The Saint Louis Art Museum we acknowledge Sidney Goldstein, associate director, who has served as administrative liaison with the Staatsgalerie on both facets of the exchange. Jeremy Strick, curator of modern art, selected the works of art for this exhibition from Stuttgart's impressive holdings and wrote the catalogue entries for this book. Mary Ann Steiner produced the catalogue with the assistance of Suzanne Tausz and Patricia Woods. We

thank Judy Schmitt, Bette J. Russ, and Mary Espenschied of Cracom Corporation who helped with the book's production. We are grateful to Elizabeth Pendleton Streicher for her essay that introduces the catalogue; it is an excellent summary of the major movements and characters of nineteenth-century German art and a very welcome addition to the literature. John Butler-Ludwig researched the Stuttgart collection and also wrote several of the catalogue entries, which are noted with his initials. Kay Porter, director of community relations, facilitated much of the communication between the two museums and with our corporate sponsor, Daimler-Benz. Registrar Nick Ohlman and assistant registrar Jeanette Fausz negotiated the complexities of international shipping arrangements. Dan Esarey, director of building operations, and Jeff Wamhoff, installation designer, prepared an especially elegant setting for the visiting works of art.

Finally, we are most grateful to one of the world's great companies, Daimler-Benz, for sponsoring this exchange. With their growing presence in North America, this unique cooperation between two cities, regions, and museums demonstrates their commitment to enhancing the quality of life in this country as they do in Germany. We thank Matthias Kleinert, Executive Vice-President Public Affairs for Daimler-Benz; Hans J. Baumgart, curator Daimler-Benz art collections; and especially Edzard Reuter, Chairman Daimler-Benz, for his innovative and farsighted approach to cultural exchange.

JAMES D. BURKE
Director
The Saint Louis Art Museum

Contents

The Romantic Age in German Art: Masterworks from Stuttgart

"A painter should not paint merely what he sees in front of him, he ought to paint what he sees within himself." With these words, written in 1830, the landscape painter Caspar David Friedrich characterized with subtlety and insight the intentions of his own pantheistic and visionary art. Yet this aphorism also has come to serve in a more general sense as one of the signal definitions of nineteenth-century romanticism. To the extent that any continuities may be discerned among the greatest achievements in German art of the last century, they involve these attributes of introspection and subjectivity, and a turning away from the dictates of academic teaching and of institutions in general, be they religious or secular. Friedrich explicitly criticized some of his contemporaries for failing in this calling, but the best artists of the period were sincerely and consciously striving for a high degree of individual expression.

• • •

In the period under consideration in this exhibition, from the late eighteenth through the early twentieth centuries, Germany's artistic situation was unique, determined to a large extent by its political circumstances. Unlike either France or England, both of which had long-standing—if evolving—political and artistic institutions, Germany lacked both a sense of national identity and a coherent national artistic tradition.

At the end of the eighteenth century, the German-speaking lands of Europe were divided into nearly two thousand diverse political entities, of which the monarchies of Prussia and Austria were by far the most important; the remaining territories were both secular and ecclesiastical and included many different forms of government. The period of French occupation, which lasted from the Peace of Basel in 1795 until the Wars of Liberation of 1811–1813, brought fundamental conflicts and tensions to the fore. While Napoleon had his sympathizers in Germany even among the intelligentsia, the seeds of political unity and the growth of patriotic sentiment were sown during this time. The confederation of German states that was created following Napoleon's defeat and exile was dominated once again by Prussia and Austria, but now comprised a mere thirty-nine entities. Further consolidation was achieved after the liberal uprisings of 1848, when the so-called *Kleindeutschland,* or small Germany, was created as a Prussian state independent of Austria. Nonetheless, Germany did not achieve true political unity until its victory in the Franco-Prussian War of 1870–1871, orchestrated by Otto von Bismarck, which culminated in the proclamation of the German Empire and of Wilhelm I as Emperor in the Hall of Mirrors at Versailles on 18 January 1871.

This arduous and protracted course of political unification was accompanied by a related quest for a national cultural identity. During the Napoleonic era, philosophers, writers, poets, and artists staked out two opposing, but not entirely mutually exclusive, positions: a European cosmopolitanism based on ancient and renaissance classical culture, and a native patriotism rooted in the German gothic and renaissance past. During the decades at mid century, these issues receded somewhat from public consciousness, but in the wake of unification, the

question of a national cultural identity, to accompany the new political one, acquired greater urgency. The earlier cosmopolitanism was increasingly seen as internationalism and entailed an acceptance of foreign, usually French, influence in the arts. Meanwhile, in a romantic revival of sorts, native German traditions were evoked in the name of patriotism.

Germany's political decentralization meant that each principality aspired to its own royal collection, its own art school, and eventually its own art gallery and exhibitions. The older academies, including those in Berlin, Dresden, and Vienna, date to the late seventeenth and early eighteenth century; but the greatest proliferation occurred in the second half of the eighteenth century, when schools were founded successively in Düsseldorf, Stuttgart, Leipzig, Munich, and Weimar, to name only the most important. Many of these institutions underwent transformations and reorganizations in response to the vicissitudes of their royal patronage. Each had different specializations, which changed as professors came and went. Early in the century, Stuttgart and Berlin were centers for neoclassical landscape painting and portraiture, while Dresden concentrated on romantic landscape; later, Düsseldorf was a leader in naturalistic landscape and attracted foreign students, including a number of talented Americans; Karlsruhe also was a center for landscape painting and realistic genre; and Munich developed an international reputation for realism and history painting.

While the most ambitious art students in France eventually gravitated to the École des Beaux-Arts in Paris and their British counterparts to the Royal Academy in London, German artists tended to have peripatetic existences, moving from academy to academy, following favored professors or fields of study. It was not unusual for an artist to study in two, three or more cities in Germany, followed by, or interspersed with, sojourns in Rome or Paris. Thus young students had few constants in their professional lives and no centralized authority against which to measure themselves. In the last decades of the nineteenth century and the first years of the twentieth century, it was not unusual for an artist to exhibit at the Salon in Paris, in academy or Kunstverein shows in Munich, Berlin, and other German cities, and with the secessions and other privately organized groups. A painting could provoke a scandal in Berlin but pass virtually unnoticed in Munich or create a sensation in Paris or Vienna after having been maligned at home in Germany.

German art of the nineteenth century defies the ready historiographic chronologies and "isms" that traditionally have been used to define the canon of avant-garde French painting: the orderly progression from neoclassicism to romanticism, naturalism, realism, impressionism, post-impressionism, cubism, and abstraction. Artificial as these terms have proved to be even when applied to French art, this book will employ some of the same nomenclature and groupings. In the case of German art, however, this kind of linear chronology tends to highlight the discontinuities rather than the continuities between and among artists. Therefore, it will be preceded here by brief discussions of a number of the recurring issues and themes that united German art and distinguished it from that of other countries.

– As has already been intimated, German struggles for political unity and cultural identity were played out against the background of France. In the latter half of the eighteenth century, and the first years of the nineteenth century, German painters and sculptors worked alongside French artists in Rome, some even studied in Paris—most notably Hetsch, who

trained with Vien, and Schick, who entered the studio of Jacques-Louis David. Around midcentury, many German artists visited Paris, and some studied there for extended periods, several in the studio of Couture. The Universal Expositions in Paris in 1855 and 1867, and to a lesser extent the annual Salons, attracted Adolph von Menzel and others as both participants and visitors. Perhaps even more importantly, in 1869, a number of French painters, including Courbet, Corot, Millet, other members of the Barbizon school, Ribot and Manet, exhibited at the first International Art Exhibition in the *Glaspalast* in Munich. Their canvases and the encouragement they offered their German colleagues marked a turning point in the careers of a number of artists—particularly Leibl and the members of his circle.

In the later 1870s and 1880s, German artists often felt uncomfortable and unwelcome in Paris, but they nonetheless contributed to the Universal Expositions of 1878, 1889 and 1900, and were accepted at the Salon with regularity. French artists again exhibited in Germany, including at the second International Art Exhibition in Munich in 1879, when some of the same painters from the Barbizon group participated, along with Breton, Bouguereau, Couture, Fantin-Latour, Meissonier, Moreau, and members of the Hague school, and at subsequent international exhibitions in the Bavarian capital. With this degree of exposure to French art, it is hardly surprising that young German artists willingly absorbed some of its lessons or that the official art establishment often opposed its influence, as an impediment to the definition of a truly national culture.

Significantly, British art does not seem to have exerted a comparable influence or threat. Despite the many affinities between German and British neoclassical and romantic art, they developed along parallel, rather than intersecting, lines. Few artists visited London and beyond a number of individual cases, interactions seem to have been rare. Nonetheless, toward the end of the century, British and other foreign artists, especially the Pre-Raphaelites, were welcome and much-admired participants in German exhibitions.

– An even greater number of important German artists spent significant proportions of their careers in Italy, often in a kind of self-imposed exile. Dürer and Goethe were just two of the venerable precedents for German artists and writers drawn to the ancient and renaissance art in the museums, churches, and palaces; the picturesque views and dazzling sunlight of the countryside; and the warmth and openness of the Mediterranean people and their culture. Three overlapping groups of German artists made Italy, and especially Rome, their mecca. First, the later eighteenth- and early nineteenth-century neoclassical artists, notably Mengs, Carstens, Dannecker, Koch, and Schick; then in the 'teens and 1820s, the slightly younger generation of the Nazarenes, led by Overbeck, Pforr, Cornelius, and Schnorr von Carolsfeld, whose sojourns overlapped with Blechen's visit; and in the 1850s through the end of the century, the so-called *Deutsch-Römer*, Feuerbach, Marées, and Böcklin.

– The artists who were attracted to Rome often entertained grand ambitions. In their search for artistic models, Carstens, the Nazarenes, Marées, and others turned to the monumental commissions of Raphael, Signorelli, and Michelangelo and aspired to paint frescoes in magnificent architectural settings. While some found patrons in Rome, many more received commissions at home in Germany. Although the artists frequently failed to complete the projects, the drawings and full-scale cartoons of Carstens, Cornelius, and others had an enduring influence upon younger generations.

– Other important artists of the period were equally adamant in their refusal to visit Paris or Rome and in their search for an art based on nature and on a shared cultural past of German gothic and renaissance art. Runge, Friedrich, and the latter's circle in Dresden were the main proponents of the only exclusively German movement of the century.

– More generally, this period witnessed an extraordinary blossoming of landscape as an independent genre. German painters made early contributions that have no equivalents in French art prior to impressionism. Sketches after nature had been an important part of the neoclassical academic curriculum, and French and German artists working in Rome— especially Corot, Valenciennes and Blechen—raised the *plein air* oil sketch to the level of high art. Less constrained than the French or British by traditional academic hierarchies favoring historical, religious, and mythological subjects, German painters such as Koch and Reinhart created classicizing landscape compositions reminiscent of those of the seventeenth century. The romantic landscapes of Friedrich were without precedent.

– While portraiture did not undergo transformations as dramatic as landscape or history painting, it remained a favored category, for which German artists had a special aptitude. From Schick, Runge, and the Nazarenes to Feuerbach, Leibl, Corinth, and Slevogt, their likenesses—usually of their friends or themselves—are imbued with great personal sympathy and often penetrating psychological insight. The so-called *Freundschaftsbild,* a portrait of a friend, or of the artist and a colleague together, became a particular speciality.

– The nineteenth century also was an era of extraordinary accomplishment in the graphic arts in Germany. Drawing was the basis of all academic curricula, but that obligation, which often was resented by students, can explain only some of these products. Other contributing factors may have been the need for quantities of drawings for monumental public commissions as well as the absorption in, and respect for, the details of nature inherent in the new romantic philosophies. Original printmaking in the great northern tradition of Dürer, Holbein, and Rembrandt experienced a revival at the end of the century in the works of Klinger, Kollwitz, Munch, and the expressionists. Significantly, royal cabinets of prints and drawings were established in major artistic centers at more or less the same time as art museums and academies, and they continued to enjoy relative autonomy.

– Paradoxically, during this time when art academies were established in virtually every principality and capital of consequence in Germany, an anti-academic sentiment among artists grew at an even greater pace. In Germany, the mood of discontent was first publicly expressed by Carstens, who in 1795 severed his relations with the Berlin Academy on a matter of principle. It was perpetuated by the Nazarenes, who in 1809 resigned from the Academy in Vienna and retreated to Italy, and it culminated in the 1890s in the organization of the secessions in Munich, Vienna, Berlin, and other cities.

– Artists' desires for greater freedom from academic institutions and traditional patronage coincided with a new romantic cult of genius, which catapulted the artist, writer, or composer to the pinnacle of the intellectual and social hierarchy as the bearer of innate creative powers. These ideas were perpetuated later in the century in the philosophy of Nietzsche. Genius also acquired the subcategory of the tragically failed or flawed genius, whose most noteworthy prototypes were Michelangelo and Beethoven. Artists from Carstens to Klinger were compared to Michelangelo in the grandeur of their ambitions.

– A number of these artists were music lovers and amateur musicians, and were enamoured of the compositions not only of Beethoven but of their contemporaries Schumann, Schubert, Wagner, and Brahms. Some of them also avidly followed the careers of leading performers. Runge, Schwind, Klinger, and Slevogt all attempted to synthesize art, music, and poetry; Runge and Klinger aspired to a kind of Wagnerian *Gesamtkunstwerk,* with their works placed in specifically designed architectural settings, accompanied by music.

– Throughout this period, art in Germany had a strong philosphical bias. Almost every new artistic development was inspired by, or at least accompanied by, treatises, books, and published diaries or letters written by philosophers, poets, or the artists themselves. The theoretical foundations of neoclassicism were established by Winkelmann, Lessing, and Goethe, among others; romanticism began as a literary movement in the writings of Wackenroder, Tieck, Friedrich Schlegel, and Novalis, later augmented by the theories of Runge, Friedrich, and Carus; the classicizing idealism of the third quarter of the century was propagated in the writings of Conrad Fiedler, Feuerbach, and Adolf von Hildebrand; the ideologies of the 1880s and 1890s were defined in part by the philosophies of Schopenhauer and Nietzsche; a new and independent role for graphic works vis-à-vis paintings was proposed by Klinger; and aspirations for modernist German art were debated by Liebermann and Corinth among other writers. This pervasive intellectualizing contributed to a tendency toward so-called *Gedankenkunst,* or an art of ideas, perceived to be an inherently German phenomenon.

– In the second half of the nineteenth century, in the wake of the revolutions and democratic reforms of 1848, the German art world was transformed as it began to reach out to a new audience of affluent, upper-middle-class visitors and collectors through large international exhibitions and art periodicals. Until the middle of the century, exhibitions were local affairs, sponsored by the academies or the Kunstvereine, private organizations of artists and patrons founded earlier in the century. In 1856, however, one step toward national unity in the arts was achieved with the establishment of the *Allgemeine Deutsche Kunstgenossenschaft,* an organization for professional artists with chapters in most important German cities, which served as an umbrella organization for the individual Kunstvereine.

By midcentury Munich had already become the cultural capital of the German-speaking countries. In 1858 the first historical German Art Exhibition was organized there, surveying German art from Carstens to Piloty. After 1864 Munich was able to assume an international role, with the opening of the *Glaspalast,* modelled after the Crystal Palace in London. The first international Art Exhibition was organized in 1869, another show devoted only to German art followed in 1876, then three International Art Exhibitions were held in 1879, 1883, and 1888; annual exhibitions were inaugurated in 1889.

In 1886 Berlin finally acquired a comparably suitable building for exhibitions, the *Landesausstellungspalast.* The inaugural exhibition there was the *Jubiläumsausstellung* in 1886, celebrating the one-hundredth anniversary of Berlin Academy exhibitions. It also was Berlin's first international show, but French artists still were excluded due to the acrimonies following the Franco-Prussian War. French artists were invited to participate in subsequent exhibitions, however. As in Munich, several thousand works of art were shown.

Not surprisingly, this staggering number of paintings, sculptures, drawings, and prints made attendance at these exhibitions numbing and often frustrating experiences. Debates arose about subject matter, technique, and especially the appropriateness of including foreign art—and hence foreign influence and foreign competition—in the local markets. For all their democracy of spirit, artists' submissions sometimes were rejected by the organizing committees. Out of these controversies, the Munich Secession was born in 1892, the Vienna Secession in 1897, and the Berlin Secession in 1898. While the Munich, Vienna, and Berlin organizations shared many of the same participants, both German and foreign, they tended to go their own competitive ways.

In 1906, however, inspired by the French centennial exhibition of 1900, the art establishments of Berlin, Munich, Hamburg, and other cities joined together to organize a belated centennial, the *Jahrhundertausstellung,* celebrating German art from 1775–1875. This exhibition in the Nationalgalerie in Berlin included some two thousand works of art and was of great historiographic significance. It was organized by Hugo von Tschudi, director of the Nationalgalerie in Berlin, Alfred Lichtwark, director of the Kunsthalle in Hamburg, and the critic Julius Meier-Graefe, all of whom advocated bringing Germany into the mainsteam of European art by promoting foreign, and especially French, influence. Emphasizing that their objective was to show unknown or lesser-known art, the organizers managed to all but exclude academies such as Werner and Piloty, admitting only a few works by each, while painters deemed more modern were represented by twenty or thirty, or in one case, sixty-eight works. The exhibition in effect set the standard for the essentially Francocentric view of German art that prevails to this day.

The critical disputes of the turn of the century were ultimately related to the growing realization among both politicians and artists that a national cultural identity could define, or at least reinforce, a national political identity. Critics came to see their missions as both pedagogical and patriotic. Many new periodicals specializing in art were founded, including *Die Kunst für Alle, Die Zeitschrift für bildende Kunst, PAN,* and *Deutsche Kunst und Dekoration,* to name just a few of the more important; art reviews appeared regularly in newspapers in Berlin, Munich, Leipzig and many other cities.

The problem, however, was that this new generation of critics could not agree on what constituted patriotism, much less good art. In the 1870s and 1880s, Friedrich Pecht, Ludwig Pietsch, Adolf Rosenberg, and others advocated a German realism free from foreign influence, and generally favored the paintings of Werner, Piloty, and other academic artists over the realism and *pleinairisme* inspired by Courbet and the Barbizon painters. By the 1890s, a younger generation of neo-romantic or neo-idealist critics, including Hermann Bahr, Richard Muther, Cornelius Gurlitt, and the young Meier-Graefe, accepted naturalism and positivism only as stepping stones toward an art of the imagination, so-called *Gedankenkunst.* Böcklin, Klinger, and Thoma were their exemplars. The tides turned again around 1900, when an older Meier-Graefe and others proposed yet another definition of modern art, using French works as the norm. No artist of significance during this period, not even Menzel, escaped these critical debates.

The *Jahrhundertausstellung* was remarkably innovative in its willingness, indeed eagerness, to present the art of the previous century from a new and fresh point of view, with full recognition that the selection challenged the taste of the emperor and his cultural

functionaries. Even more extraordinary is the fact that qualitatively the selection has largely stood the test of time. Nonetheless, the earlier assumption that modernism in general, and especially modernism in Germany, should be defined solely in terms of French art increasingly is being challenged today. In recent scholarship, a more nuanced view of the art and the institutions of the period is emerging. Polemics aside, some artists excluded from Meier-Graefe's pantheon have proven to be among the most modern and influential of all.

Collectors and dealers played a more salutary role in the acceptance of modern French and German art. French impressionism was introduced into Germany gradually, in the 1880s and 1890s in Berlin, through the collecting of Carl and Felicie Bernstein, Max Liebermann, and Eduard Arnhold. Baron Schack in Munich was an important patron and collector of Lenbach, Feuerbach, Marées, and Böcklin; Alexander Hummel in Trieste was the most committed collector of Klinger's paintings; and Harry Graf Kessler assembled an important collection of paintings by French impressionist and post-impressionist artists, and other modernists such as Munch.

Perhaps because the great international exhibitions in Munich had always served as a marketplace, fewer galleries opened in that city. In Berlin, however, dealers played a leading role in explosing a larger public to contemporary art. In the 1880s, the Fritz Gurlitt Gallery exhibited the French impressionist paintings collected by the Bernsteins and others borrowed from Durand-Ruel in Paris. Gurlitt also showed works by contemporary German masters, including paintings by Böcklin and paintings and prints by Klinger. The publishing house of Amsler und Ruthardt specialized in prints, especially the graphic cycles of Klinger. In the 1890s, the galleries of Hermann Pächter, Keller und Reiner, Ernst Arnold, and especially Bruno and Paul Cassirer were important supporters of modern European art. The Eduard Schulte Gallery traditionally had shown academic paintings, but it served as host for the XI— a precursor of the Berlin Secession—after the group was established in 1892.

– Although German artists did not seek modernity as consciously as their counterparts in France, who had the Academy and the Salon against which to rebel, Blechen, Menzel, Friedrich, Klinger, and Marées, to name just a few, more randomly achieved what now has been revealed to be a modernism of equivalent importance for the history of art. In their individual investigations, particularly in studies of nature, Blechen and Menzel anticipated the compositional and technical innovations of impressionist painting in France by three decades or more; Friedrich and other northern romantic landscape painters have been linked with Rothko and postwar abstraction; Klinger's prints inspired the art of the expressionists and the surrealists; Marées and Hildebrand were precursors of twentieth-century formalist art and art criticism; and Germanic *Gedankenkunst* was the basis not only for early twentieth-century expressionism, but for subsequent neo-expressionist movements.

The section that follows is intended as an overview of the major movements and artists of the period, with special reference to paintings and drawings in the collection of the Staatsgalerie Stuttgart. More detailed biographies of individual artists and discussions of the individual works are included in the body of the catalogue. The exhibition this book accompanies includes important works by most of the significant artists of the century, with special strength in Swabian neoclassicism, for which Stuttgart was the artistic center. As was mentioned earlier, there simply was no linear development from movement to movement in Germany, so any

ordering of artists is highly arbitrary. It cannot be stressed often enough that many of these styles and movements were contemporaneous. The neoclassicism of Koch's later years in Rome, the northern romanticism of Runge and Friedrich, and the Nazarene movement all date from the first three decades of the century; *plein air* sketches by Blechen and Menzel, as well as Biedermeier genre scenes by Spitzweg, date from the 1830s and 1840s; Feuerbach and Marées were painting idealizing reveries in Italy in the 1860s through the 1880s, even as the trenchant realism of Liebermann and Klinger was provoking debates in Berlin and Munich.

• • •

Patronage of the arts in Stuttgart was typical for a German princely city-state. The royal art collections of Württemberg date back to the sixteenth and seventeenth centuries, although serious collecting of important Old Masters did not begin until after the construction of the ducal residence at Ludwigsburg in the first decades of the eighteenth century. The guiding spirit in the formation of the collections and the establishment of the art school was Duke Carl Eugen (1728–1793). In 1761, he founded the Académie des Arts and at the same time began collecting reproductive prints to serve as models for artists. In 1782, the art school was annexed by the Hohe Carlsschule, which had been founded earlier in the century as a school for the sons of the deserving poor. As an academy of art, the Hohe Carlsschule was renowned throughout Europe for its teaching of neoclassicism. Upon the death of its patron in 1793, however, the school was closed. A number of the teachers and students, including Schick and Koch, then found their ways to Rome and Paris.

In 1829, the art school was revived in slightly modified form, as an elementary school for arts and crafts and was housed in a military officers' pavilion along with antiquities and sculptures. Finally, in 1843 the enlightened King Wilhelm I of Württemberg (1816–1864), depicted two decades earlier in a portrait by Joseph Joachim Schnizer (no. 42), founded the Museum der bildenden Künste, now the Staatsgalerie, in a neoclassical building designed by Gottlob Georg von Barth. The art academy shared the same premises, and until the end of the century professors served as the museum's directors. Two symmetrical wings in the rear, designed by Albert von Bok were added between 1881 and 1888. The museum was destroyed during the Second World War, but was reconstructed and reopened in 1958. The collection of Old Masters still resides in this edifice. In 1984, a new addition designed by James Stirling was built and presently houses modern art and temporary exhibitions.

The German tradition of linking an art museum with an art school and installing art professors as museum directors meant that collections tended to grow according to the prevailing artistic philosophies of professors. As a result, the Stuttgart collection has always been strong in neoclassical painting and drawing, with a relative weakness in the contemporaneous, rival currents of romanticism, particularly the works of the Nazarenes. During the nineteenth century, the collections of contemporary art were developed mainly through bequests from these same professors and directors.

Several of the artists in the exhibition played seminal roles in this history. Dannecker and Hetsch were both students at the Hohe Carlsschule and then professors until the school was disbanded. Hetsch taught some of the most important neoclassical artists, including Schick and Koch.

Neoclassicism

Neoclassicism was a truly international phenomenon and quickly encompassed the arts, architecture, aesthetics, philosophy, and many other related fields. Its roots can be traced back to the second quarter of the eighteenth century, to the excavations at Herculaneum and Pompeii. The theoretical basis of this new art was established by two German writers. In *Thoughts on the Imitation of Greek Works in Painting and Sculpture* (1755), Johann Joachim Winckelmann argued that modern art could only become great through imitation of the ancients, especially the Greeks, whose "noble simplicity and calm grandeur" he proposed as a model for contemporary artists. His *History of Antique Art* (1764) pursued his thesis that true and timeless beauty resided in the classical perfection of Greek sculpture. Gotthold Ephraim Lessing expanded upon Winckelmann's theories in his equally original *Laocoön, On the Limitations of Painting and Poetry* (1766). Contrasting pictorial and literary modes of expression, he discussed the subjects that are appropriate to each and their relation to time and space. Ironically, both Winckelmann and Lessing chose the *Apollo Belvedere* and the *Laocoön* as their ideals of Greek high classicism, although we now recognize both sculptures as hellenistic, and the latter as proto-baroque in its expressive distortions. The reverberations of their texts continue to be felt in German aesthetic theory and criticism, and had particular resonance at the end of the nineteenth century in the writings of Klinger and Hildebrand.

The two leading German neoclassical artists of the first generation were both active in Rome in the late eighteenth century. Anton Raphael Mengs (1728–1779) is best known for his painting of *Parnassus,* from 1761, on the ceiling of the Villa Albani in Rome, a stilted rendition of a centralized, Raphaelesque figure composition that all too literally embodies the classical tranquility espoused by Winckelman. Among the most important works by the more gifted but also much more volatile Asmus Jakob Carstens (1754–1798) are his Michelangelesque, full-scale designs for monumental mural paintings of mythological subjects. The paintings were never executed, but in their elegant linearity, the monochromatic contour drawings may be compared to works by Carstens's English contemporary William Blake.

Carstens also was remembered throughout the next century as the prototype of the rebellious, misunderstood artist who came to personify romantic genius. Refusing to return to the Berlin Academy at the end of his stipend in Rome, he wrote to his benefactor, the Prime Minister of Prussia, "I must tell you, Excellency, that I belong to humanity, not to the Academy of Berlin. It was never my intention, nor did I ever promise to become the life-long serf of an Academy, in return for a few years' pension granted me for the development of my talent. . . . My capabilities were entrusted to me by God. . . ." Soon thereafter, in another iconoclastic gesture of independence, he organized an exhibition of his own works in Rome.

Back in Germany, Johann Wolfgang von Goethe was the main upholder of the neoclassical faith. Although he had earlier been a principal exponent of the *Sturm und Drang* movement, advocating a nostalgic return to national roots, after his trip to Italy in 1786–1788, Goethe came to share Winckelmann's reverence for ancient Greek art. While in Rome, he met the painters Angelica Kauffmann (1741–1807) and Johann Heinrich Wilhelm Tischbein (1751–1829). The latter's painting *Goethe in the Roman Campagna* from 1787

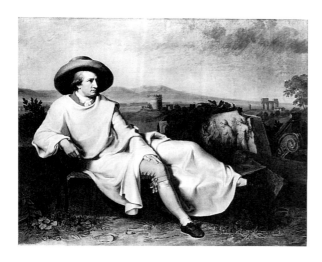

Figure 1
Johann Heinrich Tischbein, 1751–1829. *Goethe in the Roman Campagna*, 1787. Oil on canvas; 164 × 206 cm. Courtesy Städelsches Kunstinstitut, Frankfurt.

(Figure 1), immediately became the archetypal portrait of the European gentleman on the Grand Tour amidst the classical ruins of Italy.

Through his art periodical *Propyläen* and the annual drawing competitions he sponsored with the *Weimarer Kunstfreunde,* Goethe was able to exercise his judgments and influence in favor of neoclassical art. Carstens, Runge, and Friedrich all submitted works to these competitions; Runge's were rejected, but he and Goethe ultimately corresponded at length about their mutual interest in color theory.

For German neoclassical artists, Rome and Paris were the preferred destinations for training and inspiration. Dannecker, Hetsch, and Schick spent extended periods in both cities, while Koch remained in Rome from 1795 on. Another important center of neoclassical teaching was the Academy in Copenhagen: Carstens studied there, as did Runge, Friedrich, Dahl, Kersting, and Dannecker's Danish colleague and fellow sculptor Bertel Thorvaldsen (1770–1844). Paintings and sculptures by these artists reflect the traditional academic categories of historical, religious, literary and mythological subjects, portraiture, and landscape. Neoclassical works usually were intended for public display and therefore were of relatively large scale. The canvases often measure a meter or more in both height and width, while the sculptures can be life size or larger.

Three of the most important German neoclassical artists—Dannecker, Schick, and Koch—were born and trained in Stuttgart. Dannecker was primarily a sculptor; Schick excelled as a history, landscape, and portrait painter; while Koch was the neoclassical landscapist *par excellence.* To their ranks also may be added the lesser-known but likewise talented Hetsch, who specialized in history painting and portraiture. All of these artists were skilled draughtsmen; Koch, in particular, created some of his most fully realized compositions on paper rather than canvas.

Germany's most accomplished neoclassical sculptor, Johann Heinrich Dannecker (1758–1841) was a friend and colleague of Canova and Thorvaldsen in Rome. The Staatsgalerie is the main repository of his elegantly sinuous works, mostly of romantic and sentimentally touching mythological subjects. Dannecker's sculptures are executed in a full range of materials and scales, from terracotta to plaster, porcelain, and marble, reflecting the changing practices of neoclassical sculptors, who often created versions of their works in different

media, and enlarged or reduced them, in response to patron demands, the art market, and opportunities for public exhibition. Many were destined for tombs and other monuments.

Dannecker also was a friend of Schiller and Goethe, both of whom visited him in Stuttgart. His life-size *Bust of Schiller* from 1794, a plaster version of which is in the exhibition (no. 1), was the basis for the famous colossal bust he created after the writer's death in 1805. While he had earlier captured his friend's warmth and humanity, in the later monument he immortalized him as a heroic, solitary genius and planned to install the bust in a temple-like building with dramatic overhead illumination.

Like Dannecker, Philipp Friedrich Hetsch (1758–1838) was a generation older than Schick and Koch. As much as any German artist of the period, Hetsch paid homage to his French contemporaries Vien and David. He studied with Vien during two sojourns in Paris in the early 1780s, when he also met David. Among his finest works are the highly finished drawing *Tullia Driving Her Chariot over the Corpse of Her Father,* of 1786 (no. 9), and the painting *Cornelia, Mother of the Gracchi,* from 1794 (no. 8), which share the theatrical, staged qualities of David's high-minded republican dramas of subjects from Roman antiquity, enacted in clearly articulated architectural settings under cool, even lighting. In the painting, however, the rigors of David's style are mitigated somewhat by the more lyrical art of Vien, in the elegance of the gestures and the subdued tonalities. In contrast, in his *Self-Portrait* of 1787–1790 (no. 7), Hetsch reverted to a German model, that of Tischbein's likeness of Goethe, depicting himself not as a painter, but as an elegantly dressed gentleman at ease in a classical setting.

Christian Gottlieb Schick (1776–1812) was the leading German history and portrait painter of the period and, of all German artists, was the closest to David, with whom he studied from 1798–1802. His most ambitious project, *Apollo among the Shepherds,* from 1806–1808 (no. 32), was painted while he was living in Rome, and is based, roughly, on Mengs's *Parnassus,* although in Schick's idealized mythological world the figures disport themselves with greater ease and grace.

Schick's likeness of *Wilhelmine Cotta,* from 1802 (no. 30), is acknowledged to be one of the masterpieces of neoclassical portraiture and a quintessentially German variant of a genre that had many practitioners in both British and French art. As a full-length, life-size portrait of a distinguished personage in a refined landscape setting, it has precedents in the works of Gainsborough, Reynolds, and others. And in the languor and grace of the subject's seated pose and the simplicity of her Empire dress, the painting bears comparison with contemporary likenesses by David, from whom Schick had just parted in Paris. The painting's uniqueness and importance lie elsewhere, however, in the subtly nuanced balance between idealism and realism as mediated by Schick's classicizing style. The elegance of Frau Cotta's pose, her fashionable costume and coiffure, the schematic coloristic triad of green-white-red, and the bucolic, parklike setting are rendered particular and individual by the artist's sympathetic portrayal of her attractive, somewhat blunt features and the freely painted glimpse of Swabian countryside in the distance.

Unlike his fellow neoclassical artists, who returned to Germany after their sojourns in Italy, Joseph Anton Koch (1768–1839) spent most of his career in Rome, staying long enough to work also with the Nazarenes. Koch was the most influential German painter of classical

landscapes in the first half of the nineteenth century and the preeminent illustrator of Dante. Based on models by the seventeenth-century French masters Claude and Poussin, his landscapes embody the Enlightenment ideal of rational harmony between man and nature. In Koch's ordered cosmos, the countryside is picturesquely Italianate or Tyrolean, with trees in the foreground and either a path or a body of water in the middle ground that leads the eye back into a barren, mountainous distance. Composed of distinct compartments of varying terrain, the scenes are illuminated by uniform, crystalline light under changeable, cloudy skies. The ostensible subjects are often mythological or biblical, but the figures are always small in scale and happily going about their everyday lives, often in the company of a menagerie of domesticated animals.

Koch executed some of his finest works on paper, in media ranging from cursory pen-and-ink drawings to highly finished, large-scale compositions that are either sepia-toned, monochromatic pen-and-ink, highlighted with white gouache—three of which are in the present exhibition (nos. 24, 25, 26)—watercolors worked up in such detail to be tantamount to paintings.

Among Koch's best-known works are several renditions of the *Heroic Landscape with Rainbow*. Whether the rainbow alludes to a benevolent universal presence, or simply symbolizes hope, the overall mood is one of optimism and confidence.

Schick and Johann Christian Reinhart (1761–1847) also were important practitioners of the heroic landscape. In addition, the latter produced a series of celebrations of trees, studies in gray crayon that are so large, and so detailed, that they border on a kind of abstraction (nos. 11, 12). Some of the most original and beautiful drawings of the period were created by artists on the periphery of these artistic circles in Rome. To cite one example, in *Waterfall in the Forest* (no. 15) the little-known Friedrich Christian Reinermann (1764–1835) brilliantly evoked a sun-filled glade, in which the tiny figure of an artist sketching is nearly lost amidst moss-covered rocks and trees. To achieve these effects, he used a minimum of technical means—just pencil, the white backgound of the paper, and touches of watercolor in a subtle palette of greens.

Romanticism

Although romanticism is usually discussed after neoclassicism, it should be emphasized that the movements were neither consecutive nor mutually exclusive. It has long been recognized that even the most rigorous neoclassicists, such as Koch, introduced elements of romanticism into their later works. Koch's *Landscape after a Storm,* of c. 1830 (no. 21), for example, contains atmospheric effects and dramatic contrasts of light and dark between near and far which characterize in a very general sense the art of his almost exact contemporary, Caspar David Friedrich.

There were two main strains in German romantic art, one centered on nature and the other on Rome; the former Protestant and the latter predominantly Catholic. They shared common roots, however, in the intellectual and literary circles of Weimar and Jena around the turn of the century. Friedrich Schlegel, Ludwig Tieck, and Novalis, as well as Goethe and Schiller, were key members. Inspired by Wilhelm Heinrich Wackenroder's book *Outpourings of*

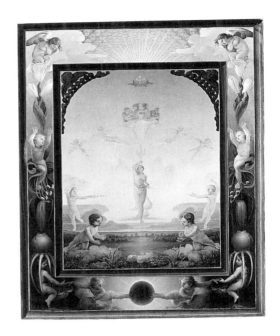

Figure 2
Philipp Otto Runge, 1777–1810. *Morning* (small version), 1808.
Oil on canvas; 109 × 85.5 cm. Courtesy Kunsthalle, Hamburg.

the Heart of an Art-loving Monk (Herzensergiessungen eines kunstliebenden Klosterbruders),
published in 1797, these writers and philosophers came to share a longing for the spirituality of
the Middle Ages, whose art and religion had been united in the gothic architecture that they
believed to have been of German rather than French origin. Perpetuating their a-historical and
subjective appraisals of earlier art, they chose as their medievalizing models Dürer, Raphael, and
other painters of the Renaissance, ignoring classical aspects of their styles. Nature also acquired
new significance, as it came to be seen as a reflection, even an embodiment, of the spirit of the
creator. Thus landscape offered an alternative, secularized outlet for yearnings for new
meanings in art and life.

Runge, Friedrich and Northern Romantic Art

Runge and Friedrich were both Protestants who had intensely personal, pantheistic
views of man and his relationship to nature. They remained true to their origins and made
the closely circumscribed worlds of northern Germany and the adjacent islands of the Baltic
their own special domain. Friedrich spent much of his career in Dresden; Runge lived there
for two years, and spent the remainder of his short life mainly in his native Hamburg. Neither
ever traveled outside Germany.

In his highly theoretical art, Philipp Otto Runge (1777–1810) sought to find allegorical
equivalents in nature for traditional Christian iconography. His investigations ranged from the
detailed and specific renderings of flowers and leaves in his exquisite paper cutouts (nos. 43,
44, 45), to the ambitious cosmological program of his cycle of paintings, *The Four Times of
Day*, begun in 1802 and intended as a *Gesamtkunstwerk* to be installed in its own gothic-
style building and exhibited to the accompaniment of choral music. Only drawings, etchings,
and a few canvases exist. The sole completed painting was the preliminary (so-called small)
version of *Morning*, from 1808 (Figure 2). Its rigid symmetry, emphasis on linearity, and
decorative border designs have various sources—from Dürer to Raphael to the drawings of

Bonaventura Genelli and John Flaxman—but the totality is entirely of Runge's own invention. The central figure of Aurora, part Aphrodite and part Madonna, is borne aloft by cherubs who emanate from cloudlike flowers, while children below watch over a Christ-like baby. The whole is bathed in an ethereal, rosy golden glow. If these complex allegories of nature are ultimately somewhat impenetrable, however, Runge's portraits of family and friends possess an almost hallucinatory clarity and immediacy. His likenesses of children are touching and respectful homages to their humanity.

Caspar David Friedrich (1774–1840) shared many, but not all, of Runge's artistic goals. He devoted himself almost exclusively to landscape, working his paintings up from sketches made during his frequent travels to his native Greifswald, and to his favorite sites on the desolate island of Rügen, and in Pommern, the Riesengebirge, Bohemia, and the Harz Mountains.

Friedrich's landcapes are unmistakable in their originality. They simply look like no others produced before or since. Above all, they are characterized by a dreamlike quietude and enchantment. The scenes may portray dramatic mountain peaks and vistas, gentle hills and valleys, meadows, the seacoast, wooded forests, or gothic ruins, but the mood is always one of silence and meditation. Many of these landscapes are unpopulated, with no intimations of human presence. Others contain a solitary figure, or a small group of figures, usually seen from behind, standing or seated in the foreground. Surrogates for the viewer, they contemplate the infinite beyond. Occasionally Friedrich's paintings include boats or ships, or a distant steeple or cross. Even in the absence of literal symbolism, however, his canvases convey deep religious feeling.

Other artists such as Carus and Schinkel shared some of Friedrich's subject matter, but they never achieved the metaphysical tranquillity of his art. Much of this was accomplished by compositional and technical means. Although based on meticulous studies from nature, the final paintings remain highly synthetic, the spaces inaccessible and remote. In contrast to Koch's countrysides, which are mapped out and teeming with life and incident and are intended to be experienced vicariously, Friedrich's are objects of reflection, usually with no means of entry. Instead of the orthogonals employed by landscape painters since the seventeenth century, Friedrich organized his terrain in horizontal bands, beginning with a relatively unarticulated foreground, which sometimes includes figures or trees some distance away, past a virtually nonexistent middleground, to an expanse of mountains, sky, or sea in the distance.

In his use of color and evocations of light and atmosphere, Friedrich also exercised characteristic restraint. While the range of his palette is quite broad, his colors are always so carefully modulated and so close in tone that many of his paintings have a nearly monochromatic effect. His scenes are often set at dawn or dusk, with the landscape enveloped in mist. Sometimes the foreground is illuminated and the distance cast in greater darkness, in others the conditions are reversed. This often arbitrary illumination from foreground to background enhances the subtle and expressive tensions created by the spatial juxtapositons of near and far. *Bohemian Landscape,* from c. 1808 (no. 46), exemplifies these carefully conceived compositions, from the centrally placed twin trees in the foreground to the barely visible church in the left distance.

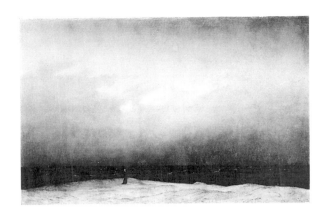

Figure 3
Caspar David Friedrich, 1774–1810. *Monk by the Sea,*
1809–10. Oil on canvas; 110 × 171.5 cm. Courtesy
Nationalgalerie, Berlin.

Friedrich often prepared his paintings as pendants. One of the most remarkable pairs, from 1809–1810, includes *Abbey under Oak Trees* (Nationalgalerie, Berlin) and *Monk by the Sea* (Figure 3). Both are among Friedrich's most moving, even despairing and pessimistic, compositions, and Friedrich's contemporaries found them unsettling. In *Abbey under Oak Trees,* Friedrich described a lonely procession of monks carrying the coffin of one of their brothers through a snow-covered, abandoned graveyard, to the ruin of a gothic church. The jagged, bare branches of oak trees are silhouetted against an overcast sky. Friedrich was known for his nationalistic sympathies during the Napoleonic era, so the gothic church may have political as well as religious connotations. *Monk by the Sea* is Friedrich's most strikingly modern image of man's confrontation with the infinite expanse of the universe. A solitary figure stands on a narrow margin of barren beach, before an equally contracted band of darkened sea, engulfed by a lowering sky that comprises the upper three-quarters of the canvas. When this painting was exhibited in Berlin in 1810, the dramatist Heinrich von Kleist wrote that "the picture stretches before us like the Apocalypse . . . and since, in its uniformity and its boundlessness, it has no other foreground than the frame, when one looks at it it is as if one's eyelids had been cut away."

Friedrich had a small circle of followers, but his paintings, which now seem so premonitory of modern art, were little known after his death in 1840. Two major works by Friedrich came to the Nationalgalerie in Berlin when it was founded in 1876, and the Kunsthalle Hamburg purchased one of his paintings around the turn-of-the-century, but his art, like that of the other romantics, was not rediscovered until the *Jahrhundertausstellung* of 1906, when thirty-eight of his canvases were shown.

The most notable of Friedrich's followers were Georg Friedrich Kersting (1785–1847), Karl Friedrich Schinkel (1781–1841), the Norwegian Johann Christian Clausen Dahl (1788–1857), and Carl Gustav Carus (1789–1869). None achieved the subtlety or sublimity of Friedrich's compositions, but Carus in particular arrived at his own variant of pure romantic landscape. Kersting is better known as a Biedermeier genre painter, Schinkel as Germany's leading neoclassical architect, and Dahl as a painter of harbor scenes and *plein air* sketches. Trained as a doctor and natural scientist and self-taught as a painter, Carus also was an important theoretician of the romantic movement, writing on the connections between science, philosphy, and art. *View from Montanvert Overlooking the Montblanc Range,* of 1822–1824 (no. 57), is typical of his oeuvre, both in its echoes of Friedrich's subject matter

Figure 4
Johann Friedrich Overbeck, 1789–1869. *Italia and Germania,* 1828. Oil on canvas; 94.4 × 104.7 cm. Courtesy Bayerische Staatsgemäldesammlungen, Neue Pinakothek, Munich.

and compositions and in Carus's own interest in documenting geological formations with a scientific precision that Friedrich never would have sought.

The Nazarenes in Rome

The Nazarenes represent the Catholic, southern strain of German romanticism. The members of the group met as students at the Academy in Vienna but, discouraged by the conservatism of its classical instruction, decided to go their own way. In July 1809, with Johann Friedrich Overbeck (1789–1869) and Franz Pforr (1788–1812) as leaders, they founded the Brotherhood of Saint Luke, named after the patron saint of painters. Inspired by the philosophies of Wackenroder, Friedrich Schlegel, Novalis, and others, the group sought a renewal of Christian art based on German gothic and Italian quattrocento principles, with Dürer, Masaccio, Fra Angelico, Raphael, and Michelangelo as models. In 1810, they moved to Rome, taking up residence in the abandoned cloister of Sant' Isidoro, and soon came to be called "Nazarenes" as they adopted Christ-like looks, with long hair and picturesque medieval costumes. Most eventually converted to Catholicism. The Nazarenes' idealizing aspirations for artistic revitalization are summed up in Overbeck's painting *Italia and Germania* of 1828 (Figure 4). Both in renaissance dress, the two women are personifications of their respective countries and cultural traditions. Blonde Germania on the right leans earnestly towards an acquiescent brunette Italia on the left; the landscape behind confirms their identities, a northern hill town with a gothic spire on the right, and a classical landscape with a roman basilica on the left.

The Nazarenes soon were joined by a number of talented German contemporaries, including Peter Cornelius (1783–1867), Wilhelm Schadow (1788–1862), Philipp Veit (1793–1877), Julius Schnorr von Carolsfeld (1794–1872), Friedrich Olivier (1791–1859)— whose brother Ferdinand (1785–1841) remained in Vienna but was considered a member of the group—and Carl Philipp Fohr (1795–1818). The Nazarenes never arrived at a common style, but their works nonetheless had a recognizable identity. Reflecting the group's collective sources, their drawings and paintings shared a medievalizing linearity and two-dimensionality as well as graceful surface patterns. They often enclosed their scenes in gothic- style architectural frames or organized them as triptychs.

The main ambition of these artists was to paint monumental frescoes in the public buildings of Germany. Their first commissions, however, were for residences in Rome. On the walls of one room of the Casa Bartholdy they painted illustrations from the Old Testament story of Joseph in Egypt, and on the walls and ceilings of three rooms of the Villa Massimo they painted scenes from Dante, Tasso, and Ariosto. The latter project was never completed, however, as various members of the brotherhood began to disperse.

Only Overbeck remained in Italy. The other Nazarenes gradually returned to Germany, where they finally received the public commissions for which they had longed. Several of the most important figures also became directors of leading academies and museums, exercising a far-reaching and often conservative influence on art instruction. The spirit of their time together in Rome was captured in a famous painting by Franz Ludwig Catel (1778–1856) from 1824, depicting *Crown Prince Ludwig of Bavaria in the Spanish Tavern in Rome,* (Munich, Bayerische Staatsgemäldesammlungen, Neue Pinakothek), at a lunch the Crown Prince hosted for Thorvaldsen, Leo von Klenze, Philipp Veit, Schnorr von Carolsfeld, and Catel himself, among others.

For Crown Prince—later King—Ludwig I of Bavaria, Cornelius painted frescoes of mythological subjects in the Glyptothek in Munich. Later, for King Friedrich Wilhelm IV of Prussia he prepared giant cartoons for a Christian fresco cycle. When the commission was cancelled, he continued working on the huge charcoal drawings (Nationalgalerie, Berlin); they were considered a remarkable achievement by a younger artist, if only for his perseverance in completing them. Veit painted a famous cycle on the *Introduction of the Arts into Germany through Christianity* (Städelsches Kunstinstitut, Frankfurt); and Schnorr decorated the living quarters of the Residenz in Munich with scenes from the *Niebelungenlied,* the medieval German epic that had been rediscovered in 1755. Schnorr's drawing *Volker and Hagen Refuse to Greet Kriemhild,* from 1829 (no. 63), is a study for one of these frescoes, as is his oil painting *Siegfried's Triumphant Return,* from 1838 (no. 61).

The Nazarenes' greatest legacy may be as draughtsmen, because many of their ambitious painted commissions remained uncompleted for one reason or another. The group made countless, classicizing landscape drawings in the manner of Koch, with whom they worked on occasion in Rome, as well as delicate renderings of flowers, leaves, and other bits of nature. They also particularly excelled as portraitists. The likeness of Heinrich Karl Hoffmann, from 1816, by Fohr (no. 65), is one of a series of studies the artist made in preparation for a group portrait of his friends in Heidelberg as Knights of the Round Table. These portraits have the precision and fluidity of silverpoint drawings from the Renaissance and a psychological penetration that marks them as products of the nineteenth century.

Moritz von Schwind (1804–1871) provides a transition between romanticism and Biedermeier. He was a second-generation Nazarene, who studied with Schnorr in Vienna, after the latter returned from Rome, and was influenced by Cornelius in Munich, where he spent the better part of his professional life. Schwind's immensely popular pictures of poetical subjects from old German folk tales and folk songs feature nymphs, gnomes, hermits, and fairies cavorting in forest glades. These subjects also were treated in his numerous fresco cycles for public buildings in Germany and Austria, including the Kunsthalle in Karlsruhe, the Städelsches Kunstinstitut in Frankfurt, and the Vienna Opera House. The watercolor *The Strange Saints,*

from 1835 (no. 69), is a study for such a project, a tale of two brothers disillusioned by life and love. This charming folkloric narrative is presented in the archaizing style of a medieval manuscript, complete with decorative borders, jewellike colors, and a triptych as a frame.

Schwind had a special love for music. An amateur violinist, he was friends with musicians and composers, including Schubert, and followed the careers of leading musicians, especially the soprano Caroline Hetzenecker, whom he portrayed often in his art (no. 72). The canvas *The Three Hermits,* from either the later 1840s or 1859 (no. 68), brings Schwind closer to a Biedermeier style. A study for a series called *Four Pictures of Love,* it represents the renunciation of love, personified by three hermits who live together in the woods.

Biedermeier

"Biedermeier" is the designation given a style in German painting and decorative arts from approximately 1815–1848, from the Wars of Liberation to the Revolutions of 1848. A combination of the names Biedermann and Bummelmeier, two characters from the widely read satirical periodical *Fliegende Blätter,* the term generally is applied to canvases depicting scenes of everyday, unpretentious, small-town life, and to simplified Empire-style fruitwood furniture. Both were intended for a middle-class market and middle-class interiors and therefore are modest in scale. Biedermeier also serves very conveniently as a way of grouping the myriad pleasant, idyllic, and decidedly escapist genre pictures that were painted and collected with enthusiasm throughout much of the nineteenth century.

Several small-format genre paintings from this period included in the present exhibition typify this general category: *Italian Wooded Landscape,* n.d., by Catel (no. 73), depicts a peasant family going about its daily life outside the crumbling stone building they have made their home; *Roman Peasants before an Inn,* from 1835, by Heinrich Bürkel (1802–1869) (no. 80), represents a picturesque and animated crowd gathered outside a tavern on the outskirts of Rome; and *Swabian Fair,* from 1839 (no. 74), by Johann Baptist Pflug (1785–1866), portrays the festivities of a village market fair, even to the smallest anecdotal details of celebration and costume.

The quintessential Biedermeier painter, however, whose name is synonymous with the term is Carl Spitzweg (1808–1885). A native of Munich, where he lived throughout his life, Spitzweg was largely self-taught, but traveled widely, studying the works of seventeenth-century masters in the Netherlands, Barbizon painters and Delacroix in Paris, and Turner and Constable in London. *The Sunday Hunter,* c. 1841–1848 (no. 77), and *The Alchemist,* c. 1860 (no. 79), are both typical of Spitzweg's much-beloved art, which focused on the provincial world of small towns and their petit-bourgeois inhabitants. Spitzweg's characters often seem absent-minded and eccentric, sometimes slightly ridiculous, exaggerated types. However, he stops just short of caricature, content instead to rely on gentle, observant humor. Spitzweg's pictures remained popular throughout the century. Thirty-three of them were shown in the *Jahrhundertausstellung* on the basis of their "modern", painterly execution reminiscent of the Barbizon school.

Ferdinand Georg Waldmüller (1793–1865) and Eduard Gaertner (1801–1877), the former from Vienna and the latter from Berlin, practiced a more sophisticated, urban version of a

Biedermeier realist style. Waldmüller was known principally as a society portraitist and as a painter of landscapes and genre scenes set in the vicinity of Vienna. In *Portrait of Frau A. von Winiwarter with Her Son,* from 1829 (no. 75), he described the subjects' stylish costumes and their uncanny physiognomic resemblance with the same meticulous exactitude. Gaertner brought a comparable precision to his many views of the architecture, avenues, bridges, and monuments of nineteenth-century Berlin. With their combination of topographical accuracy and gentle atmospheric effects, works such as *The Long Bridge in Berlin,* from 1842 (no. 76), are among the most revealing and informative documents of the apppearance of Berlin before the destructions of the Second World War.

Early Realism: Blechen, Menzel, and Others

Beginning in the 1820s and 1830s, two Berlin artists—Carl Blechen (1798–1840) and Adolph von Menzel (1815–1905)—began presenting the world around them and even traditional subjects with new compositional and painterly means, a freshness and spontaneity that anticipated later artistic developments by decades. Blechen was a landscape painter by training, first in Berlin and then in Dresden, where he may have met Friedrich and Carus. After working as a set designer at the Königstädtisches Theater in Berlin, at the recommendation of Schinkel, and painting late romantic landscapes in the manner of Friedrich's followers in Dresden, he made the trip to Italy which forever transformed his art.

Like Corot, who was in Italy at about the same time, Blechen responded immediately and instinctively to the sun-drenched splendor of the southern Italian *campagna.* He visited all the traditional sites, but he saw them with new eyes—his own. In several versions of *In the Park at Terni,* the Stuttgart one dating from c. 1828–1829 (no. 94), Blechen transformed canonical nymphs into everyday young Italian women who have shed their clothing in order to bathe in a stream, a scene that shimmers with the reflected light of a wooded park. The picture, while still broadly alluding to traditional subject matter, is obviously "composed". However, in many of his most remarkable works from this and later periods, Blechen left convention behind, depicting arbitrarily chosen bits of topography and architecture under changing atmospheric conditions. He very possibly saw the exhibition of Turner's works in Rome in 1829. In *View of Roofs and Gardens,* from c. 1833 (Berlin, Nationalgalerie), a remarkable example of his precocious informality of composition, Blechen simply painted what he saw outside his own window. His technique became increasingly summary in both oil and watercolor, as evidenced by the delicate tonal washes and expanse of white paper in a work such as *Italian Landscape with Ancient Temple,* of 1828–1829 (no. 95).

As early as the 1820s and 1830s, two artists based in Munich, the considerably older Johann Georg von Dillis (1759–1841) and Carl Rottmann (1797–1850), executed freely painted sketches from nature based on travels to the Mediterranean. Many of Rottmann's works are studies for monumental landscape paintings of Italy and Greece commissioned by King Ludwig I of Bavaria for the Hofgarten in Munich. *Sunset near Aegina,* from the 1830s (no. 93), is charactersistic of these works in its broad painterly qualities and interest in meterological effects.

Menzel was the most revered and honored German artist of the nineteenth century, his life spanning almost the entire century, and then some. An unmistakable presence in Berlin, he was of diminutive stature—only four feet six inches tall—and dressed in a specially designed overcoat with eight pockets to hold his many sketchbooks. Active from the 1830s on, Menzel studied only briefly at the Berlin Academy, after training as a lithographer in his father's business. He traveled regularly, mainly to cities and holiday retreats within Germany, but also to Paris, Vienna, Verona, and other cities in Europe.

Menzel established his reputation early, with four hundred woodcut illustrations for Franz Kugler's *History of Frederick the Great,* published serially between 1840 and 1842. For these and subsequent projects devoted to the enlightened eighteenth-century Prussian monarch, Menzel made hundreds, if not thousands, of studies—of rococo interiors, including Frederick's residence at Sanssouci, storage rooms filled with mysteriously animated suits of armor, and military and court costumes.

In the Kugler illustrations and the canvases he made after them in the 1850s, Menzel in effect reinvented history painting. Instead of the state occasions, official ceremonies, and famous battles of Frederick's reign, he presented the ruler's more informal, behind-the-scenes activities. The King is shown greeting soldiers before or after battle, visiting an artist in his studio, and participating in a musicale at the palace. In the latter scene, the famous *Flute Concert,* painted in 1850–1852 (Nationalgalerie, Berlin), based on the Kugler illustration, Menzel painted the monarch playing the flute, accompanied by other instrumentalists, including Carl Philipp Emanuel Bach at the harpsichord.

From these imagined historical events, Menzel moved easily to the everyday world and to court and society occasions of his own day. The oil sketch called *Masked Supper,* from 1855 (no. 99), describes a rococo interior illuminated by flickering candlelight, crowded with tantalizingly anonymous masked guests, portrayed not at table, but in those animated, anticipatory moments before places have been assigned and roles defined. His famous *Iron Rolling Mill,* of 1875 (Nationalgalerie, Berlin), commissioned by the uncle of Max Liebermann, glorified both the modern worker and modern industry.

From the 1860s on, Menzel was the *de facto* court painter in Berlin. He continued in that role well into the years of the empire, chronicling royal occasions from King Wilhelm I's departure for the front during the Franco-Prussian War to imperial palace balls. Menzel's style became more anecdotal and his touch less spontaneous, but he remained a keen and essentially neutral observer of the increasingly conservative rituals of the court.

Quick, summary brushstrokes, informally cropped views, and an interest in transitory atmospheric effects—from the golden glow of artificial illumination to the shifting clouds of stormy skies—characterized much of Menzel's art after 1840. Some of the impetus for this freedom of technique and composition may have come from his older and shorter-lived contemporary Blechen, and from Constable, whose paintings Menzel admired when they were exhibited in Berlin in 1839.

Menzel was familiar with contemporary French painting. He traveled to Paris on numerous occasions, visiting the Universal Expositions of 1855 and 1867, and exhibiting in the Salon of 1868 and the Universal Expositions of 1878 and 1886. In 1885, a widely

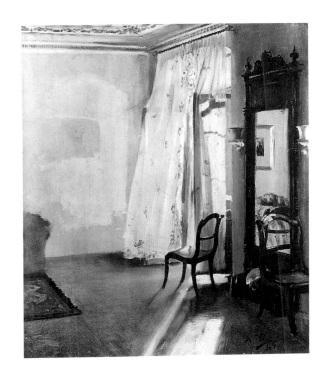

Figure 5
Adolph von Menzel, 1815–1905. *Balcony Room,* 1845. Oil on canvas; 58 × 47 cm. Courtesy Nationalgalerie, Berlin.

acclaimed retrospective of his works was held in Paris in celebration of his seventieth birthday. Menzel's ties with French art and artists were close: he knew Courbet, was a friend and admirer of Meissonier, and his work was copied by Degas. Although Menzel's works are in many respects proto-impressionist, his disingenuous denunciations of French impressionism were legendary in the Berlin art world in the last decades of the century.

One of the most gifted draughtsmen of all time, Menzel had an unerring and unremitting eye for composition and detail. For more than seventy years, he indulged his creative obsessions, executing more than six thousand drawings, ranging from landscapes and nature studies, to library shelves laden with books, uniforms of eighteenth-century Prussian courtiers, gruesomely dead and wounded soldiers, rococo picture frames and furniture, a fur coat, a pillow, his right hand drawn by his left, workers in Silesian iron mills, his family, his friends, and himself. Some are quite finished, highlighted with gouache, while others are fleeting impressions captured with a few strokes.

Toward the end of his life, Menzel was most admired for the same works which captivate us today, a stunning series of freely painted glimpses of everyday urban and domestic life from the 1840s. Fragmentary and unpretentious, they include the view from his window of workers napping in a palace garden, a backyard with laundry drying, and the famous *Balcony Room,* of 1845 (Figure 5), a mere corner of a room flooded with air and light, its windows flung open and its translucent draperies fluttering in the breeze. These canvases recall scenes by Blechen of more than ten years earlier, but also anticipate comparable developments in French painting by at least two decades.

These unpretentious sketches were never exhibited during Menzel's lifetime. They were discovered by a dealer at the end of the century but were shown publicly for the first time at the retrospective of Menzel's oeuvre organized by the Nationalgalerie in Berlin in 1905, a few

months after the artist's death. In the *Jahrhundertausstellung* the following year, these small, informal canvases were selected to represent Menzel's works, along with a few paintings from the Frederick the Great series, and the *Iron Rolling Mill*.

Academic Painting in Munich and Berlin

By the 1870s and 1880s, during the so-called *Gründerzeit* that defined a period of rapid economic growth after the Franco-Prussian War, Berlin aspired to become a world-class political and cultural capital, to rival Paris, London, and Vienna. Slowly it began to challenge Munich's position as the country's cultural center. In both cities, the art world was dominated by the academies, their professors, and the Kunstvereine. In Berlin, the ties between the Academy and the imperial court grew closer as the government came to see the arts as an instrument of cultural policy.

In Munich, Karl Theodor von Piloty (1824–1886) was the leading history painter and, from 1874, director of the Academy. A student of Schnorr von Carolsfeld and influenced by Delaroche and Belgian art, Piloty was credited with reintroducing color into painting, after the long years of Cornelius's tenure. In 1855, his reputation was instantly established when King Ludwig I purchased his giant canvas *Seni before the Body of Wallenstein* (Munich, Bayerische Staatsgemäldesammlungen, Neue Pinakothek) immediately after its completion. A scene from the seventeenth-century German past, it remains Piloty's best known work, demonstrating his mastery of dramatic reenactments of historical events, naturalistic detail, and bravura coloristic technique.

Also in Munich, Franz von Lenbach (1836–1904), a student of Piloty, became the preeminent portraitist of the empire. Lenbach was renowned for his eighty likenesses of chancellor Otto von Bismarck and for portraits of European nobility painted in dark "Old Master" tones reminiscent of Rembrandt. At the *Jahrhundertausstellung*, however, his early nature studies and informal depictions of shepherds were singled out for special praise. An eager social climber, Lenbach eventually installed himself at the center of the Munich art world in an opulent villa, now called the Lenbachhaus.

The leading artist in Vienna was Hans Makart (1840–1884), another student of Piloty, who reigned as a painter-prince in the Austrian capital, in an atelier provided by the emperor at state expense. His extravagant costumes, lavishly decorated studio, and wall-size canvases were all of a piece. His paintings often featured voluptuous female nudes cavorting in exotic Eastern settings and were richly painted. *Cleopatra,* from 1874–1875 (Figure 6), is a quintessential *Gründerzeit* production, filled with optimism, energy, and theatrical bombast.

For more than three decades, Anton von Werner (1843–1915) dominated the Berlin art world as director of the Academy, president of the Berlin Kunstverein, painter to the imperial court, and the empire's artistic ambassador abroad. His status was established when he was called to Versailles in January 1871 to begin preparations for a vast canvas commemorating the proclamation of the German Empire. During the following decades he represented court ceremonies, scenes from the Franco-Prussian War, and private family occasions among the upper bourgeoisie in a technically accomplished, anecdotal style.

Figure 6
Hans Makart, 1840–1884. *Cleopatra,* 1874–75. Oil on canvas; 189.5 × 50.6 cm. Courtesy Staatsgalerie, Stuttgart.

The *Deutsch-Römer* and Max Klinger

Deutsch-Römer, or "German-Romans" is the name given to the third group of nineteenth-century German artists—after the neoclassicists and the Nazarenes—who spent most of their careers in Italy. Anselm Feuerbach (1829–1880), Hans von Marées (1837–1887), and Arnold Böcklin (1827–1901) went to Italy independently in the 1850s and 1860s and lived there off-and-on for the rest of their lives. The writer and critic Konrad Fiedler and the sculptor and theorist Adolf von Hildebrand also were members of this loosely defined circle.

These artists, with the possible exception of Böcklin, were committed to defining a new idealizing mission for art, based on the formal and timeless principles of classical antiquity. Feuerbach's letters and diaries support his classicizing impulses based on the "noble simplicity and calm grandeur" of the Greeks; Fiedler, the most important theorist among them, followed the philosopher Immanuel Kant in exhorting artists to go beyond external, visual reality to represent their own inner realms; and Hildebrand, in his treatise *The Problem of Form in Art,* proved to be a precursor of formalist artists and critics of the twentieth century in his emphasis on the purity of material and form. Each in his own way achieved a timeless classicism of striking modernity.

Feuerbach came from a prominent intellectual family, the son of a well-known archaeologist, and the nephew of the famous philosopher Ludwig Feuerbach. His mother died soon after he was born, but he was exceedingly close to his stepmother, Henriette, who provided emotional and financial support throughout his life, helping to sell his pictures and editing his posthumously published letters. After studying briefly at the academies in Düsseldorf, Munich, and Antwerp, Feuerbach traveled to Paris, where he spent two years in the studio of Couture, which marked the turning point in his art. From 1854 on he lived mainly in Italy, first in Rome from 1854 until 1873, then in Venice from 1877 until his death in 1880, interrupted only by a brief, unsatisfactory tenure as a professor of history painting at the Vienna Academy.

In a monumental, classicizing style not unlike that of Couture, or Puvis de Chavannes, Feuerbach created idealized pictures of an imagined antique world, populated by handsome, statuesque figures, in the muted, chalky tones of renaissance frescoes. Among his most famous compositions on literary and historical themes are two versions of the *Banquet of Plato* reminiscent of Couture's giant *Romans of the Decadence,* and four representations of *Medea* (see nos. 88, 89). Although Feuerbach's paintings always had specific subjects, increasingly he renounced narrative and anecdotal detail in favor of generalized moods of melancholy, reverie, or longing.

Between 1861 and 1865, Feuerbach's model, mistress, and muse was a cobbler's wife named Nanna Risi. He portrayed her as the Madonna, in the style of Raphael, as various historical and literary personages, and as an idealization of an upper-class woman of fashionable society, but never simply as herself. His numerous portraits of *Nanna,* including the Stuttgart painting of 1861 (no. 84), are formal and elusive. Here she is shown in a three-quarter length seated pose, her strong features in near profile, and her figure reduced to an elegant and inaccessible pyramid of sumptuous drapery. Her costume is rather severe, in one of Feuerbach's favorite hues—black modulating into gray and mauve—but it is adorned with a magnificent array of fashionable jewelry described in exquisite, painterly detail.

An icon of yearning, *Iphigenia* is Feuerbach's most familiar and characteristic image. Nanna was the model for Feuerbach's first version from 1862 (Darmstadt, Hessisches Landesmuseum). Her successor, Lucia Brunacci, wife of an innkeeper, posed for the second rendition from 1871, in Stuttgart (no. 85), and for the third from 1873–1875 (Düsseldorf, Kunstmuseum). *Iphigenia,* too, is presented as a pyramid of monochrome drapery, her profile nearly lost as she stares out to sea. As in *Nanna,* brilliantly painted details, here of plants, grasses, and a butterfly, provide a welcome hint of access and physical immediacy.

The austerity of Feuerbach's classicizing style is tempered in many of these works by dazzling still-life passages and glimpses of landscape. His studies of flowers, for example, are among the most beautiful in the history of art, comparable to those of Courbet and seventeenth-century masters, and his subtly evocative landscape backgrounds anticipate the pastels of Degas. Feuerbach's gift for spontaneous renderings of nature is demonstrated in *In the Park of the Villa d'Este in Tivoli,* from 1857 (no. 86), in which he captured the mystery and magic of an afternoon in a deserted woodland park.

Feuerbach enjoyed official patronage from King Ludwig II of Bavaria, Emperor Wilhelm II, and others, presumably through the intercession of his stepmother, but he achieved public renown only after his death with the publication of his writings. In the 1890s, his works were extolled by neo-romantic writers who found his classicizing brand of *Gedankenkunst* admirably Germanic. Unlike Böcklin and Klinger, however, he also was commended by Meier-Graefe for the formal qualities of his art. Of all the painters in the present exhibition, Feuerbach was represented by the largest selection in the *Jahrhundertausstellung,* with sixty-eight works.

Marées also spent most of his career in Italy, from 1864 when Schack first commissioned him to paint copies of Old Masters, until his death in 1887, with just one interlude when he was called back to Germany for military duty at the time of the Franco-Prussian War. His style also was a classicizing one, but in most other respects it was very different from

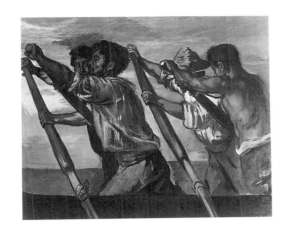

Figure 7
Hans von Marées, 1837–1887. *The Oarsmen*, 1873. Oil on canvas;
136 × 167 cm. Courtesy Nationalgalerie, Berlin.

Feuerbach's. While Marées's ostensible subjects were scenes from mythology, or even from daily life, the narrative elements increasingly were subsumed by pictorial and formal concerns, in a process that reflected the theories of Fiedler and Hildebrand.

In 1873, the German zoologist Anton Dohrn engaged Marées to decorate the library of the newly established German Marine Zoological Station in Naples with fresco murals. The program included five main scenes separated by illusionistic architectural elements, which were painted by Hildebrand. Instead of a traditional theme from literature or history, the artists chose the Bay of Naples itself, its expansive vistas and rugged fishermen. The largest and most stunning of these compositions depicts oarsmen rowing across the bay. The famous oil sketch for this portion, *The Oarsmen,* is itself monumental in scale, measuring more than a meter in each dimension (Figure 7). A consummate synthesis of realism and classicism, the fully realized Michelangelesque forms of the oarsmen glide frieze-like across the picture plane. In contrast to Feuerbach's muffled palette, Marées's colors are saturated with the intensity of the Mediterranean sun.

Marées's ultimate ambitions, however, were invested in four great triptychs he executed in the 1880s, the most successful of which was *The Hesperides,* of 1884–1885 (Munich, Bayerische Staatsgemäldesammlungen, Neue Pinakothek). Spatial tensions implied in *The Oarsmen* are even more present in these panels. The figures and landscape backgrounds are contracted into overlapping planes near the pictures' surfaces, and narrative is suppressed in the interest of surface decoration. In an attempt to achieve greater luminosity and depth of tone, Marées executed these panels in tempera overpainted with oils, a technique of his own invention that has not always stood the test of time.

Marées's paintings were little known in Germany during his lifetime. Soon after his death, Fiedler arranged a memorial exhibition in the *Glaspalast* in Munich. Marées did not gain true recognition, however, until the *Jahrhundertausstellung* in 1906, when thirty-two of his works were shown at the behest of Meier-Graefe, who began to counter the prevailing view of Marées as a tragic failure unable to live up to his lofty ambitions and instead championed his skills at monumental decoration.

After attending the academy in Düsseldorf with Feuerbach, the Swiss-born Böcklin went directly to Paris, where he, too, became acquainted with the works of Corot and Couture. Böcklin spent extended periods in Rome in the 1850s and 1860s, only returning to his native

Basel and Munich for financial reasons. In 1874 he moved to Florence, where he lived until 1885; after returning to Switzerland for a time, he made Florence his permanent residence in 1893. Böcklin's early works from the 1840s and 1850s were mainly whimsical depictions of nymphs, satyrs, Pan, and other mythological characters in atmospheric landscapes, painted in a light, loose manner reminiscent of Corot. By the early 1870s, however, his style had been dramatically transformed. In many works, he exchanged the fluidity of oil paint for the tighter control of tempera; the figures grew proportionately larger; the colors became brighter; and mythological beings came to personify forces of nature or to embody political messages.

Böcklin's most influential and famous images, however, are the so-called villa pictures, of which *Villa on the Sea,* of c. 1877, is the next to last version (no. 83). The series shares a romantic iconography of poetic melancholy—an elegant, solitary villa by the sea, which is silhouetted against a twilight or stormy sky, surrounded by tall cypresses and birches, and protected by sea walls that have begun to crumble under the crashing waves. Sometimes the villa and its estate are the setting for dramatic incidents, from a murder to a lovers' rendezvous, but in the present painting, Böcklin dispenses with narrative and includes only a lone, Iphigenia-like figure—her head and shoulders shrouded in black—who has taken refuge within the ruin of a wall.

Unlike his fellow exiles in Italy, Böcklin enjoyed a degree of critical attention, if not always success, in Germany. While his early works generally were acclaimed for their combinations of naturalism and fantasy, by the early 1870s, Böcklin often was accused of being sensationalist and bizarre, of striving for effect. In the 1880s, however, the Berlin dealer Fritz Gurlitt began exhibiting his paintings and commissioned Klinger to make prints after some of his most popular pictures. Klinger's print of the *Isle of the Dead* came to be a mainstay of German upper-bourgeois decor. By 1900, Böcklin's paintings were the most expensive contemporary works in Germany, praised for their fusion of the classical and the German, the antique and the modern. After being saluted as a Nietzschean genius and compared to Goethe, Beethoven, and Wagner, however, his critical fortunes began to change, as Meier-Graefe and others attacked his art on the basis of these same qualities, as "too Germanic" and as an "obstacle to progress." Nonetheless, forty-six of Böcklin's works were included in the *Jahrhundertausstellung,* and neo-romantic paintings such as *Isle of the Dead* inspired De Chirico, Strindberg, and Rachmaninoff, among others.

Of all the significant artists of this period, Max Klinger (1857–1920) has always been the most difficult to categorize. Younger than the *Deutsch-Römer,* the Leibl Circle, and Liebermann, and older than Slevogt, Munch, Kollwitz, and the expressionists, Klinger belonged to what was essentially a generation of one. Klinger will be considered here with the *Deutsch-Römer* because he spent some of his formative years in Rome and sought to achieve some of the same ideals and goals in his art. He also, to some extent, shared their critical fortunes at the end of the century.

A printmaker, painter, and sculptor, Klinger's works ranged in style from penetrating realism to lofty *Gedankenkunst.* After first studying in Karlsruhe, Klinger moved to the academy in Berlin, where he made an early debut in a sequence of exhibitions in 1877 and 1878, in which his drawings elicited both hyperbolic praise and vituperative criticism. Singled out for special mention was his autobiographical cycle of drawings *Paraphrase on the finding*

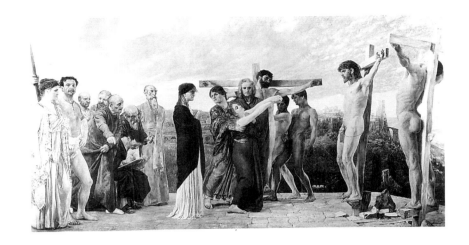

Figure 8
Max Klinger, 1857–1920.
Crucifixion, 1891. Oil on
canvas; 251 × 465 cm.
Courtesy Museum der
bildenden Künste, Leipzig.

of a glove: dedicated to the loser, on which he later based his most famous series of prints.
Set at a Berlin roller-skating rink, it begins as the artist himself swoops down to pick up a
lady's fallen glove, in the plate called *Action* (St. Louis, The Saint Louis Art Museum). Various
dreams-cum-nightmares ensue, in scenes depicting the glove's loss, rescue, abduction,
triumph, homage, and repose, until it finally comes to rest at the artist's bedside, guarded by
a cupid.

In all, Klinger produced fourteen graphic cycles during his career, on themes ranging
from modern urban life, love, death, relations between the sexes, antiquity, Christianity, and
music. His subjects reflect his broad-ranging interests in ancient mythology, French, German,
and Russian literature, Darwin, pre-Freudian dream analysis, Schopenhauer, Nietzsche, and
the music of Schumann, Brahms, and Beethoven. His treatment of these timely themes,
however, is always original and often intensely personal.

By the time Klinger was twenty-six years old, in 1883, he had already completed eight of
his fourteen graphic cycles and had moved to Paris in order to devote his energies to painting
and, to a lesser extent, sculpture. In the course of the next decade, he lived mainly in Paris
until 1887 and then in Rome until 1893, when he returned permanently to his native Leipzig.
In Paris, Klinger worked on decorations for the vestibule of a villa in Berlin, for which St.
Louis owns one of the most important preparatory oil sketches (St. Louis, The Saint Louis
Art Museum). The panels are executed in a bright, loosely painted impressionistic style that
reflects contemporary French painting.

During this decade, Klinger also produced two of his three most important and
monumental canvases, the *Judgment of Paris,* from 1885-1887, and the *Crucifixion,* from
1891 (Figure 8). The exhibition of the *Crucifixion* in Munich in 1891, along with all of his
graphic works to date, launched Klinger's career in its mature phase. The preparatory drawing
for the *Crucifixion* in Stuttgart is one of the first fully realized compositional sketches for the
project, dating from c. 1883 (no. 90). Klinger's *Crucifixion* was revolutionary in terms of both
subject matter and composition. In contrast to traditional centralized, iconic images of a
decorously draped Christ elevated on the cross, Klinger's rendition is asymmetrical and
unidealized: the three most important figures, the crucified, are placed together on the right
side of the canvas; all are naked and resting on crosses placed unceremonially low to the
ground, a touch of historical accuracy that some of Klinger's contemporaries found disturbing

27

and blasphemous, including the Catholic authorities who insisted that Christ's genitals be covered with a cloth. Klinger's polychrome sculptures were equally innovative and controversial. Most renowned was his monumental, enthroned *Beethoven* (Leipzig, Museum der bildenden Künste), executed in colored marbles and semi-precious stones and embellished with cast bronze reliefs, which was the sensation of the Vienna Secession of 1902.

Klinger's work in these different media had a theoretical basis, articulated in his essay *Malerei und Zeichnung,* published in 1891. Modeling his arguments on Lessing's distinctions between painting and poetry in the *Laocoön,* Klinger assigned separate but complementary roles to *Zeichnung*—drawing, or any medium in black and white, and to *Malerei,* painting. To drawing he accorded the domain of reality, fantasy, and the world as it is, and to painting the realm of nature, beauty, and the world as it should be.

By the 1890s, when he was still in his thirties, Klinger already was considered one of the grand old masters of German art. He was caught in the critical crossfire of the later nineteenth century, however. In the 1870s and 1880s, his realist drawings and prints had met with the approval of Pietsch, Pecht, and other proponents of a native realism. Then in the 1890s, as he moved into a more intellectual and idealizing mode in his paintings, sculptures and prints, his cause was picked up by neo-romantic critics such as Muther, Gurlitt, and even the young Meier-Graefe, who championed Böcklin, Thoma, and Klinger as purveyors of a quintesssentially Germanic *Gedankenkunst.* Hailed as a genius and compared to to Michelangelo, Dürer, Goethe, Wagner, and Beethoven, Klinger soon was denounced by Meier-Graefe and his sympathizers in much the same terms as Böcklin. Klinger exhibited in the Munich, Vienna, and Berlin Secessions, but only one of his works was included in the *Jahrhundertausstellung,* presumably because he was too young. Klinger's art, however, had an enduring influence on younger generations. His prints and the subjectivity he accorded them inspired artists from Kollwitz, Munch, and Kubin to Ernst and De Chirico.

Realism in Munich: The Leibl Circle

Leibl and the members of his loosely defined group, the so-called Leibl Circle, were the first artists in Germany to consciously model their art on French prototypes. In most cases, their initial exposure to French painting was at the first International Art Exhibition in Munich in 1869, when Courbet, Corot, other members of the Barbizon school, Ribot, and Manet exhibited for the first time in Germany. After visiting Paris and returning to Munich, most of them followed Leibl in retiring to the Bavarian countryside, away from both critics and public. They often painted with and for each other, specializing in genre scenes, landscapes, and portraits. Most adopted the loose brushwork, colorful palette, and informal compositional structures of their French colleagues. Gradually, however, subject matter and anecdote gave way to purely visual effects, as they sought an art of pure painting, *l'art pour l'art.*

Wilhelm Leibl (1844–1900) was the most talented of the group. He studied at the Munich Academy, with Piloty briefly, and found his initial inspiration in Netherlandish Old Masters. At the first International Art Exhibition in 1869, he exhibited his *Portrait of Frau Gedon* (Munich, Bayerische Staatsgemäldesammlungen, Neue Pinakothek), the likeness of a

young pregnant woman, in which he combined an accomplished painterly technique reminiscent of Hals and Rubens with keen psychological insight. The work won the admiration of Courbet, who invited him to Paris. When Leibl exhibited the painting at the Salon of 1870, it was awarded the gold medal. Forced to return to Germany a few months later, due to the hostilities of the Franco-Prussian War, Leibl soon retreated permanently from urban life, choosing to live in small Bavarian villages. Portraiture remained his principal subject matter, with family and friends his usual sitters.

Throughout his life Leibl worked in two nearly opposite styles and techniques. By the mid-1870s, he had developed his meticulously realist "Holbein style", best exemplified by his masterpiece *Three Women in a Church* of 1878–1882 (Kunsthalle, Hamburg), showing village women in Bavarian costume, one young and two old, reading and praying in church. The picture is remarkable not only for the immediacy of its sharply focused, enamel-like detail, but for the affecting spirituality of its subjects, who worship not as a part of a ritualized service, but alone, out of personal devotion.

Leibl also painted in a more spontaneous and painterly mode, inspired by Courbet and Dutch and Flemish masters. In works such as the oil sketch *Head of an Old Farmer,* from c. 1895 (no. 108), and the drawings *Head of a Country Lad,* from 1889 (no. 109), and *Young Woman with a Hat, Sitting by a Window,* from 1900 (no. 110), Leibl used chiaroscuro effects to focus attention on the strong, rugged features of rural villagers, whom he presented with dignity and humanity, without a hint of condescension.

Leibl's art was admired and emulated by contemporary artists but criticized by some writers for carrying realism to the point of ugliness. He exhibited often in the 1890s, to great acclaim at the Berlin International Exhibition of 1895, and at the Berlin Secession of 1899. As a prime exponent of French realism, Leibl was well represented in the *Jahrhundertausstellung,* with forty-three works.

After attending the academy in Karlsruhe, Wilhelm Trübner (1851–1917) transferred to the academy in Munich in 1869, where he was introduced to the works of Leibl and Courbet at the first International Art Exhibition. From 1872 to 1895, he lived in Munich, and worked with other members of the Leibl Circle, particularly Schuch, who on a number of occasions painted the same subjects. Trübner's early realist works such as *Boy at the Cupboard* of 1872 (no. 112), his first big success at the Munich Kunstverein, retained the dark "Old Master" tonalities, and humorous, anecdotal qualities of conventional genre painting. Affinities with the canvases of Leibl and Courbet, however—especially the broad, painterly brushwork—presaged a more modern direction for his art.

In the early 1870s, Trübner traveled throughout Europe, and in 1879 he visited Paris. By this time, his palette had brightened, probably under the influence of Liebermann, and he began painting the kinds of landscape subjects for which he is best known: views of the Herreninsel and Fraueninsel in the Chiemsee, carpenters cutting wood, potato fields at harvest time, the park-like settings of opulent villas. More concerned with public recognition than some of his colleagues, he also painted mythological and religious subjects and freely executed, elegant portraits of upper-bourgeois sitters. A successful professor in Frankfurt and Karlsruhe, Trübner was a member of the Munich and Berlin Secessions. Thirty-three of his works were included in the *Jahrhundertausstellung.*

Of all the members of the Leibl Circle, Carl Schuch (1846–1903) was the most intellectual and widely traveled and spent the longest periods abroad. He attended the academy in his native Vienna and lived briefly in Munich in 1870–1872, when he met Leibl and Trübner. However, Schuch spent most of his career in Venice and Paris. Known principally as a painter of still lifes, he concentrated on formal problems of composition and technique. *Still Life with Cheese, Apples, and Bottles* (no. 111), from his Paris period of 1882–1894, is characteristic in its simple, architectonic structure and regularized brushstrokes reminiscent of Cézanne. However, the thick impasto and dark ground also recall the still lifes of Vollon, Bonvin, and other realist painters in France. During his lifetime, Schuch was little known in Germany, where he neither exhibited nor sold his works. At the *Jahrhunderausstellung*, however, he was deemed one of the most significant members of the Leibl Circle, along with Leibl himself and Trübner.

From the beginning of his career, Hans Thoma (1839–1924) painted genre scenes, landscapes, and still lifes. He studied in Karlsruhe and Stuttgart before visiting Paris in 1868, where he was introduced to the works of Courbet and the Barbizon school. These impressions of French painting were reinforced at the first International Art Exhibition in Munich the following year. In 1870, he met the members of the Leibl Circle and Böcklin. Beginning in 1874, Thoma also made frequent trips to Italy.

Thoma's early genre scenes are unsentimental depictions of bucolic country pastimes—children reading, sewing, or dancing in a sunny meadow—and are executed in a realist style reminiscent of Leibl's art. By the early 1870s, however, the influence of Courbet was clearly perceptible, especially in Thoma's exquisite still lifes, the best known of which is *Still Life with Wildflowers* of 1872 (Berlin, Nationalgalerie, Staatliche Museen zu Berlin Preussischer Kulturbesitz). The work recalls Courbet's floral still lifes in its unpretentious subject matter and painterly execution but also the paintings of Henri Fantin-Latour in its vertical format and random arrangement of elegant, but ordinary and somewhat incongruous domestic objects.

Thoma spent many summers and vacations in his native Black Forest, in the 1870s and 1880s often painting views of rolling fields and lush vegetation. These pictures are bright and atmospheric, using rich greens, applied with loose, broken brushstrokes. In the mid-1870s, Thoma began introducing allegorical figures into his landscapes, in the manner of Böcklin, which gave them an idyllic, faintly folkloric character. *Landscape on the Rhine*, from 1888 (no. 104), is characteristic of this lyrical genre, as children pick wildflowers and weave garlands under the shifting skies of a sunny spring day.

The enchantment of these late landscapes contributed to Thoma's increasing popularity in Germany at the turn of the century. A much-acclaimed exhibition of his works at the Munich Kunstverein in 1890 enhanced his reputation. In 1899, he was named professor at the art school and director of the museum in Karlsruhe. In the 1890s, Thoma was linked with Böcklin and Klinger as an exemplary Germanic artist upholding native traditions. Nevertheless, his early naturalistic works met with Meier-Graefe's favor, and many of his paintings were included in the *Jahrhundertausstellung*.

Louis Eysen (1843–1899) trained in Frankfurt, before moving in 1866 to Munich, where he met Leibl. As early as 1868 or 1869, he studied in Paris with a fellow member of the Leibl

Circle, Otto Scholderer (1834–1902) and with Bonnat; at that time he also met Courbet and became acquainted with the works of the Barbizon painters. A close friend and colleague of Thoma from 1870 on, Eysen specialized in pure landscapes, without allegorical or symbolic references. Eysen's landscapes such as *Fruit Garden,* from c. 1880 (no. 107), are distinctive in their palette of bright, fresh greens, and their elevated viewpoints, which often block out most or all of the sky. Eysen's paintings remained virtually unknown until after his death, when his loyal friend Thoma organized exhibitions of his canvases in Karlsruhe, Munich, Berlin, and Frankfurt. Shortly afterward, they were included in the *Jahrhundertausstellung.*

"German Impressionism" and the Art of the Secessions: Liebermann, Uhde, Slevogt, Corinth, and Hodler

The term "impressionism" is problematical when applied to German painting. German artists experienced the works of the Barbizon school and Courbet firsthand in Munich and Paris, but fewer had direct exposure to French impressionism. They shared the French painters' commitment to painting *alla prima* on the canvas, *en plein air,* with quick, spontaneous brushstrokes and a heightened palette, as well as their interest in atmospheric effects and subjects from modern life. However, they generally abstained from the most innovative impressionist practices including the scientific division of color; representation of spatial recession solely through atmospheric perspective; and radical cropping of figures and forms. In most instances, the German painters retained a greater sense of form and measurable space than their French counterparts and favored rural subjects to city ones. Nonetheless, each of these artists created works that were unmistakably modern, and all played leading roles in the organization of the secessions. Uhde was active in Munich, and Liebermann, Corinth, and Slevogt in Berlin.

The secessions in Munich, Vienna, Berlin, and other cities were organized in response to the exhibition policies of the local academy and Kunstverein. The secessions were not exact equivalents of the French *salons des refusés* or impressionist group shows, however, because the German artists were not systematically or consistently excluded from their own academic exhibitions. Rather they found these exhibitions too inclusive, democratic, and fraught with politics. Hence the artists decided to take matters into their own hands and to organize exhibitions that were more discriminating in their selections, provided more spacious installations, and were more compatible with their own views about what did and did not constitute modern art in Germany. In many respects, the secessions were highly elitist, seeking to address only a limited audience of enlightened artists, connoisseurs, and collectors.

Max Liebermann (1847–1935) is the artist most often associated with the term "German impressionism" and with the secessionist movement. The first identity he rejected, the second he embraced. From a family of wealthy Jewish merchants and industrialists in Berlin—as was mentioned earlier, Liebermann's uncle commissioned Menzel's *Iron Rolling Mill* in 1875—Liebermann trained in Weimar from 1868–1873. At the same time, he made his first trips to Paris and Holland, which remained the touchstones of his life and his art. From 1873 to 1878, he lived in Paris, where he admired the paintings of Millet and Courbet; and from 1878 to 1884, he lived in Munich, where he came to know Lenbach and Leibl.

Almost every year of his life from 1872 until well into the twentieth century, Liebermann visited Holland. He had longstanding socialist sympathies that found the democratic culture and institutions of Holland particularly congenial, especially when contrasted with the excesses and vulgarities of *Gründerzeit* society. He also was inspired by Dutch artistic traditions, from the portraits of Hals, to the landscapes and rural genre scenes of his own contemporaries Jozef Israëls and Anton Mauve, members of the Hague school. In the 1870s and 1880s, Liebermann's art reflected these multiple influences: a painterly naturalism and affinity for rural genre subjects from Leibl, the gray tonalities of overcast skies from his Dutch colleagues; and the spontaneous *facture* of paintings by the Barbizon artists and Courbet. Nonetheless, the resulting canvases—of women plucking geese, cleaning vegetables, spinning flax, or bleaching laundry, and farmworkers harvesting turnips and potatoes—are unmistakably his own. The same may be said for Liebermann's many depictions of orphanages, schools, and old-age homes in Holland, of which *Old-Age Home for Men in Amsterdam,* from 1880 (no. 114), is a typical example.

After Liebermann moved back to Berlin in 1884, his palette brightened and his brushstrokes quickened, as his art drew closer to Manet and French impressionism. Gradually, subject matter became less important. By the 1890s, Liebermann turned increasingly to the leisurely pursuits of Berlin's upper classes—young boys bathing, men and women playing tennis or riding on the beach, light-filled views of Wannsee—and focused his energies instead on the act of painting itself. In his essay *Die Phantasie in der Malerei,* Liebermann advocated a painting whose sole aim is to transform the visual into the pictorial.

Liebermann's art was well received in Paris throughout his career, but often caused debates at home in Germany, beginning when he exhibited his painting of *Christ in the Temple* in Munich in 1879 (private collection). He used contemporary models, who were deemed blasphemous in their ugliness, including the young Jewish boy depicted as Christ. Liebermann first gained significant positive recognition in Germany in 1891, at the exhibition of the Munich Kunstverein. From the 1890s on, he was one of the leading organizers of the secessionist movement in Berlin, respected for his open-mindedness and acceptance of art that was not like his own. He was a founding member of the XI in 1892 and of the Berlin Secession itself in 1898; from 1899 to 1911, he served as the Secession's president. By the turn of the century, Liebermann's philosophies and art were very close to the ideals of Meier-Graefe, and his paintings were featured in the *Jahrhundertausstellung.*

After studying briefly in Dresden and serving in the military during the Franco-Prussian War, Fritz von Uhde (1848–1911) visited Vienna and Paris in search of instruction. The turning point in his career came in 1880, however, when he moved to Munich and met Liebermann. The latter inspired him to the use of elements of an impressionist technique and palette. The son of strict Protestants, Uhde specialized in religious themes from the New Testament presented in contemporary south German settings, often among the rural poor. *Three Models* (no. 113) is a large-scale study for a central detail of his most famous work, *Suffer the Little Children to Come Unto Me,* from 1884 (Leipzig, Museum der bildenden Künste). A poignant characterization of the moods and expressions of childhood, the work is typical of Uhde's style in its carefully delineated forms bathed in warm, clear light, executed in a modified impressionist technique of loose, but controlled brushwork.

Uhde's version of a new religious painting was well received in Paris, but met with opposition in Munich and Berlin. Critics doubted the propriety of depicting Christ in contemporary settings and of using a modern impressionist technique in portraying traditional subjects. Uhde was a founding member of the Munich Secession in 1892 and later served as its president.

The son of a tanner, Lovis Corinth (1858–1925) studied first in Königsberg, then moved in 1880 to the Academy in Munich. By 1882 he had come into contact with the Leibl Circle. Following their example, in 1884, he traveled to Paris, where he studied at the Académie Julian with Bouguereau. After moving back and forth between and among Berlin, Paris, and Königsberg, Corinth settled in Munich from 1891 until 1900 and then moved to Berlin.

Corinth's subject matter ranged from relatively modest realist, working-class themes such as butcher shops, to grand-scale depictions of traditional literary, religious, and mythological subjects. He also painted landscapes and portraits of friends, family, and especially himself. Inspired by Max Klinger and Karl Stauffer-Bern, he took up printmaking. Once Corinth had arrived at a mature style, somewhat belatedly in the early 1890s, his works were characterized by a free and fluid handling of paint, in long, slashing strokes. Never shy about controversy, Corinth introduced an aggressively charged eroticism and elements of theatricality and parody into canvases such as the infamous *Salome,* from 1900 (Leipzig, Museum der bildenden Künste).

In 1902, Corinth opened an art school for young women, where he met his future wife Charlotte Berend, who often served as his model. Portraits of Charlotte and of friends such as his fellow painter and printmaker *Hermann Struck,* from 1914 (no. 115), are evocative, straightforward, and sympathetic. Corinth created an ironical and revealing permutation of the *Freundschaftsbild* in his haunting *Self-Portrait with Skeleton* of 1896 (Munich, Städtische Galerie im Lenbachhaus), in which a doctor's model of a skeleton dangling from a pole takes the place of the traditional friend or colleague. From 1900 on, Corinth painted a self-portrait every year, usually on his birthday in July. After he suffered a stroke in 1911, his technique became even more summary and his mood increasingly introspective. In one of his last self-portraits, from 1923 (no. 117), the bravura of his earlier likenesses is gone, supplanted by a melancholic frailty.

During the last seven years of his life, Corinth and his family vacationed in Urfeld am Walchensee, where he painted more than sixty landscapes, at all times of day and year. *Walchensee,* n.d. (no. 116), depicting the lake and chalet in summer, is typical in its intensity of color and animated surface of thick impasto. These late landscapes are considered by many to be Corinth's masterpieces and his most modern works, expressionist in their subjectivity and distortions. Corinth joined the Munich Secession when it was founded; he also exhibited with the Berlin Secession, becoming a member of its executive committee in 1902, and its president in 1910.

Max Slevogt (1868–1932) followed in the footsteps of these other secessionist artists, first studying at the Munich Academy from 1885–1889, when he came into contact with the Leibl Circle, then attending the Académie Julian in Paris, where he was introduced to works by the French impressionists. Slevogt is best known as a painter of literary, religious, and historical subjects; he also painted landscapes and still lifes. He is most admired, however, for his accomplishments as a portraitist.

After living in Munich, where his works tended to be criticized, and traveling throughout Europe, Slevogt finally settled permanently in Berlin, where his art was generally better received. Newly receptive to the influences of Manet, Degas, and the French impressionists, he began to specialize in portraits of noted actors and singers. A music lover and amateur bass baritone, Slevogt followed the career of the Portuguese opera singer Francisco d'Andrade with special interest. The life-size *Champagne Song,* of 1902 (no. 118), is Slevogt's most important work in this genre, depicting the singer as Don Giovanni. Slevogt captured d'Andrade at a climactic moment, as he executes a final flourishing gesture—right hand aloft and left one extended. Standing on a dramatically foreshortened stage, D'Andrade's figure nearly fills the picture space, his left foot touching the bottom margin of the canvas, defining his figure within the flat surface of the picture plane. The portrait bears comparison with Manet's likenesses of actors and with French impressionist painting in its heightened palette and animated brushstrokes, but it differs from those prototypes in the care with which Slevogt recorded d'Andrade's features and the immediacy and specificity of the moment depicted. Slevogt was a member of the Munich Secession and later the Berlin Secession, where he also served on the executive committee.

Lastly, the Swiss-born Ferdinand Hodler (1853–1918) belonged to the same generation as the German secessionists and exhibited with them in Munich, Vienna, and Berlin. After studying at the art school in Geneva from 1871–1876, he undertook a series of trips to European capitals, broadening his artistic horizons. During his early years, Hodler concentrated on realist genre subjects of a pessimistic cast. Like Munch, he had lost close family members to illness during his childhood, and these experiences were reflected in his sensitive portrayals of relatives and friends on their sickbeds, and of convalescents. In a lighter vein, he also painted rural workers engaged in everyday activities including making nets, sharpening scythes, and praying.

In the 1880s, Hodler began executing large-scale history paintings, at first in response to organized competitions and later as public commissions—the most controversial of which was for the Landesmuseum in Zürich. The broad monumental forms, expressive linearity, and regularized brushstrokes of his mature style are already evident in these works, as well as in the more intimate easel pictures of the period. During the next decades, Hodler aspired to more synthetic, philosophical statements in both figure compositions and landscapes. In keeping with his theory of "parallelism", which sought to discover the underlying unities of nature, Hodler evolved a highly personal symbolist style in which symmetry and the rhythmic repetition of forms were emphasized. These works shared the pantheistic ambitions of Runge, while resembling the more nearly contemporary, monumental figure compositions of Puvis de Chavannes and Feuerbach.

Hodler is perhaps best known for his portraits and landscapes. The starkly frontal *Self-Portrait,* from 1900 (no. 121), is one of more than a hundred likenesses painted of himself. The Stuttgart painting recalls both Dürer's Christ-like *Self-Portrait* of 1500 (Munich, Bayerisches Staatsgemäldesammlungen, Alte Pinakothek) and van Gogh's iconic portrayals of the postmaster Roulin.

Hodler's expressionistic late landscapes, mainly of the Alps and Lake Geneva, are equivalently innovative and modern. Some are cropped, close-up views of looming peaks,

while others, such as *Lake Geneva with the Savoy Alps,* of 1906 (no. 122), are panoramic vistas seen from above. In their moods of remote physical isolation and spatial tensions engendered by overlapping horizontal planes, these canvases are reminiscent of the landscapes of Friedrich. However, their heightened palettes and overall decorative surface patterns share the increasingly non-naturalistic visions of Gauguin and Munch. Hodler's and Munch's works were featured together in the Vienna Secession exhibition of 1904. Hodler weathered considerable controversy at home in conservative Geneva, but in general his paintings were well received in both France and Germany.

<p style="text-align:center">• • •</p>

The affinities between Hodler's powerfully expressive canvases and the works of painters as diverse as Friedrich, Runge, Puvis de Chavannes, Gauguin, and Munch demonstrate just how international the cultural scene had become by the end of the nineteenth century. They also indicate how integral was the role played by artists from German-speaking countries in the development of the subjective, characteristically northern, strain of modernism presaged by Caspar David Friedrich. Leibl, Trübner, Liebermann, and Slevogt manifestly benefited from their exposure to French painting; their canvases are luminous evocations of the German countryside and of contemporary, especially rural, life. The fact remains, however, that their increasingly formal works had no meaningful artistic legacy, either in Germany or elsewhere. In contrast, the introspective and quintessentially Germanic art of Friedrich, Runge, Böcklin, Feuerbach, Klinger, Corinth, and others bore more promising fruit. With ties to philosophy, literature, and music; its continued commitment to figural representation; spatial and coloristic distortions and disjunctions; and even an early acknowledgment of the decorative potentials of linear arabesques and surface patterns, this art anticipated and inspired a number of the most significant movements in modern art, from *Jugendstil* to expressionism and surrealism.

Neoclassicism

Johann Heinrich Dannecker

Born 1758, Stuttgart; died 1841, Stuttgart

One of the most important German neoclassical sculptors, Johann Heinrich Dannecker began his study of sculpture in 1771 at the military academy in his native Stuttgart (that academy was renamed the Hohe Carlsschule in 1782). Appointed court sculptor to the Prince of Swabia in 1780 (a position he retained for life), he was sent to study in Paris with Augustin Pajou from 1783 to 1785 and then to Rome (where he befriended Canova) from 1785 to 1789. In 1790, following his return to Stuttgart, he was appointed Professor of the Hohe Carlsschule. Over the course of his career Dannecker was awarded a number of significant commissions and made a number of important friendships, most notably with the poet Friedrich von Schiller.

Dannecker's *Self-Portrait,* 1797, skillfully contrasts the rich carving of the artist's hair with the sweeping curves of drapery that cover his shoulders. Both elements are juxtaposed with the clear outline and broad planes of the face to produce a work that projects an easy confidence and self-assurance, a portrait of the artist as worldly yet idealistic, energetic yet poised.

In his *Bust of Schiller,* by contrast, Dannecker strives for an effect both more monumental and more expressive. One of many portraits that Dannecker produced of his great friend, this bust had its origin in a life-sized bust of Schiller that Dannecker carved in 1794, during Schiller's last stay in Stuttgart. Following Schiller's death in 1805, Dannecker determined to make a monument to his late friend. "I want to make Schiller live," he said, "but he can only be alive as a colossus. Schiller MUST LIVE COLOSSALLY IN SCULPTURE, I want an apotheosis." Dannecker used as his starting point the poet's appearance in his earlier bust (thus the date of 1794 that he inscribed on this work), but he simplified and stylized the features to create a heroic and eternal impression. Had Dannecker realized his plans for this sculpture, it would have sat high atop an elaborate base within a templelike structure, illuminated only with a strong light from above.

In addition to sculpture, Dannecker produced numerous drawings, some signed and highly finished, many more being informal sketches in which the artist worked out his ideas and developed his compositions. In this latter category, arguably the more remarkable of the two, Dannecker could alternate between an extraordinary purity of line, as in his *Women Mourning,* and the nervous energy found in such drawings as *Aphrodite Rescuing Paris in Battle with Menelaus* and *Apollo Helping Hector in the Battle with Patroclus.*

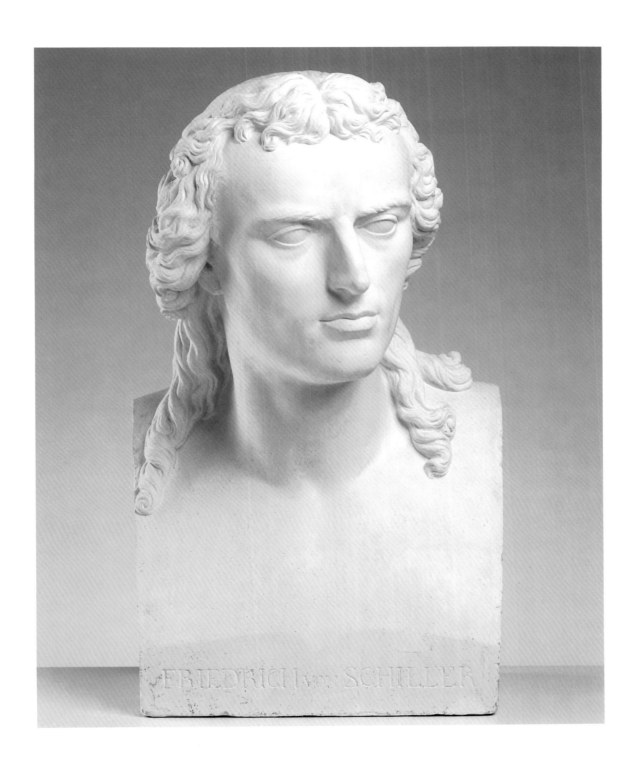

1. *Bust of Schiller*, 1794
Plaster
85 × 45 × 47 cm
Gift of King Wilhelm I; Inv. No. P 693

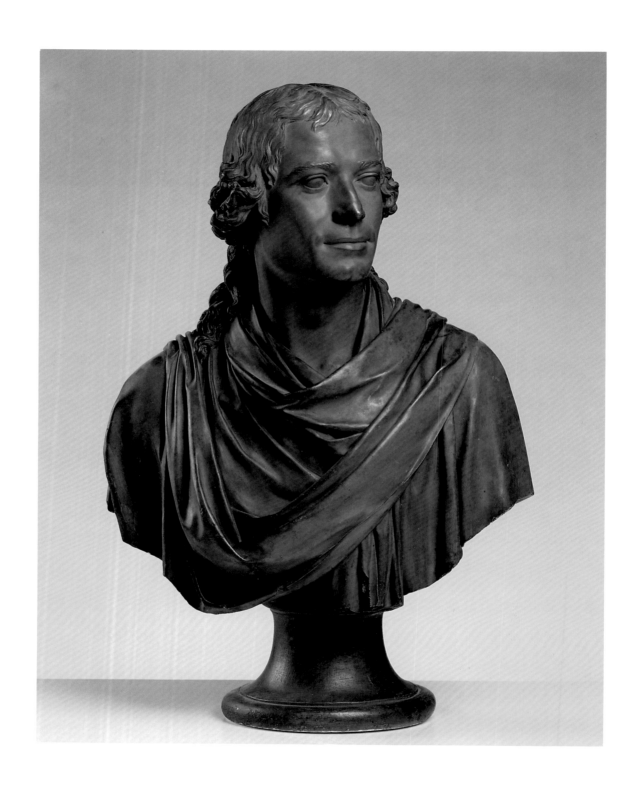

2. Self-Portrait, 1797
Plaster
74.5 × 50 × 30 cm
Gift of Friederike Dannecker; Inv. No. P 703

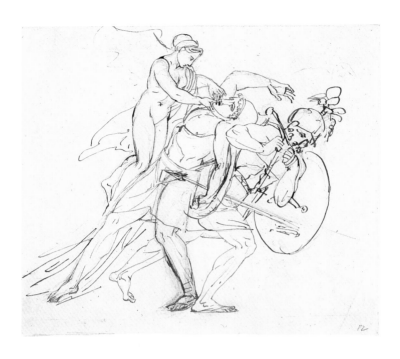

3. *Aphrodite Rescuing Paris in Battle with Menelaus,* no date
Pen over pencil on white paper
20.7 × 23.3 cm
Gift of Johann Heinrich Dannecker; Inv. No. 3589

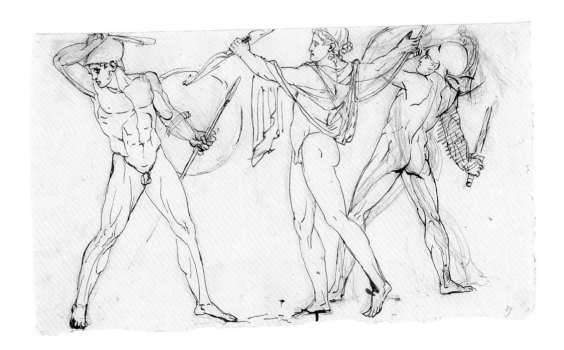

4. *Apollo Helping Hector in Battle with Patroclus,* no date
Pencil on paper
22.4 × 37 cm
Gift of Johann Heinrich Dannecker; Inv. No. 3593

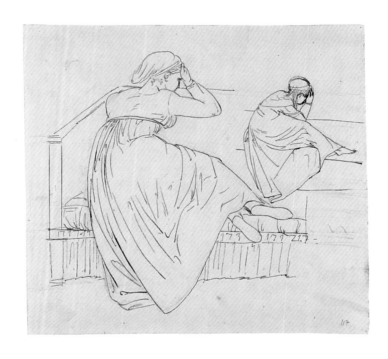

5. *Women Mourning,* no date
Pen over pencil on white paper
25.4 × 27.4 cm
Gift of Johann Heinrich Dannecker; Inv. No. 3627

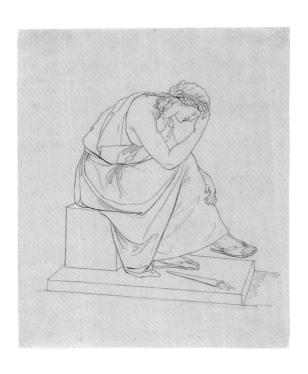

6. *Ceres Mourning,* no date
Pen over pencil on paper
21.6 × 17.7 cm
Gift of Johann Heinrich Dannecker; Inv. No. 3520

Philipp Friedrich Hetsch

Born 1758, Stuttgart; died 1838, Stuttgart

A history and portrait painter, Hetsch was, along with Gottlieb Schick, the leading representative of Swabian neoclassicism. Hetsch studied at the Stuttgart Military Academy (befriending Dannecker and Schiller) before traveling to Paris in 1780, where he studied with Joseph-Marie Vien. In 1785 he began a two-year stay in Rome, where he was influenced by Joseph Vernet and, above all, by Jacques-Louis David. Hetsch traveled once more to Paris (in 1808–1809), and twice more to Rome (1794–1796 and 1802–1803). In 1787 he was named Professor of History Painting and Drawing at the Hohe Carlsschule, and in 1798 was named director of the Ludwigsburg Gallery of Painting. Replaced in that last position by Dannecker in 1817, he seems to have entered a depression and ceased working as an artist.

Tullia Driving Her Chariot over the Corpse of Her Father, drawn in 1786, shows Hetsch at his most Davidian. The scene, full of violence and energy, is drawn from an incident in early Roman history in which Tullia, daughter of Servius Tullius, sixth king of Rome, persuades her brother-in-law, the future Tarquinius Superbus and last king of Rome, to murder her husband and her father so that Tarquinius might ascend to the monarchy and marry her. Images of civic virtue—and its antithesis—drawn from Roman history were common within David's circle and have frequently been linked to a growing republican sentiment in France and Germany.

Hetsch's *Cornelia, Mother of the Gracchi,* 1794, also depicts a scene of Roman republican virtue. Asked to show off her jewels, Cornelia, daughter of the great Roman general Scipio Africanus Major, points to her two sons (who would later become the leaders of a revolutionary agrarian reform movement). Although the subject of this painting is still Roman, the style is considerably sweeter and less violent than that of Hetsch's earlier drawing, that is, closer to Vien than to David. It seems as much a depiction of maternal sentiment as a political parable. In the wake of the French Revolution's Reign of Terror, Hetsch, like a number of artists, turned away from stern themes rendered in a severe style; Roman subjects generally gave way to Greek.

For his *Self-Portrait,* painted soon after Hetsch's return from his first trip to Rome, Hetsch represents himself in the midst of the Grand Tour: the visit to Italy required of artists and cultivated gentlemen alike. Indeed, his garb is that of the German tourist (close to Tischbein's famous portrait of Goethe in Figure 1) rather than an artist. Pose and props indicate that Hetsch has adapted this self-portrait from the model established for portraits of the nobility.

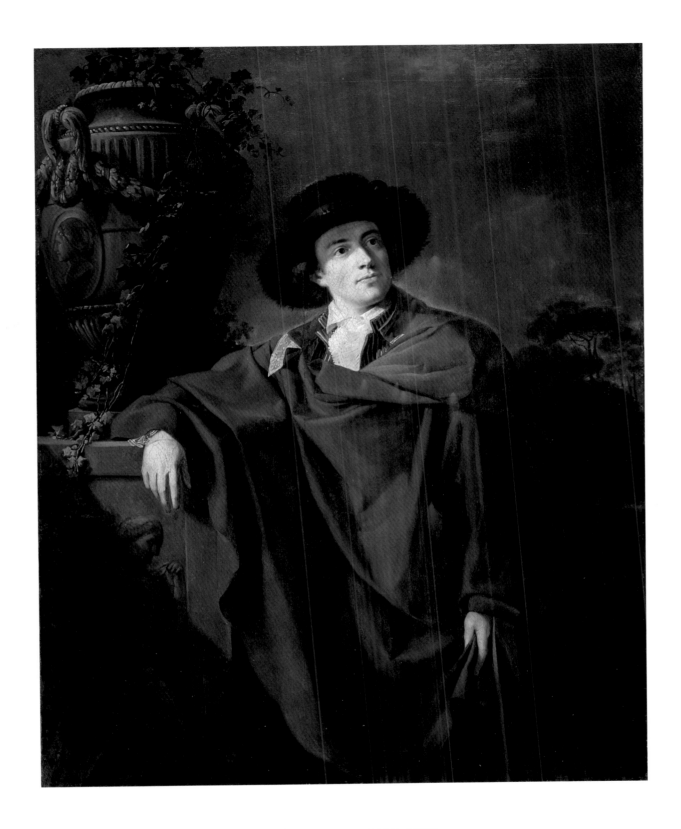

7. Self-Portrait, c. 1787–1790
Oil on canvas
144 × 113 cm
Gift of Christian Frederick Hetsch; Inv. No. 920

45

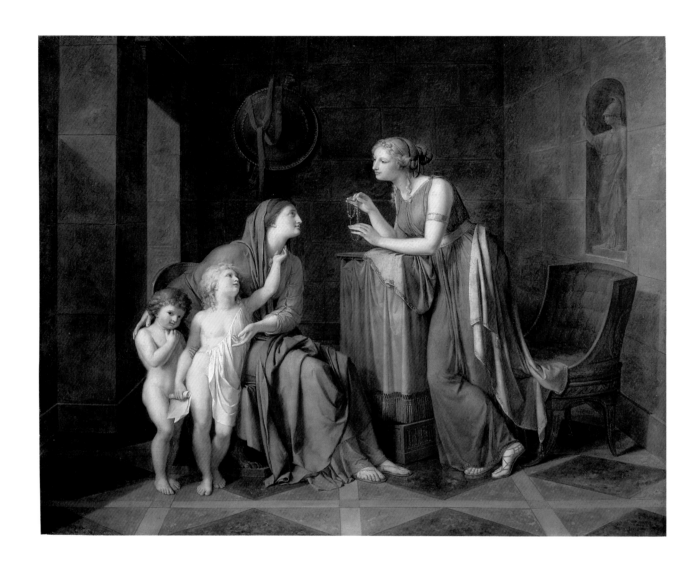

8. *Cornelia, Mother of the Gracchi,* 1794
Oil on canvas
112 × 136 cm
Gift of the City of Stuttgart; Inv. No. 679

46

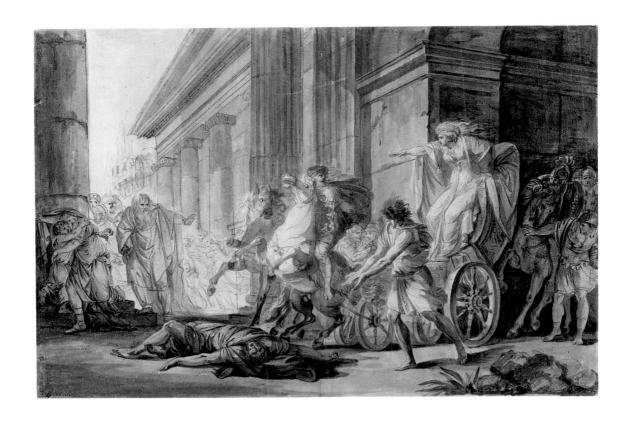

9. *Tullia Driving Her Chariot over the Corpse of Her Father,* 1786
Pen and pencil with white highlights on white laid paper
46.5 × 67.8 cm
Bequest of the Artist; Inv. No. 5596

Johann Christian Reinhart

Born 1761, Hof, Bavaria; died 1847, Rome

Johann Christian Reinhart, the most important German neoclassical landscape painter after Joseph Anton Koch, studied theology in Leipzig before beginning his artistic training in 1779 with Friedrich Oeser, Director of the Leipzig Art Academy. He had further training at the Dresden Academy in 1783, before returning to Leipzig where he befriended the poet Friedrich von Schiller in 1785. Reinhart traveled to Rome in 1789, where he met Koch and Jacob Carstens, both of whom influenced his style. Reinhart lived in Rome for the remainder of his life and became one of the leading members of the German artists' colony. His early Italian works were mostly prints, but by the early 1800s he began to produce paintings.

The Wanderer's Storm Song, 1832, reflects Reinhart's mature style. His forms are even crisper than those of Koch and, in place of the latter's vertiginous sweeps, he lays out his compositions in a series of clear receding planes. Reinhart is known for injecting a note of realism into the academic landscape style, particularly in his rendering of details—trees and foliage, rocks and hills—which maintain a natural scale and appearance in his paintings. The title of this painting, assigned after it was painted, refers to an early poem by Goethe.

Perhaps more remarkable than his paintings were the drawings that Reinhart produced in his early years in Rome. Certain of these drawings, such as his *Rock Study,* 1802, and his *Rock Study with Fallen Tree,* 1802, were produced as studies for paintings or prints. The theory of neoclassical landscape painting called for the artist to make studies of each of the principal elements of a work in order to arrive at a perfected form, just as the history painter drew studies for the poses and expressions of the major figures in a painting. In contrast, drawings like *Forest Path, with Three Great Trees,* 1794, and the monumental *Three Great Trees,* 1803, were developed as finished works. In this last drawing the trees achieve a virtually heroic character, offering more than a hint of a romantic animism.

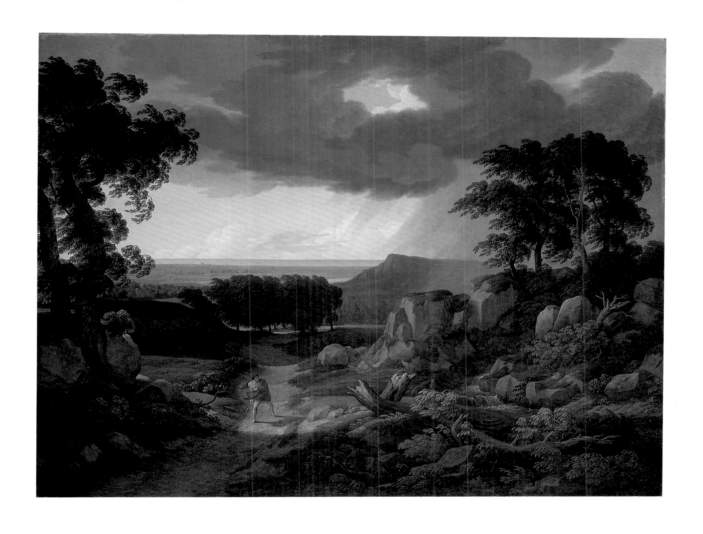

10. *The Wanderer's Storm Song,* 1832
Oil on canvas
70.4 × 92.2 cm
Purchased from the Estate of Karl Wilhelm v. Heideck; Inv. No. 93

11. *Forest Path with Three Great Trees,* 1794
Gray chalk on white paper, mounted on cardboard
66.9 × 51.7 cm
In the collection before 1918; Inv. No. 6494

12. *Three Great Trees,* 1803
Gray chalk on brown paper, pieced and mounted
88.9 × 66.8 cm
In the collection before 1918; Inv. No. 6495

13. *Rock Study,* 1802
Gray chalk on paper
31.9 × 40.9 cm
Inv. No. C 27/65

14. *Rock Study with Fallen Tree,* 1802
Gray chalk and white highlights on laid paper
28.8 × 43.1 cm
Inv. No. C 27/66

Friedrich Christian Reinermann

Born 1764, Wetzlar; died 1835, Frankfurt

T he engraver, lithographer, and landscape painter Friedrich Christian Reinermann followed the normal path of artistic education for both academic and non-academic German artists during the late eighteenth and early nineteenth centuries by going to Rome and then spending the greater portion of his artistic career in the German-speaking countries. In Rome he was the pupil of Louis Ducros from 1789–1790, and from 1793 to 1803 Reinermann worked in the Swiss publishing house Chr. V. Mechel. In 1811 he returned to his native Wetzlar, and in 1818 he moved to Frankfurt where he stayed for the remainder of his life.

During his lifetime Reinermann completed several series of watercolor and sepia landscapes, including nineteen views of the river Lahn, twenty-four of the river Mosel, and twenty-four of the Elms. Although there is no indication that the Stuttgart watercolor belongs to one of these or to another specific series, its medium and subject matter suggest that it too is a faithfully reproduced view of a German forest. Although the exact date of the work is unknown, Reinermann's attention to observed nature and contrasts of light and dark mark him as a precursor of the naturalistic tendencies in German art that peaked at mid-century.

J. B.-L.

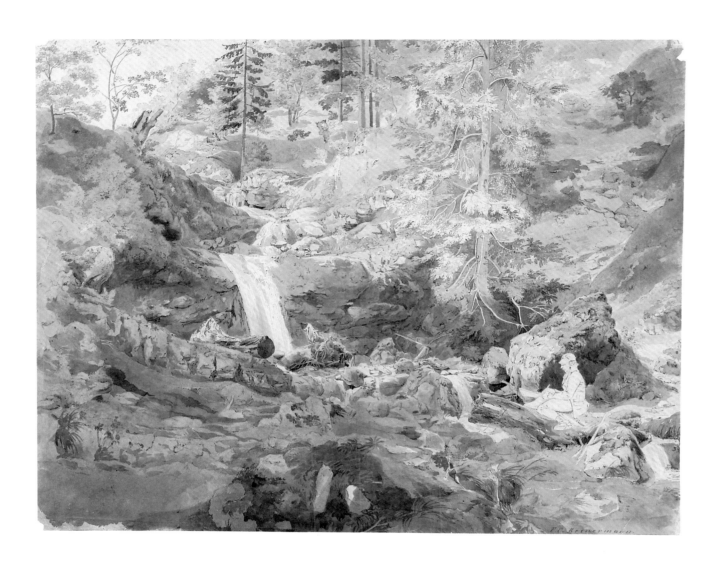

15. *Waterfall in the Forest,* no date
Watercolor over pencil on paper
41.5 × 52.2 cm
Inv. No. C 27/62

Johann Gottfried Schadow

Born 1764, Berlin; died 1850, Berlin

Rising from humble origins as the son of a tailor, Johann Gottfried Schadow was considered the greatest German neoclassical sculptor of his day, and his reputation has not waned with the passing of time. Schadow was trained in the Royal Sculpture Workshops in Berlin under Jean Pierre Antoine Tassert and was a pupil at the Berlin Academy of Art. He spent the years 1785–1787 in Rome. During those years, he became a close friend of the Italian sculptor Canova. When he returned to Berlin, Schadow rose quickly to positions of prominence; by 1788 he was made a Court Sculptor. In 1805 he became the Vice-Director of the Berlin Academy and Director in 1815. His most significant work, the *Quadrige mit Viktoria,* stands atop the Brandenburg Gate in Berlin (the original was destroyed during World War II, the current statue is a bronze copy) and has served as a symbol of German history and pride for two centuries.

Schadow drew the *Portrait of Queen Luise of Prussia* from life in Potsdam in 1802. The portrait is strikingly different from most official portraits of royalty at the beginning of the nineteenth century. Schadow focuses on the person, not the position. She is shown simply, neither idealized nor heroicized, and without the trappings of her role as Queen. An inscription on an accompanying sheet documents that this drawing was intended by Luise to be a gift to an unidentified person.

J. B.-L.

16. *Portrait of Queen Luise of Prussia*, 1802
Crayon and pencil on paper
31.9 × 24.8 cm
Gift of C. G. Boerner; Inv. No. C 62/1037

Johann Jakob Müller

Born 1765, Riga, Latvia; died 1832, Stuttgart

Known as "Müller from Riga," Johann Jakob Müller studied in Dresden with Johann Friedrich Klengels from 1798 to 1801, before traveling to Stuttgart and then to Switzerland in 1801. From 1802 to 1804 he was in Rome, where he met Schick; after 1804 he remained in Stuttgart. A landscape painter, he painted views of Swabia, as well as Italian scenes.

Evening on the Coast of Salerno, 1817–1818, like many of Müller's paintings, melds the compositional formulas of classical landscape to topographical description. The framing devices of rocks, trees, and bridge, as well as the *staffage* that animate them, are all adapted by the artist from precedents in classical landscape. They are common to the landscape tradition that derived from the work of Claude Lorrain. By contrast, the description of the Bay of Salerno looking westward toward Amalfi is quite accurate. Müller combines the real and the ideal with a soft and gentle light that spreads evenly from the setting sun at the picture's left.

17. *Evening on the Coast of Salerno, 1817–1818*
Oil on canvas
59.5 × 84 cm
Bequest of v. Fleishmann; Inv. No. 655

Wilhelm Kobell

Born 1766, Mannheim; died 1853, Munich

Although Wilhelm Kobell was briefly a pupil at the Mannheim Academy of Art, most of his artistic training consisted of drawing from nature and copying Dutch seventeenth-century paintings under the guiding hand of his father, Ferdinand Kobell. He found early success as a court painter in Mannheim but, heeding the call of Elector Karl Theodor, Kobell moved to Munich in 1793. Between 1808 and 1815 he solidified his artistic reputation as a battle painter in the service of the Crown Prince Ludwig of Bavaria who commissioned from him thirteen monumental battle scenes celebrating Bavaria's military campaigns. In 1814 Kobell was made Professor of Landscape Painting at the Munich Academy of Art and held the position until 1826. In that year King Ludwig I abolished the positions for genre and landscape painting, sending Kobell into an early retirement. Thereafter Kobell was an active painter in Bavaria, but his scenes of battle gave way to quiet Bavarian landscapes. These paintings, which generally depict groups of large isolated figures against a vast landscape, are marked by an extreme and utter calm.

The Stuttgart *Portrait of Maria Josepha von Kobell* was probably done two years after the artist settled in Munich in 1793 and is one of the "intimate" portrayals of his family and friends that he executed between 1786 and 1795. The portrait shows that Kobell had begun applying the wealth of technical knowledge he had acquired from copying Dutch seventeenth-century painting to his own ends. The fluidity of shading and Maria Josepha's almost theatrical appearance also show Kobell's indebtedness to baroque drawings and to the theater. The vivid impression created by the unconventional pose and arrangement is all the more remarkable because in his paintings of the same period Kobell did not yet move beyond the conventional gestures and figural arrangements of his Dutch models.

J. B.-L.

18. *Portrait of Maria Josepha von Kobell,* 1795
Pencil with wash
30.8 × 20.9 cm
Inv. No. 72/2272

Nicolaus Friedrich von Thouret

Born 1767, Ludwigsburg; died 1845, Stuttgart

Nicolaus Friedrich von Thouret trained initially as a painter but saw his greatest professional success in architecture. After studies at the Military Academy of Stuttgart and then at the Hohe Carlsschule, he worked in Paris from 1789 to 1791 and then in Rome from 1793 to 1796. It was in Rome that Thouret's interests shifted from painting to architecture. Upon his return to Germany in 1796 he quickly became the leading classical architect in Stuttgart, one whose work was highly admired by Goethe.

Painted in Rome, *Cupid Bound, with Two Bacchantes,* 1793, seems to have drawn its central motif from an antique sarcophagus or vase painting. The painting takes the neoclassical concern for the antique to a mannerist extreme of delicacy and refinement. Its curious eroticism reminds us that this was the era of Casanova and the Marquis de Sade.

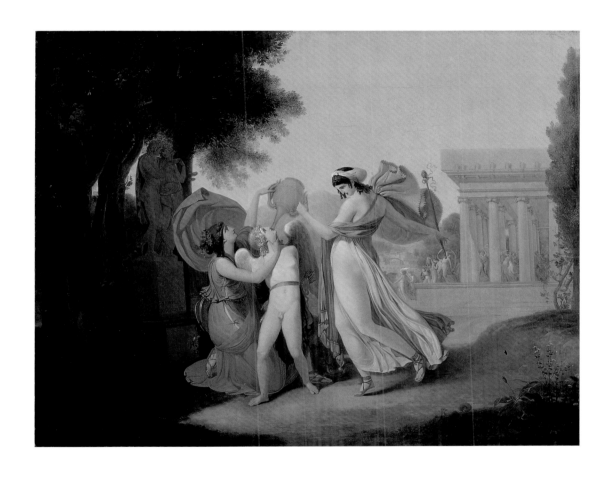

19. *Cupid Bound, with Two Bacchantes*, 1793
Oil on canvas
50.5 × 64 cm
Formerly Schloss Ludwigsburg; Inv. No. L 378

Joseph Anton Koch

Born 1768, Obergiblen; died 1839, Rome

Born in the Tyrol, Koch studied in Augsburg and then at the Hohe Carlsschule in Stuttgart under the landscape painter Adolf Friedrich Harper and the history painter Philipp Friedrich Hetsch. He traveled to Italy in 1794, arriving in Rome in 1795. He left Rome for Vienna in 1812 because of the Napoleonic wars, but returned to Rome in 1815, where he remained until his death. While Koch is regarded as the preeminent German neoclassical landscape painter, he also had important contacts with the generation of German romantic artists who arrived in Italy in the 1820s (in particular the Nazarene painters Friedrich Overbeck, Julius Schnorr von Carolsfeld, and Philipp Viet), with whom he worked on the fresco decoration of the Casino Massimo in Rome from 1825 to 1828.

Although neither Koch's *Rest on the Flight into Egypt* nor his *Landscape after a Storm* depict classical subjects, both reveal the artist's approach to landscape painting. In each, figures are set against a vast panorama. Broad, sweeping curves carry the eye through the landscape, which is organized into large masses of contrasting light and dark. Although the sky is marked by clouds, a crystalline atmosphere does not diminish our view of even the most distant object.

The heroic landscape aesthetic that Koch expressed in his paintings is also found in the many large, highly finished landscape drawings that he executed. *The Hostel on Grimsel Pass* was drawn in 1793–1794, as Koch traveled in Switzerland before pushing south to Italy. Koch harbored republican sympathies at this time and may have seen the rugged Alps, which protected the Swiss Confederation from invasion, as a virtual symbol of liberty. With their subjects taken from classical mythology, drawings like *Landscape with Cadmus and the Dragon,* 1797; *Landscape with Hylas and the Nymphs,* 1796–1797; and *Landscape with Polyphemus, Acis, and Galatea,* 1796, all exemplify the neoclassical landscape theory of the selection and combination of perfected elements. Nature, according to this theory, is imperfect, and it is the task of the artist to discover and refine those elements in nature that will result in an ideal landscape.

In addition to his work as a landscape painter, Koch achieved considerable reknown for his illustrations of Dante. He published 200 illustrations for the *Divine Comedy* and had planned to produce many more. The oil sketch of *Dante and Virgil on Geryon's Back,* c. 1802–1804, happens to be Koch's only known oil painting of a subject from Dante. The picture depicts the snake-bodied monster Geryon, the symbol of deception, transporting Dante and Virgil from the seventh to the eighth circle of hell.

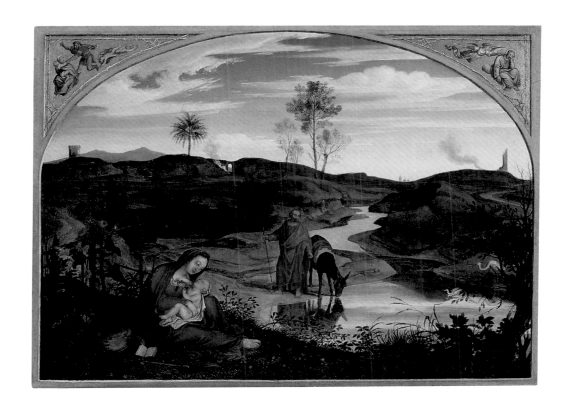

20. *Rest on the Flight into Egypt,* probably c. 1820–1825
Oil on walnut
31.7 × 41.5 cm
On loan from the Baden-Württembergischen Bank; Inv. No. L 1227

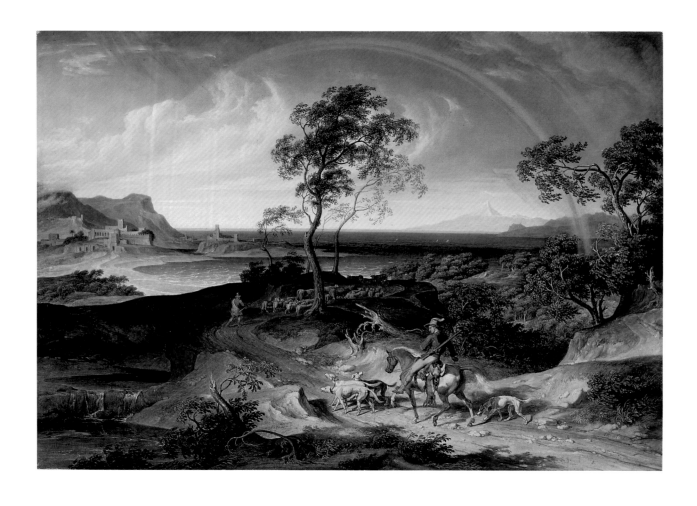

21. *Landscape after a Storm*, c. 1830
Oil on canvas
75.7 × 103 cm
Gift of Karl Wilhelm v. Heideck; Inv. No. 92

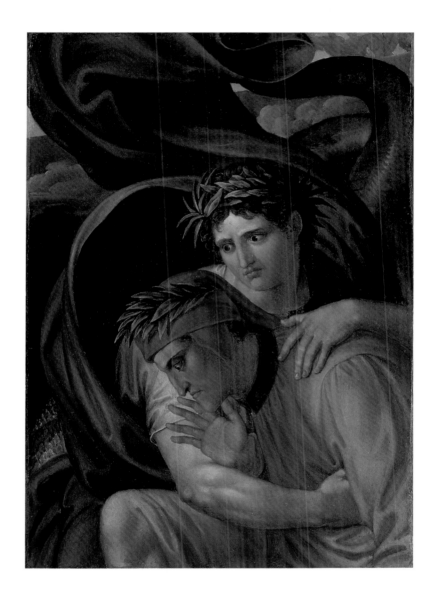

22. Dante and Virgil on Geryon's Back, c. 1802–1804
Oil on paper
44.5 × 30.5 cm
Purchase; Inv. No. 3293

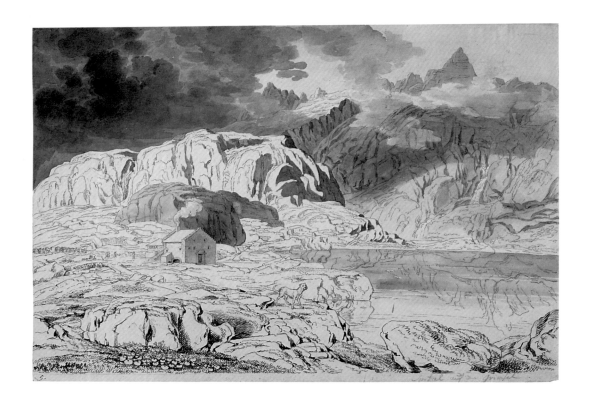

23. *The Hostel on Grimsel Pass,* 1793–1794
Pen and watercolor on white paper, pencil borders
37 × 52.1 cm
In the collection before 1906; Inv. No. 4170

24. *Landscape with Polyphemus, Acis, and Galatea,* 1796
Pen and brush with white highlights on paper
54.5 × 75.5 cm
In the collection before 1903; Inv. No. 5658

25. *Landscape with Hylas and the Nymphs,* 1796–1797
Pen and watercolor with white highlights on laid paper with a gold border
49.7 × 74.7 cm
In the collection before 1903; Inv. No. 5664

26. *Landscape with Cadmus and the Dragon,* 1797
Pen and pencil with white highlights on paper with gold border
53.9 × 76 cm
In the collection before 1903; Inv. No. 5663

Christian Ferdinand Hartmann

Born 1774, Stuttgart; died 1842, Dresden

Christian Ferdinand Hartmann enjoyed a significant reputation in his day as a history and portrait painter. He learned his neoclassical style from Philipp Friedrich Hetsch, with whom he studied at the Hohe Carlsschule in Stuttgart. He spent the years 1794 to 1798 in Rome and in 1803 established himself in Dresden. He was named Professor of the Dresden Academy in 1810 and in 1825 was made Director.

Psyche, 1797, painted in Rome, is typical of Hartmann's history paintings in its hard outlines, precise draftsmanship, and reliance upon antique sources. The painting was inspired by "Elysium," a poem by the artist's friend Friedrich von Mathhisson. Psyche in Greek means soul and butterfly: thus the figure's wings.

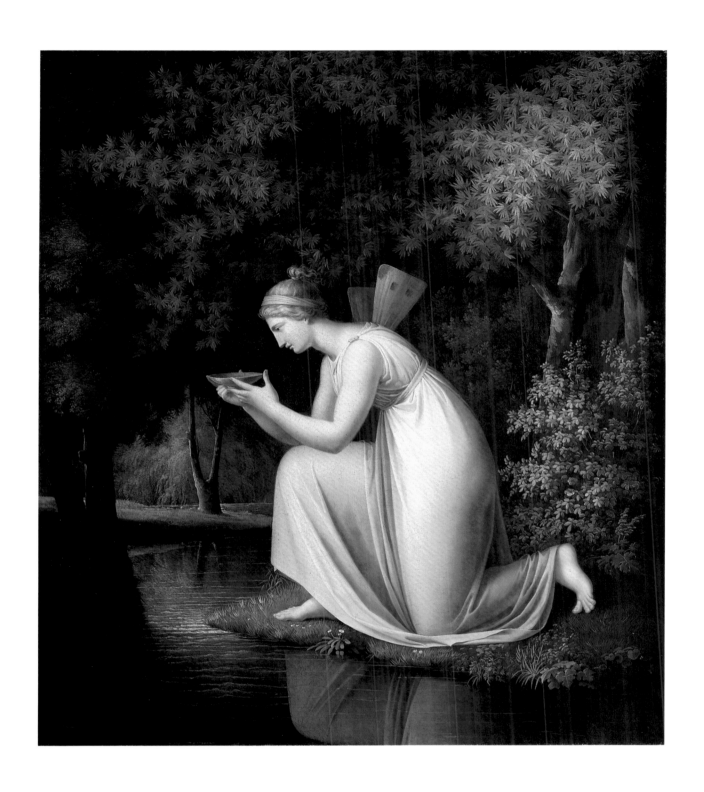

27. Psyche, 1797
Oil on canvas
114 × 94 cm
Purchase; Inv. No. 1997

73

Johann Baptist Seele

Born 1775, Messkirch; died 1814, Stuttgart

A portrait painter and above all a battle painter, Johann Baptist Seele studied from 1789 to 1792 at the Hohe Carlsschule in Stuttgart. In 1804 he was named Court Painter and Gallery Director (with Hetsch) by King Friedrich I. Seele's simple, unpretentious portrait manner is evident in his painting of Friederike Christine von Landsee, completed about 1800. The sitter, the daughter of a baker, was a dancer in the Stuttgart Court Theater. From 1792 until 1803 she was married to Karl Heinrich von Landsee, the Baron von Rotenberg. She began an affair with Seele in 1800, and she married him in 1803.

28. *Friederike Christine von Landsee,* c. 1800
Oil on canvas
55 × 44.5 cm
Bequest of Hans Otto Schaller; Inv. No. 1904

Battle of the Russians and the French on the Devil's Bridge in St. Gotthard Pass in the Year 1799 is one of Seele's most important battle pictures. The painting depicts the historic battle for the St. Gotthard Pass in which Russian troops, led by Field Marshall Aleksandr von Suvorov, defeated Napoleon's army. To stop the Russian approach, the retreating French had destroyed the so-called Devil's Bridge, but the Russians connected the span with temporary planks, across which they advanced to win the battle. Seele pays proper attention to the details of military costume, but he is even more engaged by human emotion and expression, the variety of which he charts in the faces of the French and Russian soldiers. While Seele shows the battle being won by courage and by guns, the greatest power in this painting is evidently that of nature, which dwarfs the human actors in the drama.

29. *Battle of the Russians and the French at the Devil's Bridge,*
St. Gotthard Pass in the Year 1799, 1802
Oil on canvas
76 × 99.5 cm
Formerly Schlossmuseum Stuttgart; Inv. No. L 16

Christian Gottlieb Schick

Born 1776, Stuttgart; died 1812, Stuttgart

During his brief life, Christian Gottlieb Schick established himself as a leading exponent of German neoclassicism. He studied in the Hohe Carlsschule in Stuttgart under Philipp Friedrich Hetsch, where he also formed a strong friendship with Johann Heinrich Dannecker. From 1798 to 1802, he studied in Paris under Jacques-Louis David, and he lived in Rome from 1802 to 1811.

Although Schick was considered above all a history painter, he also produced portraits and landscapes. Indeed, his best-known work is the portrait of *Wilhelmine Cotta* which he painted during a brief stay in Stuttgart in 1802, before he departed for Rome. The sitter is the wife of the important publisher and bookseller Johann Friedrich Cotta. The painting contrasts the up-to-the-minute elegance of the sitter's costume with her relatively unidealized features, a contrast that allows a sense of the sitter's individual presence to emerge.

Such presence is felt even more powerfully in Schick's unfinished portrait of Heinrike Dannecker. Painted at the same time as his portrait of Wilhelmine Cotta, this painting of the first wife of Johann Heinrich Dannecker brilliantly displays the Davidian technique Schick learned in Paris. The composition has been "squared-up" from a preparatory drawing, and the figure blocked out with relatively broad brushstrokes. What we see, then, is the ground over which a final layer of paint would be added to finish the composition (Schick did produce a finished version of this portrait, which is now in the Nationalgalerie, Berlin). Although the sitter's pose has been adapted from antique models, the overall impression is of spontaneous immediacy. Most evident is the artist's affection for his subject, whom he had known since childhood.

Schick's activity as a history painter is exemplified above all by his *Apollo among the Shepherds,* 1806–1808, among the most important history paintings produced by a German artist in the early nineteenth century. Here the god Apollo, sentenced by his father, Zeus, for the killing of the cyclops to serve for a year as a shepherd in Thessaly, teaches music and poetry to the shepherds. Instead of choosing a moment of high drama or a moral lesson for his subject, Schick has opted to make his painting a metaphor of the classical ideal: art brings beauty and order to the world, and harmony between man and nature.

Schick was the product of a highly organized system of art education in which drawing was held to be of paramount importance. Students were taught to execute a number of different types of drawings, several of which Schick epitomized in works now in the collection of the Graphische Sammlung of the Staatsgalerie Stuttgart. *Zeus* is a copy of an antique sculpture, the *Zeus of Otricoli. Standing Male Nude as a Satyr* is a study drawn from life of a nude model. *Young Man and Woman Gazing Upward* is a largely finished study for a portion of an original composition, while *Apollo and Artemis Killing Niobe's Children* is a compositional sketch. *The Five Children of the Humboldt Family* is a study for a group portrait.

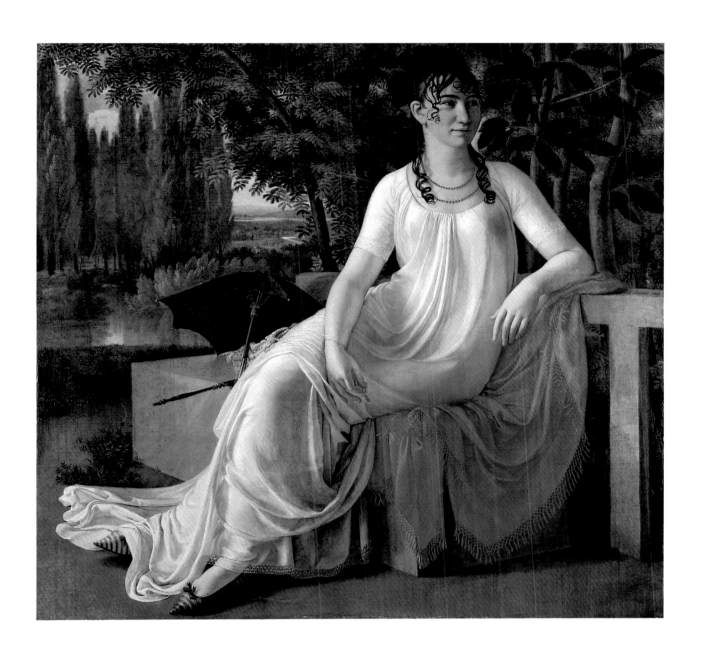

30. *Wilhelmine Cotta*, 1802
Oil on canvas
133 × 140.5 cm
Purchased with the support of the Werbefunks des Süddeutschen Rundfunks; Inv. No. GVL 87

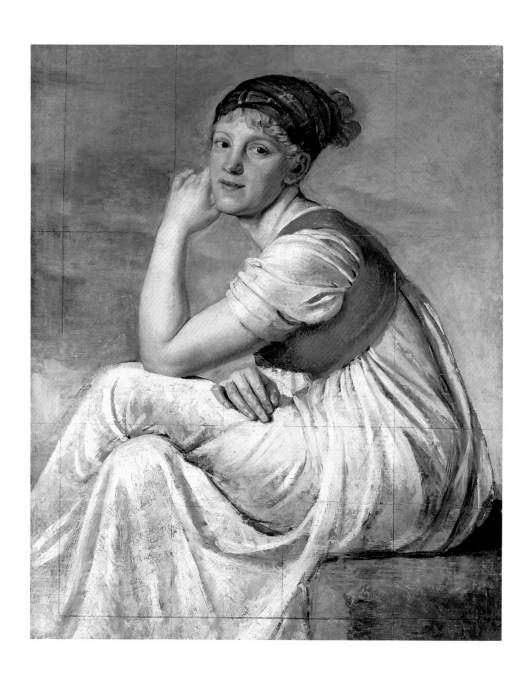

31. *Heinrike Dannecker,* 1802
Oil on canvas
91 × 70 cm
Purchase; Inv. No. 799

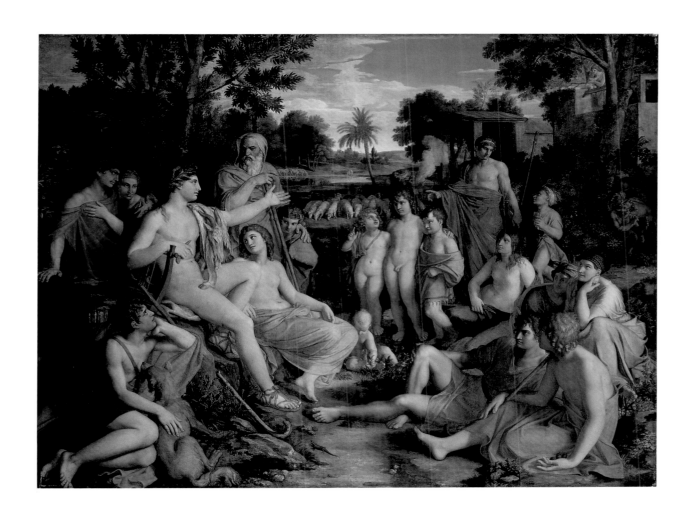

32. *Apollo among the Shepherds*, 1806–1808
Oil on canvas
178.5 × 232 cm
Gift of King Wilhelm I; Inv. No. 701

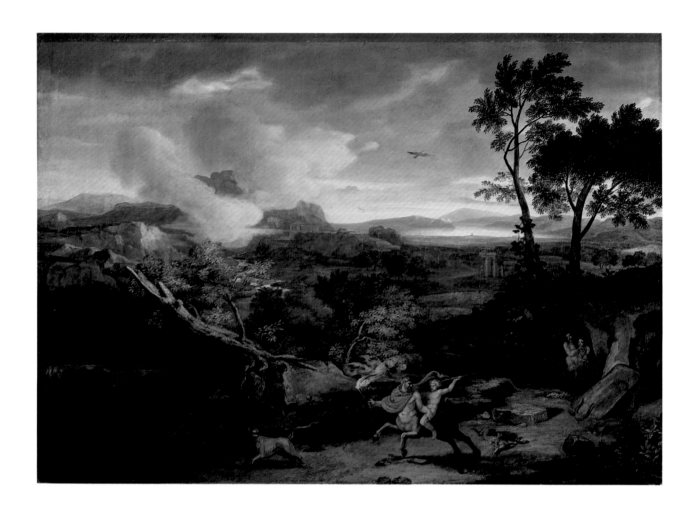

33. *Southern Landscape with the Education of Achilles*, 1807–1808
Oil on canvas
74 × 98.5 cm
Purchase; Inv. No. 2356

34. *Apollo and Artemis Killing Niobe's Children,* probably c. 1798–1802
Pencil and pen on white paper
24 × 38.6 cm
In the collection before 1918; Inv. No. 2360

35. *Zeus*, c. 1800
Chalk and charcoal on white paper, mounted
58.2 × 43.6 cm
In the collection before 1918; Inv. No. 6459

36. *Standing Male Nude as a Satyr,* c. 1803
Chalk on white paper
60.9 × 45.6 cm
In the collection before 1918; Inv. No. 6462

37. *Young Man and Woman Gazing Upward,* 1804
Pencil and charcoal on white paper, over pencil drawing
55.9 × 43.4 cm
In the collection before 1914; Inv. No. 2354

38. *The Five Children of the Humboldt Family,* c. 1804
Pencil with white highlights on white paper
39.2 × 31.4 cm
In the collection before 1914; Inv. No. 2368

Christoph Friedrich Dörr

Born 1782, Tübingen; died 1841, Tübingen

The son of a portrait painter, Christoph Friedrich Dörr studied with Philipp Friedrich Hetsch in Stuttgart. He worked in Rome from 1804 to 1807, and after 1809 he taught drawing at the University of Tübingen.

For his *Portrait of an Unknown Woman,* Dörr adapted a formula common in the early Renaissance, one taken up again by artists who worked in Rome in the early nineteenth century. The half-length figure is set against a landscape, her upper torso outlined against the receding countryside, her neck and head framed by a clear sky. While the sitter in this painting has not been identified, the landscape against which she is set is clearly marked as the Ammer Valley, near Tübingen. To the left is Schwärzloch Keep, and to the right the village of Jesingen.

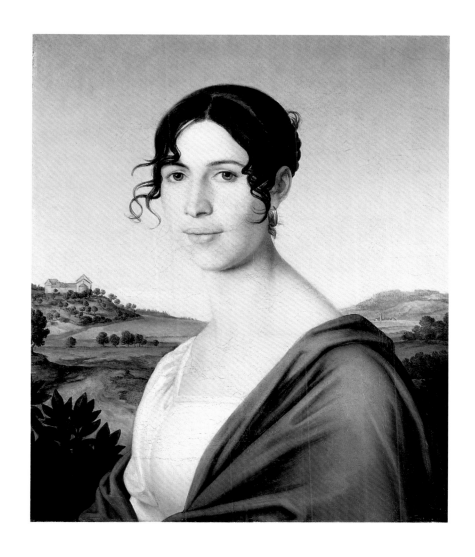

39. *Portrait of an Unknown Woman,* c. 1810
Oil on canvas
52.5 × 46 cm
Purchase; Inv. No. 1327

Leo von Klenze

Born 1784, Schladen/Harz; died 1864, Munich

L eo von Klenze is better known as an architect than as a painter. He studied architecture at the University of Berlin and was appointed Court Architect in Kassel in 1804. In 1814, during a stay in Paris, he met Crown Prince Ludwig of Bavaria, who made him his private architect in Munich. In 1816 he was named Court Architect in Munich. Regarded as the most distinguished classical architect of his time to work in southern Germany, he is responsible for the Alte Pinakothek and the Glyptothek in Munich, among other buildings.

Klenze was self-taught as a painter and only began painting in his forties. He specialized in depicting Italian sites and landscapes. A painting like *Landscape with a View of the Monastery Monte Sacro near Lugano,* although close to the work of such neoclassical landscape painters as Koch in its hard, clear light and exact detail, nevertheless betrays this artist's particular interest in the specifics of architecture and topography.

40. *Landscape with a View of the Monastery Monte Sacro near Lugano,* 1841
Oil on canvas
77.5 × 102 cm
Purchase; Inv. No. 3086

Louis Mayer

Born 1791, Neckarsbischofsheim; died 1843, Stuttgart

At the insistence of his father, Louis Mayer worked until age thirty-three as a merchant. His main interest, however, was art (his brother, Karl Mayer, was a poet), and in 1824 he began to take lessons with the landscape and history painter Gottlob Friedrich Steinkopf. From 1830 to 1832 he visited Rome, where he associated with the Swabian artists' colony. Upon his return to Stuttgart he painted Italian landscapes as well as views of his native land.

Landscape near Olevano, 1832, depicts the region east of Rome that was visited by numerous German artists who went there following in the footsteps of Joseph Anton Koch. Mayer has presented an especially grand and severe vision of this landscape of broad vistas, massive forms, and hard, clear light. In classicizing the landscape, however, Mayer has not altogether abandoned topographical description. The small hill town of Olevano sits in shadow near the center of the picture. Across the valley, touched by evening light, stands a single house, the Casa Baldi, frequented by the German artists who painted at Olevano.

41. *Landscape near Olevano, 1832*
Oil on canvas
99.5 × 136.5 cm
Inv. No. 678

Joseph Joachim von Schnizer

Born 1792, Weingarten; died 1870, Stuttgart

Joseph Joachim von Schnizer studied at the Munich Academy from 1808 to 1812, then trained in Stuttgart with Johann Baptist Seele. Like Seele, he was known above all as a painter of soldiers and battles (he served in the military and fought against Napoleon). Around 1820 he was appointed Court Painter in Stuttgart, a position from which he was removed in 1833 because of his membership in the liberal opposition.

King Wilhelm I of Württemberg, c. 1821, depicts the ruler who eventually built what is today the Staatsgalerie Stuttgart. For his portrait, Wilhelm I, who ascended the throne in 1816, chose to have himself represented as a soldier rather than as a ruler. He appears in Slavic cavalry uniform, with coat and sword both probably given to him by the Czars, while his sash and Cross of Honor are part of the Württemberg uniform. Behind the king on horseback sit two bodyguards, with the red hats (called *kollets*) that were worn from 1817 to 1821. Such details as the closed telescope and open map, as well as the King's alert, determined gaze, suggest that he is about to order his troops to advance.

Wilhelm I seems to have appreciated Schnizer's likeness. From this portrait he had a lithograph made that was circulated widely. The painting is notable for its bright, intense coloration and for its enamellike surface.

42. *King Wilhelm I of Württemberg*, c. 1821
Oil on wood
64 × 50.5 cm
On loan from the Stuttgart Galerieverein; Inv. No. GVL 101

Romanticism

Philipp Otto Runge

Born 1777, Wolhgast; died 1810, Hamburg

Next to Caspar David Friedrich, Philipp Otto Runge is the most widely known nineteenth-century German romantic artist. Runge began training in his brother's shipping and provision company in Hamburg, but in 1789 he was accepted as a pupil at the Copenhagen Academy of Art, where he remained until 1801, and continued as a pupil at the Dresden Academy of Art from 1801 to 1803. After his academic studies, Runge settled in Hamburg where he spent the rest of his brief life. Due to the enigmatic nature of his art, Runge was appreciated both by the romantics, such as Ludwig Tieck who sought him out to illustrate his work, and by neoclassical critics, such as Goethe who admired the individuality of his work.

Runge shared the romantic conviction that art would help usher in a new golden age. Runge's view of that new age was grounded in a complex pantheism and a belief in individual expression. That vision was given form above all in Runge's most ambitious project, one that occupied most of his short career: the only partially completed *Cycle of Time,* a series of paintings that stood for the creation, realization, annihilation, and rebirth of life.

Primroses, Poppy, and *Oak Leaf* are three of Runge's many portrait silhouettes and paper cutouts which were the earliest of his artistic works. He was introduced to the cutout technique by his sister, Maria Elisabeth, and it seems that his entire family participated in this activity. Runge quickly displayed an incredible virtuosity in this technique and is known to have remarked to his brother that the scissors had "become nothing more than an extension of my fingers." In 1806 Goethe requested a silhouette and flower cutouts from Runge, suggesting that they had become an important part of his artistic activity and reputation. The flowers from his cutouts appeared in Runge's art again and again either as ornaments or with specific symbolic content, such as appearance of the poppy in his painting *Moonrise* (Winterthur, Stiftung Oskar Reinhart) as a "symbol of sleep and dreams."

J. B.-L.

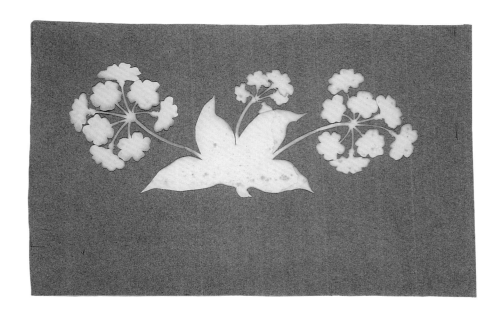

43. *Primroses,* no date
White paper cutout, laid on blue paper
10 × 24.5 cm
Gift of Ketterer Stuttgart; Inv. No. C 57/802

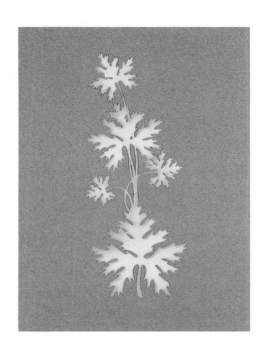

44. *Oak Leaf,* no date
White paper cutout, laid on blue paper
25.7 × 10 cm
Gift of Ketterer Stuttgart; Inv. No. C 57/803

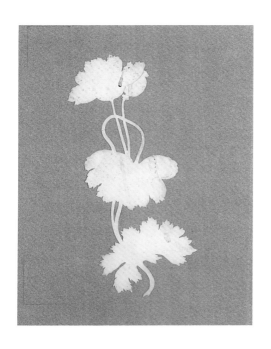

45. *Poppy,* no date
White paper cutout, laid on blue paper
25 × 13 cm
Gift of Ketterer Stuttgart; Inv. No. C 57/801

Caspar David Friedrich

Born 1774, Greifswald; died 1840, Dresden

Better known today than any other nineteenth-century German artist, Caspar David Friedrich is seen as a virtual symbol of German romanticism. Although his current fame results from a rediscovery of him in the early years of the twentieth century, Friedrich exerted considerable artistic influence in his own day and had contacts with the highest circles of German intellectual life, notably with Goethe.

Born into a Protestant family in the Baltic port of Greifswald, Friedrich's early life was marked by the tragedy of his younger brother's drowning, which he witnessed. Friedrich took lessons in drawing from Johann Quistorp, a drawing master at the University of Greifswald, before entering the Copenhagen Academy of Art in 1794, where he studied with the neoclassical history painters Christian August Lorentzen, Nikolai Abraham Abildgaard, and Jens Juel. In 1798, seemingly more attracted to landscape than to history painting, Friedrich moved to Dresden, where a school of landscape painters flourished. In his early years in Dresden he concentrated on drawing and did not begin painting regularly until 1807. He became a member of the Dresden Academy in 1816 and an associate professor in 1824. Among the artists he eventually influenced were Georg Friedrich Kersting, Carl Gustav Carus, Johan Christian Dahl, the brothers Friedrich and Ferdinand Olivier, and Karl Friedrich Schinkel. Friedrich suffered a stroke in 1835, which paralyzed his arm. Apart from a brief recovery in 1837, he did not paint again.

Friedrich, who never traveled to Italy, painted and drew the landscape of his native Germany and abandoned the subjects of myth and ancient history that filled the pictures of the neoclassical landscape painters. Nevertheless, he elevated his landscapes to the level of history painting by investing them with a symbolic content. Friedrich developed a personal language of naturalized landscape symbols, whether sunrises or sunsets, mountains or trees, church spires, tombs, or crosses, through which he meditated upon such broad themes as life and death, rebirth and redemption, as well as more specific subjects related to contemporary German politics.

A masterpiece of Friedrich's early years as a painter, *Bohemian Landscape* was painted around 1808 as a companion piece to his *Bohemian Landscape with Milleschauer* (now in the Staatliche Kunstammlungen, Gemäldegalerie, Dresden). Both landscapes represent the mountainous landscape of northern Bohemia, near the city of Tetschen (present-day Decin in the Czech Republic). The Dresden painting shows this landscape in the morning; the Stuttgart painting shows it in the evening, the sun just set behind a distant mountain. Whereas in the Dresden painting a path leads directly from the foreground into the distance, in the Stuttgart *Bohemian Landscape* our way into the vast expanse is blocked by hills and dark walls of trees. We are left to contemplate the spectacle of day quickly becoming night, marked by the most extraordinarily subtle transitions of dark to light.

Although Friedrich's paintings broached in novel fashion the most universal themes, most of his drawings remained relatively modest and precise, perhaps deceptively so. *Portrait of Catharina Dorothea Sponholz,* drawn around 1798, is typical of his portrait drawings, with the figure drawn in profile, her features unidealized. The sitter is the artist's eldest sister.

Friedrich executed numerous pencil studies. In some, like his *Tree Study,* 1809, he is concerned with recording specific natural forms—elements of landscape that might later be incorporated into a painting. Other pencil studies suggest a view of landscape at once more radical and more romantic. In drawings like *A Group of Oak Trees,* c. 1809, and *Small Hills, Seen from the Beach at Rügen,* 1806, only the fragments of a landscape are sketched in. The sheet is left largely bare, yet that very emptiness, articulated by a few meticulously drawn lines that indicate the form of a tree or the line of a coast, suggests a tremendous fullness and presence.

In more finished drawings, like *Foggy Morning,* Friedrich treated the themes for which he is best known in a manner quite close to that of his paintings. Here a figure seen from behind stands in for the viewer, allowing us imaginative access to the landscape. The entire composition revolves around a church that stands at the very center of the landscape.

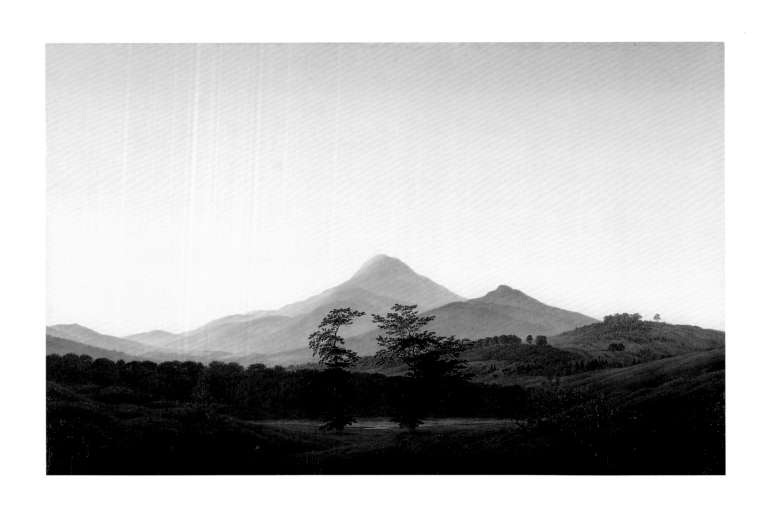

46. *Bohemian Landscape,* c. 1808
Oil on canvas
70 × 104.5 cm
Purchase; Inv. No. 1380

47. *Portrait of Catharina Dorothea Sponholz,* c. 1798
Black chalk on paper
20.9 × 17 cm
Gift of Georg Dinkela; Inv. No. C 50/162

48. *Pine,* c. 1798
Brush over pencil on white paper
21.5 × 12.7 cm
Inv. No. C 74/2423

49. Small Hills, Seen from the Beach at Rügen, 1806
Pencil on paper
22.6 × 36 cm
Inv. No. C 74/2433

50. Mountain Landscape, 1807
Pencil on paper
22.2 × 36 cm
Inv. No. C 74/2435

51. *A Group of Oak Trees,* c. 1809
Pencil on paper
26 × 36 cm
Inv. No. C 74/2438

52. *Tree Study,* 1809
Pencil on white paper
36 × 25.9 cm
Bequest of the Artist; Inv. No. C 22/131

53. *Mountain Landscape with Wooded Valley,* after 1825
Pencil and pen on white paper
21.3 × 31.9 cm
Gift of Dr. Nathan; Inv. No. C 59/896

54. *Foggy Morning,* c. 1805–1815
Brush over pencil on paper
12.1 × 18.1 cm
Gift of Georg Edward Habich; Inv. No. I 740

55. *Branch with Leaves,* no date
Pen and brush on white paper
37.2 × 27.4 cm
Inv. No. C 28/44

Carl Gustav Carus

Born 1789, Leipzig; died 1869, Dresden

Known as one of the principal followers of Caspar David Friedrich, Carus also had an exceptionally distinguished career as a doctor, scientist, and man of letters. Appointed Professor of Obstetrics and Director of the Maternity Clinic in Dresden in 1814, he published his *Gynecological Textbook* in 1820 and was named personal doctor to the King of Saxony in 1827. He corresponded with Goethe and Alexander von Humboldt and published monographs on Goethe and Caspar David Friedrich, as well as more general books on philosophy, psychology, and art. His *Nine Letters on Landscape Painting,* written between 1815 and 1824 and published in 1831, is among the more important books published on the theory of landscape painting in the nineteenth century.

Essentially self-taught as a painter, Carus derived many of his subjects and compositional strategies from Friedrich. Like Friedrich, he painted in layers of thin translucent glazes, bringing his pictures to a hard, clear finish. But whereas Friedrich invested his landscapes with a distinctly spiritual content, inventing compositions in which features of the landscape serve as symbols, Carus seems to paint more objectively, evincing his interest in scientific observation.

Carus's *View from Montanvert Overlooking the Montblanc Range,* 1822–1824, for example, reminds us of a number of paintings by Friedrich in which a cross stands isolated on a promontory. Instead of a symbolically charged cross, however, Carus paints a lone and barren spruce tree. Carus derived this composition from a drawing he made on site during a trip to the Alps in 1821. No detail of the landscape that Carus represented in that drawing has been altered. In other words, Carus found a natural equivalent for Friedrich's imagined compositions and chose to represent it as such, without adding symbolic content.

Carus's *Sailboat,* painted sometime after 1820, bears a similar relationship to a Friedrich prototype. Like the work by Carus, Friedrich's *Sailboat,* 1814 (Hermitage, St. Petersburg) depicts a couple aboard a small sailboat. In both paintings the boat is cropped in the foreground, effectively placing the viewer within the painting, standing midship. In Friedrich's painting the two figures sit on the prow of the boat, gazing across the water to a city marked by many church spires, but no such religious element is found in the Carus painting. The figures in Carus's *Sailboat* are engaged in the operation of their small ship and pay no attention to the spectacle of nature, let alone its spiritual consequences.

56. *Sailboat*, after 1820
Oil on canvas
42.3 × 33 cm
Purchase; Inv. No. 2731

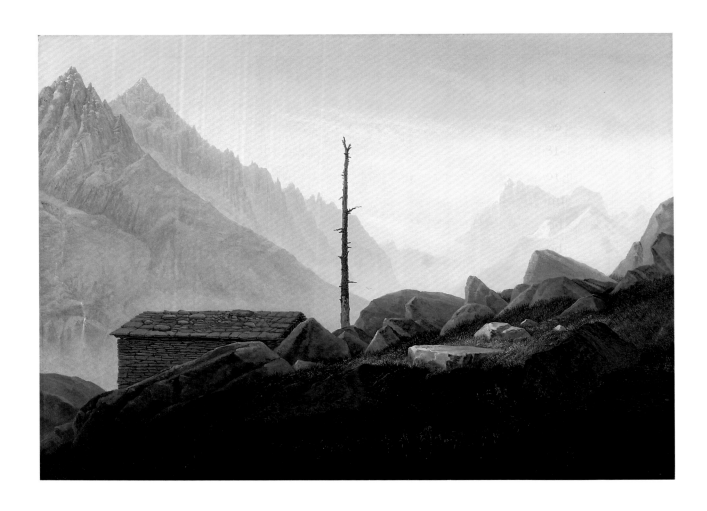

Carl Gustav Carus
57. *View from Montanvert Overlooking the Montblanc Range, 1822–1824*
Oil on canvas
122 × 167 cm
On loan from the Stuttgart Galerieverein; Inv. No. GVL 115

Johann Heinrich Ferdinand Olivier

Born 1785, Dessau; died 1841, Munich

Both Ferdinand, as this brother was known, and his brother Heinrich spent their first years as artists in Dresden, where from 1804–1806 they copied the landscape painters Claude Lorrain and Jakob Ruisdael and met Caspar David Friedrich. Ferdinand was sent on diplomatic missions to Paris from 1807 to 1809, during which time he profited from viewing the Musée Napoléon and its vast collection of art gathered by Napoleon's plundering. In 1811 Ferdinand moved to Vienna which at the end of the first decade of the nineteenth century emerged as a center for romantic art. This migration of artists to Vienna increased greatly around 1808–1809, the years of the formation of the Brotherhood of St. Luke and the arrival of the leading romantic philosopher and author, Friedrich Schlegel. In this rich and tumultuous atmosphere, Ferdinand's house was a meeting place for like-minded artists including his brothers, Friedrich and Heinrich Olivier, Julius Schnorr von Carolsfeld, and Philipp Veit, the stepson of Friedrich Schlegel, in effect forming the Vienna branch of the Nazarenes. Another influence on the Olivier brothers was the classical landscape painter Joseph Anton Koch, who was in Vienna from 1812 to 1815 and who established a direct link to the romantic artists in Rome.

Ferdinand was closely tied to the artists who later became the Nazarenes. In 1817 he and his brother Friedrich became the only landscapists officially to join the ranks of the Brotherhood of St. Luke, the nucleus of the Nazarenes. In 1815 Ferdinand and Veit left Vienna, intending to travel to Rome and to join the German artists there. On the way they stopped in the Austrian city of Salzburg. Ferdinand was so taken with the city and its surrounding countryside that he gave up going to Rome. His best known works are the highly detailed drawings made during this and a second trip to Salzburg he made with his brother Friedrich in 1817. In 1829 Ferdinand and Friedrich moved to Munich with its more supportive artistic climate fostered by King Ludwig I. On the recommendation of Peter Cornelius, the director of the Munich Academy of Art, Ferdinand became the acting General Secretary of the Munich Academy of Art and professor of art history. He remained in Munich until his death.

Both of Ferdinand Olivier's *Plant Studies* from 1812 were drawn in Vienna. They already show the close attention to detail that reaches its maturity in his Salzburg drawings. Ferdinand's meticulous focus in these two drawings is an indication that in his early career he was closer to Philipp Otto Runge's or perhaps Caspar David Friedrich's conception of religion and nature than the Nazarenes' nearly exclusive emphasis on religious subject matter.

J. B.-L.

58. *Plant Study,* 1812
Pencil on white paper
20.2 × 25.7 cm
Bequest of the Steinkopf Family; Inv. No. C 70/2028

59. *Plant Study,* 1812
Pencil on white paper, with border
18.4 × 22.8 cm
Bequest of the Steinkopf Family; Inv. No. C 70/2029

Woldemar Friedrich Olivier
Born 1791, Dessau; died 1859, Dessau

Friedrich Olivier, like his brother Ferdinand, was closely involved with the romantic circles in Vienna and was associated with the Nazarenes. Unlike his brother, however, he traveled to Rome, arriving there in December 1818. In Rome he belonged to the Protestant wing of the Nazarenes centered around Julius Schnorr von Carolsfeld; they were called the "Capitoliner" because they lived near the Capitoline Hill. The Catholic branch of the Nazarenes was known as the "Trinitasten" and was centered around the artists Friedrich Overbeck and Peter Cornelius. Despite their religious differences both groups easily associated with one another, and in 1821 members of both factions, including Friedrich Olivier, founded the Composition Club which briefly pursued the idea of publishing a popular illustrated Bible.

Not finding success in Rome, Friedrich returned to Germany in 1830 in search of better working conditions. During the last productive years of his career he finished fifty illustrations for an illustrated Bible. In 1850 he moved to Dessau where he passed the remaining years of his life.

Friedrich Olivier's *Emperor Charles V on the March against the Robber States* from 1818 is one of many copies he made of the watercolor tapestry cartoons by the sixteenth-century painter Jan Vermeyen. Vermeyen's watercolors had been discovered that same year in Vienna, and he quickly became popular with the romantic artists and authors who celebrated him as an artistic "hero" of the past. Olivier's *Emperor Charles V* is also characteristic of the increasing use of German history, fairy tales, and myths as subject matter by German romantic artists. This choice of subject matter marks a turn away from the individualistic, pantheistic art of the northern German romantic artists to the more historical, consciously traditional, and orthodoxly religious art of the Nazarenes. Friedrich's depiction of Charles V is also one of many romantic images that present an idealized and heroic view of the rulers of the Holy Roman Empire of the German Nation.

J. B.-L.

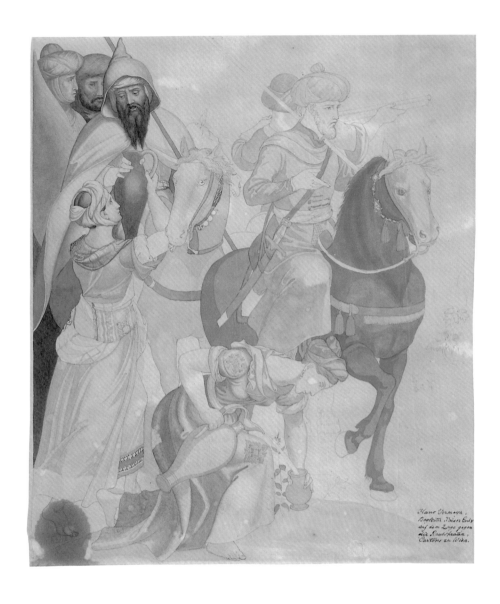

60. *Emperor Charles V on the March against the Robber States*, 1818
Pen and watercolor on paper
26.1 × 21.1 cm
In the collection before 1918; Inv. No. 1693

Julius Schnorr von Carolsfeld

Born 1794, Leipzig; died 1872, Dresden

Julius Schnorr von Carolsfeld received his first lessons in art from his father, then Director of the Leipzig Academy of Art. From 1811 to 1817 he studied at the Vienna Academy, where he was influenced by Joseph Anton Koch and Ferdinand Olivier. He traveled to Italy in 1817, where he joined the group of artists known as the Nazarenes and participated in the decoration of the Cassino Massimo. Returning to Germany in 1827 he settled in Munich, where King Ludwig I of Bavaria commissioned him to produce the Niebelungen frescoes for the royal residence. In 1846 he moved to Dresden, having been appointed Professor at the Dresden Academy and Director of the Dresden Gallery. Schnorr von Carolsfeld's career exemplifies the way in which the Nazarenes, who had rebelled against the Vienna Academy at the outset of their careers, quickly came to dominate the major German academies. Like many of his fellow Nazarenes, he eventually specialized in depictions of German history, and his religious paintings came to emphasize narrative.

A large number of Schnorr von Carolsfeld's paintings and drawings were related to the major fresco commissions for King Ludwig I that he worked on over much of his career. *Siegfried's Triumphant Return,* 1838, for example, is a study for the decoration of the wedding hall of the Munich royal court. The painting depicts the arrival of Siegfried and his warriors into Worms, with the captured Kings Lideger of Saxony and Liudegast of Denmark. In the shadow of the flag of victory follows the grim Hagen of Tronege, Siegfried's envious future assassin. Similarly, Schnorr von Carolsfeld's drawings *Volker and Hagen Refuse to Greet Kriemhild,* 1829, and *Two Female Half Figures,* c. 1835–1840, are studies for frescoes in the Munich royal residence.

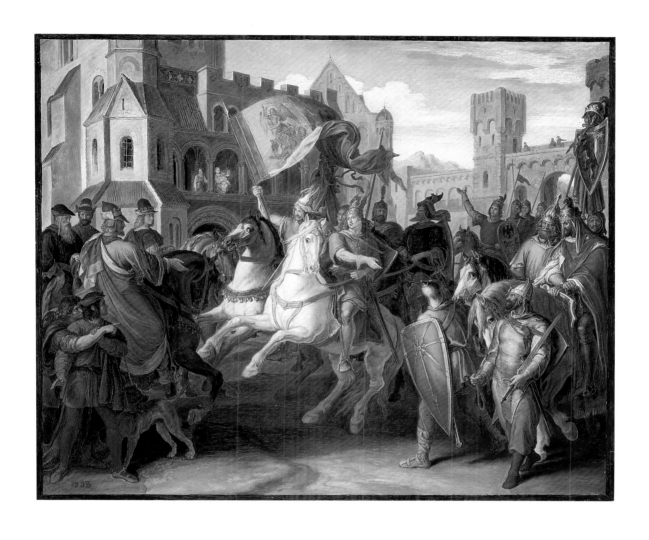

61. *Siegfried's Triumphant Return,* 1838
Oil on canvas
50.5 × 60.5 cm
Purchase; Inv. No. 943

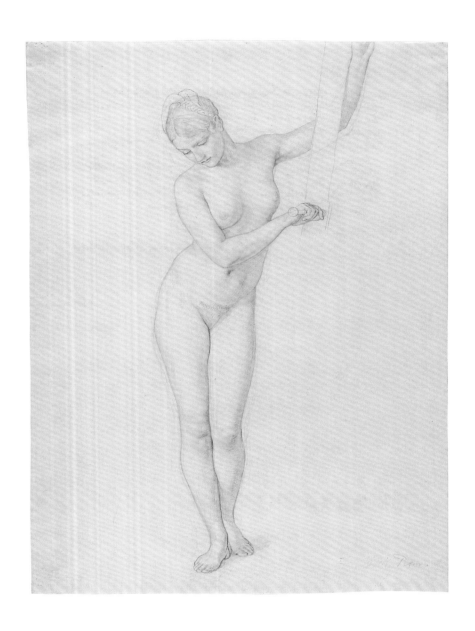

62. *Standing Female Nude,* 1820–1821
Pencil on white paper
48.5 × 35.5 cm
Gift of Ludwig Schnorr von Carolsfeld; Inv. No. C 31/45

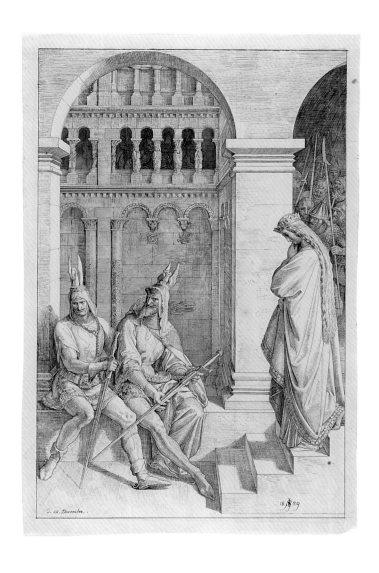

63. *Volker and Hagen Refuse to Greet Kriemhild,* 1829
Pen over pencil, borderline, on white paper
44.5 × 28.8 cm
In the collection before 1918; Inv. No. 5581

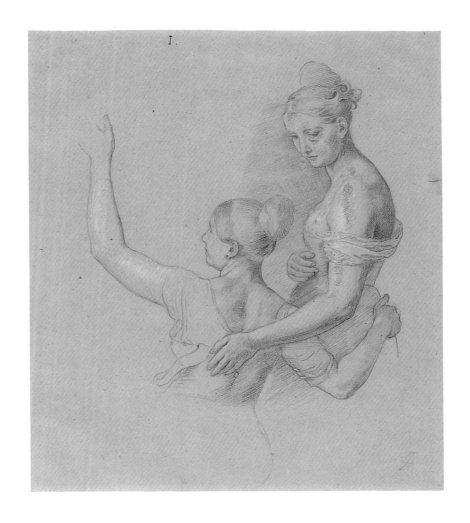

Julius Schnorr von Carolsfeld
64. *Two Female Half Figures,* c. 1835–1840
Chalk with white highlights on paper
34.5 × 29.9 cm
Gift of Karl & Faber, Munich; Inv. No. GVL 181

Carl Philipp Fohr

Born 1795, Heidelberg; died 1818, Rome

During his formative years Carl Philipp Fohr frequently took his subject matter from the German Middle Ages, fairy tales, and myths. In 1812 he won the support of the Princess Wilhelmine von Hessen who later provided him with a yearly stipend; in return he dedicated his sketchbooks from the Neckar Valley and the countryside near Baden to her. Like many young artists of his day, Fohr fell under the spell of the landscape painter Joseph Anton Koch; after seeing his powerful *Landscape with a Rainbow,* Fohr traveled to Rome to become Koch's pupil. There he matured quickly under Koch's guidance and was soon considered one of Rome's most promising talents. Fohr's life ended tragically when he drowned in the Tiber River in 1818.

Fohr's *Portrait of Heinrich Karl Hofmann* belongs to the romantic genre of "friendship portraiture" that was considered to be a physical symbol of shared beliefs and convictions. German artists generally drew such portraits with the precise lines of a sharpened pencil or pen which they felt connected them to Dürer's graphic tradition and the early Renaissance. Fohr drew Hofmann's portrait in Heidelberg before going to Rome in 1816. Hofmann's long hair and broad-collared coat (called the "old German costume") were the trademarks of "authentic" expressions of a common cultural heritage. Since the European balance of power established at the Congress of Vienna in 1815 mandated a divided Germany, German unificationists of all kinds were seen as radically dangerous elements of society. Fohr is credited with bringing the "old German costume," to Rome where it continued to be a nationalistic symbol for many German artists.

Fohr's *Mountain Ash Tree* was also drawn before he departed for Rome in 1816. Although naturalism only became prominent in German art after 1830, Fohr's drawing shows that by 1812 the careful rendering of observed reality played an increasing role in German art. However, all parts of this drawing are not equally finished; the ivy coiled around the trunk and the mottled bark show the tree to have been drawn from nature, yet the remainder of the image seems generalized. Within the context of romanticism this contrast of detail and sketch, of the specific and the general, hints at a deeper meaning. The reconciliation of opposing elements, a longing to unite the increasingly fragmentary nature of contemporary society, and art's power to achieve these goals were notions crucial to German romanticism. This longing for unity is evident as Fohr successfully brings together the "individuality" of the mountain ash tree and its generalized natural setting.

J. B.-L.

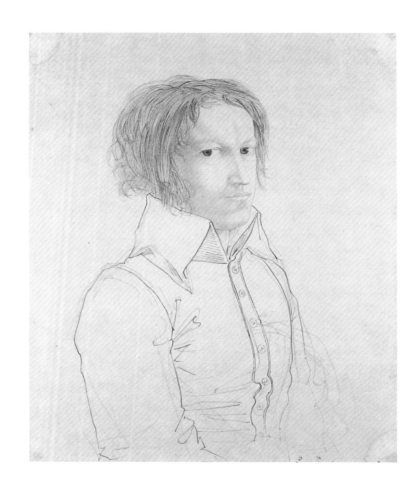

65. *Portrait of Heinrich Karl Hoffmann,* 1816
Pen over pencil on paper
25.4 × 21.1 cm
Gift of Ketterer Stuttgart; Inv. No. C 51/343

66. *Mountain Ash Tree*, 1816
Pencil, pen, watercolor on paper
44.1 × 33.9 cm
Gift of Rosi Schilling; Inv. No. C 56/661

Moritz von Schwind

Born 1804, Vienna; died 1871, Niederpöcking on Lake Starnberg

Widely popular for his published illustrations of German folktales, Moritz von Schwind produced a number of important fresco decorations and many small oil paintings. He briefly studied philosophy at the university before entering the Vienna Academy in 1821, where he studied under Ludwig Schnorr von Carolsfeld and Peter Krafft. His friends in Vienna included several poets, the composer Franz Schubert, and the painters Ferdinand and Friedrich Olivier. Schwind moved to Munich in 1828, where he studied briefly with Peter Cornelius. In 1832 he received his first commission, the decoration of a room in the Munich Royal Residence with scenes from a play by Ludwig Tieck. Schwind traveled to Rome in 1835, where he associated with the Nazarene painters, and returned to Munich in 1836 to embark upon further fresco decorations for the Residence. Named professor at the Munich Academy in 1847, he continued to receive fresco commissions and began to produce popular illustrations for journals.

Schwind's career is best understood in the context of the broad enthusiasm in the mid-nineteenth century for German folktales and legends. *Father Rhine,* c. 1842, is a study for the middle portion of the *Rhine Legends,* an uncompleted fresco cycle for the drinking hall in Baden-Baden. At the center of the composition sits Father Rhine, whose features seem to be derived from the Zeus of Otricoli (see Schick's drawing after that sculpture). On either side are allegorical figures of his tributary rivers, and behind him is a putto with the Niebelungen treasure and the allegorical figure of Speyer with its cathedral. To depict this Germanic subject, Schwind has chosen to adapt the grand manner of the Italian High Renaissance. By contrast, his *The Three Hermits,* c. 1859, approaches its subject in a much more intimate and humorous fashion.

Schwind's vivacity and imagination were given free reign in his drawings and illustrations. His drawing of the singer Karoline Hetzenecker playing the role of Valentine in Meyerbeer's opera *The Huguenots* brilliantly embodies the world of popular romantic literature, music, and theater to which his art gave visual expression. *The Strange Saints,* 1835, places three large compositions of figures set in landscapes within the framework of a medieval winged altarpiece. With its jewellike colors this drawing has the quality of a richly decorated medieval manuscript illumination. Schwind's *Cinderella* drawing, also a study for a large painting, is equally complex in its overall design, while its four large narrative panels are particularly ambitious. Schwind left this study uncolored, making his mastery of line and range of figurative invention all the more evident.

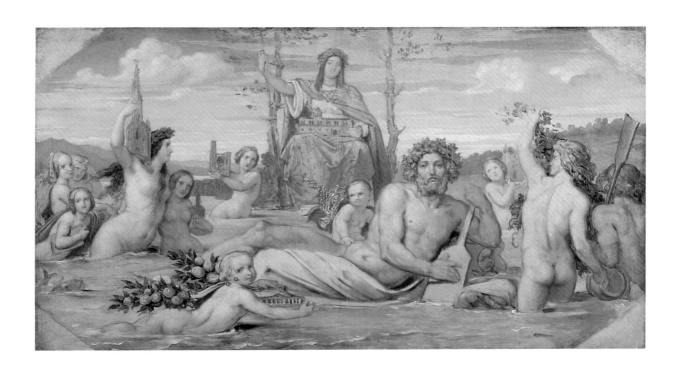

67. Father Rhine, c. 1842
Oil on canvas
43 × 77 cm
On loan from the Stuttgart Galerieverein; Inv. No. GVL 23

68. *The Three Hermits,* c. 1859
Oil on canvas
42.8 × 44 cm
Bequest of the Privy Councillor A. v. Pflaum; Inv. No. 1517

69. *The Strange Saints*, 1835
Pen and watercolor on laid paper, mounted on cardboard
42 × 45.5 cm
Private Collection; Inv. No. CN 38

70. *Study for Cinderella (left portion)*, 1852
Pen and brush over pencil on white laid paper
50.3 × 82.5 cm
Gift of Professor Fallati; Inv. No. 6448

71. *Study for Cinderella (right portion)*, 1852
Pen and brush over pencil on white laid paper
50.3 × 69.4 cm
Gift of Professor Fallati; Inv. No. 6449

72. *The Singer Hetzenecker as Valentine in Giacomo Meyerbeer's 'The Huguenots,'* c. 1848
Pencil with white highlights
41.6 × 30.9 cm
In the collection before 1906; Inv. No. 5195

Biedermeier

Franz Ludwig Catel

Born 1778, Berlin; died 1856, Rome

Franz Ludwig Catel began studies at the Berlin Academy in 1797 and became a member in 1806. During the first decade of the nineteenth century he exhibited watercolors and published book illustrations. In 1811 he traveled to Italy, where he associated with Joseph Anton Koch and with the painters known as the Nazarenes. He is best known today for two depictions of German figures in Italy, *Crown Prince Ludwig in the Spanish Tavern in Rome* and *Schinkel in Naples,* both painted in 1824, but he also achieved considerable success in his own time as a painter of Italian landscape and genre.

In such paintings as *Italian Wooded Landscape,* produced after 1811, Catel adapted the formal neoclassical landscape style of artists such as Koch and Christian Gottlieb Schick into more easygoing, yet still idealized depictions of contemporary Italian life. Catel's outlines remain hard and his forms precise, but the elements of his landscape are more loosely deployed, and his use of light seems to soften forms rather than freeze them.

73. *Italian Wooded Landscape,* no date
Oil on canvas
40 × 55.5 cm
Purchase; Inv. No. 95

Johann Baptist Pflug

Born 1785, Biberach; died 1866, Biberach

From 1806 to 1809 Johann Baptist Pflug studied at the Munich Academy under Johann Christian von Mannlich. He also devoted time in Munich to copying Dutch genre pictures. The remainder of his life was spent in his native Biberach where, in addition to his painting, he worked as a drawing instructor.

Swabian Fair, 1839, is one of many representations of peasant life that Pflug painted. The scene has its art-historical roots in the paintings of Bruegel and of the genre painters of seventeenth-century Holland. Pflug updates this tradition by carefully delineating the various social classes and types who mix at the raucous fair, from farmers and soldiers to intellectuals, politicians, and thieves.

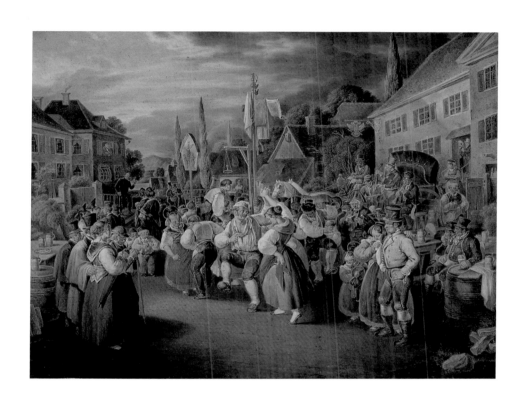

74. *Swabian Fair,* 1839
Oil on wood
44 × 57 cm
Purchase; Inv. No. 996

Ferdinand Georg Waldmüller

Born 1793, Vienna; died 1865, Hinterbrühl near Mödling

A painter of portraits and landscapes, as well as genre and still life, Ferdinand Georg Waldmüller studied intermittently at the Vienna Academy from 1807 to 1813. He worked as a drawing instructor and as a theater painter in several cities before returning to Vienna in 1817. From 1829 to 1857 he served as curator of the painting gallery and professor at the Vienna Academy and during those years made many trips to Italy, traveling to London and Paris as well. He was suspended from the Academy in 1857, after he published polemical essays denouncing the Academy and academic instruction. Although he remained popular in Europe, he was not rehabilitated by the Austrian Emperor until 1864, the year before his death.

Portrait of Frau A. von Winiwarter with Her Son, 1829, displays all of Waldmüller's talents as a portraitist. The painting is lavish in its delicate rendering of finery, from satin and lace to jewelry and flowers. Waldmüller takes care to distinguish between the sweet, if vapid expression of the son and the more pensive, even melancholy attitude of his mother. This portrait is more than a simple society portrait in which the sitter is represented through the rendering of clothes and setting. Here Waldmüller seems concerned to contrast that rendering with a sense of the sitter's inner state.

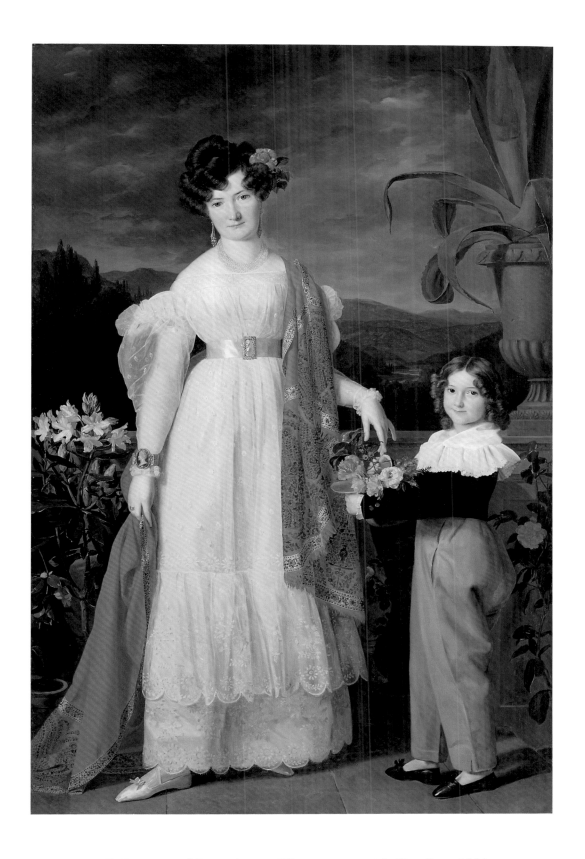

75. Portrait of Frau A. von Winiwarter with Her Son, 1829
Oil on canvas
197.5 × 130.5 cm
Purchase; Inv. No. 3206

Eduard Gaertner

Born 1801, Berlin; died 1877, Berlin

Eduard Gaertner was the most important veduta painter in mid-nineteenth-century Berlin. His best known work, the *Panorama from the Roof of the Friedrichwerdersche Church,* won him commissions not only in Germany but also in St. Petersburg and Moscow. Gaertner's numerous depictions of the Unter den Linden, the great avenue in Berlin, as well as other official sites and monuments, have shaped a lasting image of Berlin in the age of Prussian ascendency.

Having trained first as a painter's apprentice at the Royal Berlin Porcelain Manufactury, beginning in 1814, Gaertner then worked in the studio of the court theater painter Carl Wilhelm Gropius. From 1825 to 1827 Gaertner received a royal stipend to study in Paris, where he worked under Jean-Victor Bertin, a neoclassical landscape painter who had taught Corot. Gaertner became a member of the Berlin Academy in 1833.

The Long Bridge in Berlin, 1842, unites two of the qualities for which Gaertner remains so appreciated: his remarkably exact and precise description, combined with his unusual sensitivity to transitions of light and shade. In the middle of the picture is the sculptor Andreas Schlüter's monument to the Great Prince (which today stands in front of Berlin's Charlottenburg Castle). The guard troop that crosses the bridge is heading toward the castle.

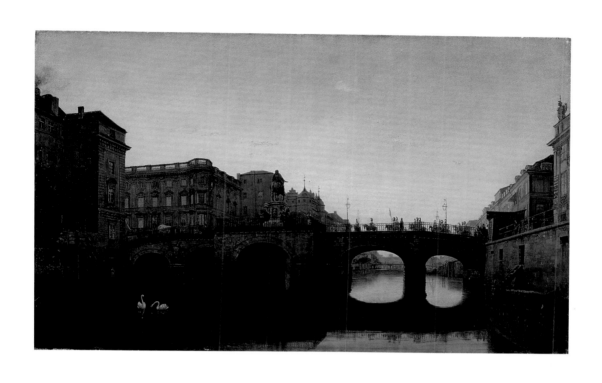

76. *The Long Bridge in Berlin,* 1842
Oil on canvas
39 × 63.5 cm
Purchase; Inv. No. 3234

Carl Spitzweg

Born 1808, Munich; died 1885, Munich

Carl Spitzweg specialized in small paintings that gently mocked the manners and pretensions of the *petite bourgeoisie.* He had trained initially as a pharmacist, but in 1833, following a bout with typhus, he decided to become a painter (he had come into an inheritance that same year). He was largely self-taught, having formed friendships with a number of Munich landscape painters and having copied the Dutch paintings in the Alte Pinakothek in Munich. Beginning in 1844 he produced illustrations for the Munich journal *Fliegende Blätter* (for which Spitzweg's friend Moritz von Schwind also worked). Although he was not a member of the Munich Academy, his work had great commercial success. That success proved important to the growth of the Kunstvereine, the artists' clubs that allowed artists the opportunity to exhibit and sell their work outside the purview of the academies.

The Sunday Hunter, c. 1841–1848, although a relatively early work by Spitzweg, is nevertheless a typical example of the artist's subject and attitude. The well-dressed city dweller, having finished his meal, turns suddenly to stare at the viewer, thinking him an approaching animal. Of course, his thick glasses cause us to doubt that he can see much of anything, and his expression is one of confusion rather than concentration or determination. Spitzweg has been compared to the French caricaturist Honoré Daumier, among whose favored subjects was the city dweller, out of place in the country.

The subject and composition of *The Alchemist,* c. 1860, are close to a number of Dutch seventeenth-century models, as is its carefully modulated use of brown tones and its subtle lighting. While we do not know the precise nature of his experiment, the alchemist's housecoat and slippers, as well as his wine-red nose, suggest that we are not about to witness a scientific milestone.

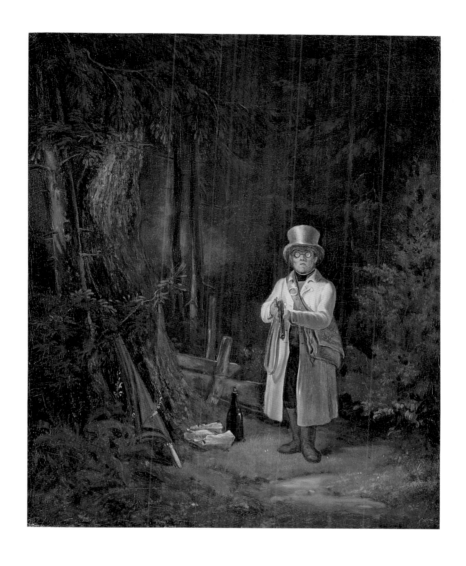

77. *The Sunday Hunter,* c. 1841–1848
Oil on canvas
40 × 32.5 cm
Purchase; Inv. No. 2127

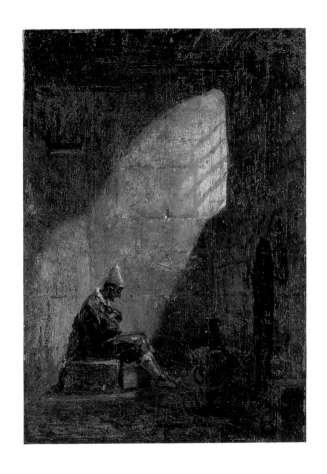

78. *Ash Wednesday,* c. 1855–1860
Oil on wood
21 × 14 cm
Purchase; Inv. No. 905

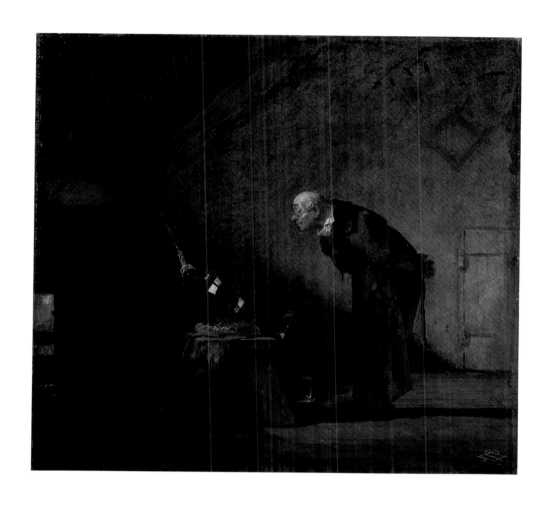

79. *The Alchemist,* c. 1860
Oil on canvas
36 × 38 cm
Purchase; Inv. No. 1515

Heinrich Bürkel

Born 1802, Pirmasens; died 1869, Munich

A prolific artist who painted more than 1500 pictures, Heinrich Bürkel specialized in scenes of folk life in Italy and the Alps. Initially self-taught as an artist, Bürkel enrolled in the Munich Academy in 1822. In addition to his academic training, he spent time in Munich copying the work of such seventeenth-century Dutch landscape painters as Jacob van Ruisdael, Philipp Wouwerman, and Allart van Everdingen. His first of many trips to Italy took place in 1827.

Roman Peasants before an Inn, 1835, is typical of a number of paintings Bürkel made of similar subjects. It is best thought of as a northern genre scene shifted to the south. The landscape is not idealized, as in the work of the neoclassical landscape painters, nor is it given the realist's attention to the specifics of site, light, and atmosphere that are evident in some of the Italian landscapes of Blechen. Rather, Bürkel offers a lively, festive vision of a virtually timeless peasant life set beneath the warm Italian sun.

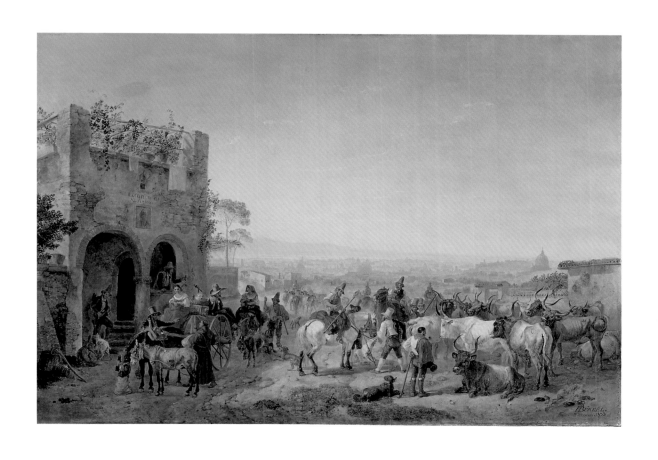

80. Roman Peasants before an Inn, 1835
Oil on canvas
61 × 89 cm
Schloss Rosenstein, König Karl Foundation; Inv. No. 938

147

Emanuel Leutze

Born 1816, Gmünd, Swabia; died 1868, Washington, D.C.

Emanuel Leutze is most famous in America for his painting *Washington Crossing the Delaware.* Leutze emigrated with his family to the United States in 1825. He studied painting in Philadelphia with J. A. Smith, then returned to Germany in 1841 to study art, working under the landscape painter Carl Friedrich Lessing at the Düsseldorf Academy. Between 1842 and 1844 he traveled to Munich and then to Italy. He returned to the United States in 1859 and remained there until his death in 1868.

Juliane Leutze, 1846, is a portrait of the artist's wife, a native of Stuttgart. Painted one year after their marriage, the portrait seems especially sympathetic, emphasizing the young woman's delicacy and grace and setting her features off against the warm colors and fine detail of her shawl.

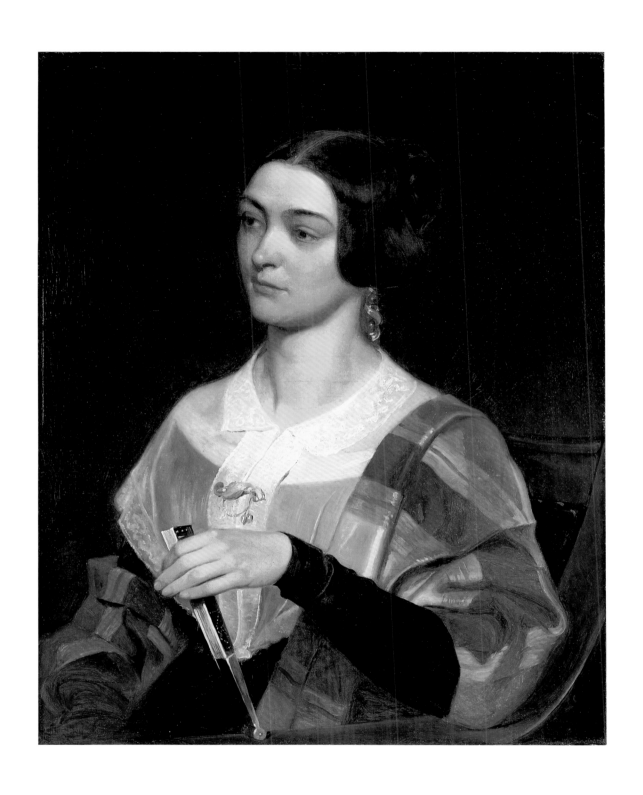

81. *Juliane Leutze,* 1846
Oil on canvas
78 × 62 cm
Purchase; Inv. No. 1383

Theodor Schüz

Born 1830, Thumligen; died 1900, Düsseldorf

The devout son of a clergyman, Theodor Schüz studied first in Tübingen, then at the Stuttgarter Kunstschule, and finally in Munich, where he resided from 1854 to 1866, working with the history painter Karl Theodor von Piloty. *Afternoon Prayer during Harvest,* painted in Munich in 1861, is regarded as the artist's masterpiece: a striking combination of naturalist landscape and popular religious sentiment. The scene is set overlooking the Ammer Valley (near where the artist grew up). A well-to-do family gathers in prayer beneath the shade of a great tree before beginning their meal. Around them more poorly dressed harvesters eat and drink in less solemn fashion. In the center foreground Schüz places a small lamb, and the farmer's wife is given an explicitly madonna-like pose. In the frame of the picture Schüz has quoted from Psalm 104, 27–28:

> They all depend upon you, to feed them when they need it.
> You provide the food they gather, your open hand gives them their fill.

All of nature in this painting, with its soft light and clear detail, seems the expression of God's generosity. Yet that generosity is extended above all, Schüz makes clear, to those who uphold His ways.

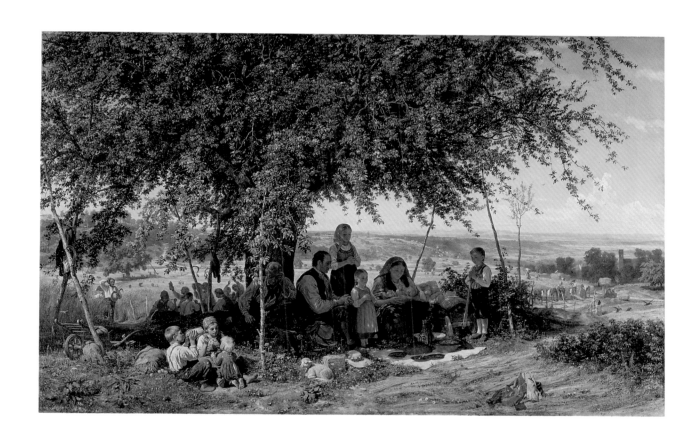

82. *Afternoon Prayer during Harvest,* 1861
Oil on canvas
108.5 × 172.5 cm
Purchased from the Artist; Inv. No. 89

Idealism

Arnold Böcklin

Born 1827, Basel; died 1901, San Domenico, near Fiesole

Born in Switzerland, Arnold Böcklin trained in landscape painting at the Düsseldorf Academy. During his long and successful career he worked in Rome and Florence, Basel, Weimar, and Zurich. In 1872 he was made an honorary member of the Munich Academy and in 1884 was elected to membership in the Berlin Academy. In 1890 he was made an honorary citizen of the city of Zurich (having received an honorary doctorate from the University of Zurich the year before), and in 1897, to mark his seventieth birthday, the cities of Basel, Berlin, and Hamburg organized exhibitions of his work.

Above all, Böcklin was associated with the community of German artists and intellectuals living in Rome and Florence in the late nineteenth century who championed the idealist aesthetics of the Italian Renaissance. His friends included the artists Hans von Marées, Adolf von Hildebrand, and Anselm Feuerbach, the cultural historian Jacob Burckhardt, and the art historian Heinrich Wölfflin, who wrote favorably about his work.

In his paintings, Böcklin frequently adapted the mythological motifs of renaissance art, favoring subjects such as nymphs, satyrs, and sea monsters that articulated universal themes of life and the natural order, even while they were more accessible to a broad public than the more explicitly literary depictions of Feuerbach or von Marées. At the same time Böcklin developed certain subjects entirely of his own invention that suggested melancholy and decay, the passing of the golden age of the classical past into darkness.

Perhaps the most famous of these latter subjects is Böcklin's *Isle of the Dead*, but his *Villa on the Sea*, c. 1877, is also well known. Altogether, Böcklin completed five versions of this theme over a period of fifteen years, varying each version to create a different mood and effect. The Stuttgart painting, the fourth and next-to-last in the series, is somewhat darker and more menacing than the earlier versions, its mood heightened by the rough surf that rolls into the foreground.

Celebrated in his lifetime, Böcklin was attacked soon after his death by the great German art historian, Julius Meier-Graefe. In his book *The Case of Böcklin and the Theory of Unities*, Meier-Graefe criticized German idealism and held Böcklin up as the archetype of all that he thought wrong with nineteenth-century art.

83. *Villa on the Sea,* c. 1877
Oil on canvas
108 × 156 cm
Bequest of Queen Olga; Inv. No. 1512

Anselm Feuerbach

Born 1829, Speyer; died 1880, Venice

Son of a professor of archaeology, Anselm Feuerbach is known for his depictions of literary and mythological subjects that draw upon the broad humanist culture in which he was raised. He entered the Düsseldorf Academy of Art in 1845, where he worked in the studio of Wilhelm von Schadow and studied with the landscape painter Johann Wilhelm Schirmer. In 1848 he moved to Munich, studying at the Academy and copying Rubens; in 1850 he moved to Antwerp to study there. From 1851 to 1854 he lived in Paris, working in the *atelier* of Thomas Couture. In 1855, he traveled to Venice and then to Rome, where he remained until 1873. He was appointed Professor of History Painting at the Vienna Academy of Art, where he stayed until his retirement in 1877. He then returned to Venice where he lived until his death.

Nanna, 1861, is a portrait of Nanna Risi, the young woman who served as Feuerbach's mistress, model, and muse from 1860 to 1865. Nanna embodied Feuerbach's ideal of classical beauty, and it is not coincidental that this portrait, which monumentalizes its sitter, nevertheless fixes upon the description of her strong features and the finery of her dress, while conveying little of her mood or character.

Nanna was succeeded as Feuerbach's mistress by Lucia Brunacci, who served as the model for a number of his paintings, including *Iphigenia,* 1871, one of Feuerbach's best-known works. The subject of this painting is the daughter of King Agamemnon, leader of the Greeks in the Trojan War, who was ordered to sacrifice his daughter to the goddess Artemis so that his ships might be allowed to depart for Troy. Artemis took pity on Iphigenia, secretly rescuing her from the sacrificial altar and carrying her away to the distant island of Tauris to serve as a priestess. In Feuerbach's painting, Iphigenia gazes longingly back toward her Greek homeland. Encased in her white robes, her features turned away from view, this massive figure seems less a character in a complex narrative than a virtual personification of yearning.

Feuerbach's two drawings of the Medea story, like his paintings of Iphigenia, display the artist's technique of concentrating narrative within a single figure, who stands as an embodiment of a particular emotion. The sorceress Medea, daughter of King Aeëtes of Colchis, betrayed her father and killed her brother in order to rescue her beloved Jason and help him win the Golden Fleece. When she is in turn betrayed by Jason, she takes revenge by slaying his new wife and killing her own two sons. *Medea's Wet Nurse* is the embodiment of nurturing solicitude, while maternal despair is captured in the depiction of *Medea,* who grieves over her two children.

84. *Nanna,* 1861
Oil on canvas
119 × 97 cm
Purchase; Inv. No. 1426

85. *Iphigenia*, 1871
Oil on canvas
192.5 × 126.5 cm
Purchased from the Artist; Inv. No. 770

86. *In the Park of the Villa d'Este in Tivoli*, 1857
Black chalk and gouache on brown paper
45.1 × 31.2 cm
Gift of Grand-duke of Oldenburg; Inv. No. C 20/5

87. *The Roman Campagna,* 1857–1858
Black chalk and white highlights on paper
29 × 35.7 cm
Gift of Grand-duke of Oldenburg; Inv. No. C 20/8

88. *Medea,* 1868–1869
Black and colored crayon on brown paper
51.4 × 41.5 cm
Gift of the Grand-duke of Oldenburg; Inv. No. C 20/3

89. *Medea's Wet Nurse,* c. 1860s
Black and colored chalk on brown paper
39.2 × 29.8 cm
Gift of the Grand-duke of Oldenburg; Inv. No. C 20/4

Max Klinger

Born 1857, Leipzig; died 1920, Grossjena

Max Klinger is best known for his fantastic and almost surrealistic graphic works, especially the strangely unnerving cycle of prints entitled *Paraphrase on the finding of a glove* which evokes a nightmarish world of unknown and unfulfilled desires. Despite his reputation as a graphic artist, Klinger's ambitions lay in sculpture and in his desire to realize a *Gesamtkunstwerk,* or the combination of architecture, sculpture, and painting into a "total" work of art. In 1883 Julius Albers commissioned Klinger to create such a work for the vestibule of the Villa Albers in Berlin, which is one of the nineteenth century's most successful realizations of a unified artistic environment.

In 1883, the same year that he began work on the Villa Albers, Klinger drew the *Crucifixion,* a preparatory drawing for a painting. That painting would be his second monumental work, and its completion occupied him for a period of eight years from 1883 to 1901. Of the two sketches Klinger completed, the Stuttgart drawing is essentially the model for the larger oil sketch that he completed in 1884 and 1885. In the drawing Mary and Mary Magdalene are placed at the center of the composition, and it is their stoic and emotional suffering that is the focal point of the unfolding drama. Klinger's depiction of a nude Christ in the 1883 *Crucifixion* (and in the other studies and the final version as well) caused a scandal when the final version was exhibited in Munich in 1891, because of its striking departure from traditional images of the crucifixion.

J. B.-L.

90. *Crucifixion,* 1883
Pen on white paper
26.7 × 45.5 cm
Gift of R. Hagenlocher; Inv. No. C 69/1760

Hans von Marées

Born 1837, Elberfeld; died 1887, Rome

After two years of study at the Berlin Academy, Hans von Marées moved in 1856 to Munich, where he found work as a portrait painter. Marées was not associated with the Munich Academy, but in 1864 he met Count Adolf Friedrich von Schack, who sent him with a fellow portrait painter Franz von Lenbach to Italy, where they were assigned to copy the Old Masters. In Italy Marées formed an important friendship with the sculptor Adolf von Hildebrand and also with the art lover and theorist Konrad Fiedler, who became the artist's most important patron. Remaining in Rome through most of his life, Marées came to be known as one of the three "Deutsch-Römer" (with Arnold Böcklin and Anselm Feuerbach), all artists who attempted to find a modern language for the themes of classical idealism. Marées worked in relative obscurity through most of his life, keeping his work largely to himself in his studio. His posthumous rediscovery is owed largely to the admiration of the art historian Julius Meier-Graefe, who published a monograph on the artist that assigned him an important place in the history of modern art and compared him favorably to Cézanne. Other art historians and critics have admired Marées's intentions, but felt his results fell short.

Family Portrait, an unfinished painting dating from around 1867, is typical of many of Marées's paintings in which nude figures are set into a landscape. Marées seeks to create a timeless presence for his figures that resonates equally with the present and the mythic past. His *Self-Portrait* drawing of 1883 indicates a portion of the painstaking process by which the artist prepared his compositions. The drawing is a study for his last self-portrait, a painting that now hangs in the Neue Pinakothek in Munich. It is one of four such studies, the only one in which the artist's left hand is brought up to hold his coat, rather than his right hand. Marées did not make precise studies for his paintings that he then copied exactly. Rather, he thought and rethought his compositions, not stopping the process of reworking even as his images were being painted.

91. *Family Portrait*, c. 1867
Oil on canvas
135 × 102 cm
On loan from the Stuttgart Galerieverein; Inv. No. GVL 68

92. *Self-Portrait,* 1883
Red ochre on white paper
45 × 44.8 cm
Gift of Stuttgarter Kunstkabinett R. N. Ketterer; Inv. No. C 52/440

Early Realism, Landscape, and the Liebl Circle

Carl Rottmann

Born 1797, Handschuhsheim near Heidelberg; died 1850, Munich

Much of Carl Rottmann's artistic career was devoted to the execution of two commissions for King Ludwig I of Bavaria: the fresco decoration of an arcade in the west wing of the Munich Hofgarten with views of Italy, which he completed in 1833, and the decoration of the north arcade with views of Greece, completed in 1850. Before receiving these commissions, Rottmann first studied art under the supervision of his father, a drawing master at the university in Heidelberg. He continued his studies at the Munich Academy from 1821 to 1826, and in 1826 and 1827 traveled to Rome with a stipend from King Ludwig I.

In conjunction with his Munich fresco cycles, Rottmann continued to make small oil paintings of Italian and Greek landscapes which were especially popular. Despite its title, *Sunset near Aegina,* 1836, was actually painted in Bavaria and depicts Lake Starnberg as a storm passes over. Rottmann has given to this northern site the brighter tones of a Greek landscape and has added the ruins of an ancient temple to establish further an exotic, distant sense of place. As is the case with most of these small paintings, Rottmann creates dramatic effects of light with dense, solid brushwork.

93. *Sunset near Aegina,* c. 1836
Oil on paper on canvas
35 × 60 cm
Bequest of Otto Knaus; Inv. No. 2162

Carl Blechen

Born 1798, Cottbus; died 1840, Berlin

Carl Blechen apprenticed as a banker in Berlin before entering the Berlin Academy in 1822 to study landscape painting. With the recommendation of the architect and painter Karl Friedrich Schinkel, he obtained a position as a stage set painter at the Königstädtischens Theater in Berlin in 1824—a position he resigned in 1827 following a dispute with a prominent prima donna. He found early success as a landscape painter, owing much to the vogue for subjects of popular romanticism—ruins, monks, and magicians, which he rendered with somewhat heavy brushwork, frequently employing dramatic contrasts of light and dark.

In 1828 and 1829 Blechen traveled in Italy, a trip that deeply affected his art. Unlike such neoclassical landscape painters as Joseph Anton Koch and Johann Christian Reinhart, with whom he stayed in Rome and whose subjects were largely the sites and stories of Italy's classical past, Blechen was drawn above all to the bright southern light and clear atmosphere. His palette lightened and his brushwork attained a fluid character, qualities his art retained following his return to Germany.

Blechen was appointed professor of landscape painting at the Berlin Academy in 1831 and was elected to membership in the Academy in 1835. In 1836, suffering from mental illness, he resigned that position.

In the Park at Terni, 1828–1829, is one of several closely related versions of a subject that Blechen evidently found quite appealing: two women bathers surprised by the arrival of the viewer. The painting is typical of Blechen's work in its subtle rendering of light and in its free brushwork, both of which owe much to the technique and aesthetic of the open-air oil sketch, which Blechen mastered in Italy in such paintings as *Italian House,* c. 1829.

The special quality of Italian light that so moved Blechen is also evident in his watercolor *Italian Landscape with Ancient Temple,* c. 1828–1829. By contrast, the ink drawing *Wooded Landscape,* c. 1835, returns to the artist's earlier romantic roots, while suggesting a view of nature that has been linked to the mental illness Blechen suffered in his later years. The small figures in this drawing are dwarfed by their surroundings. They are enclosed on all sides by vegetation, which seems poised to engulf them.

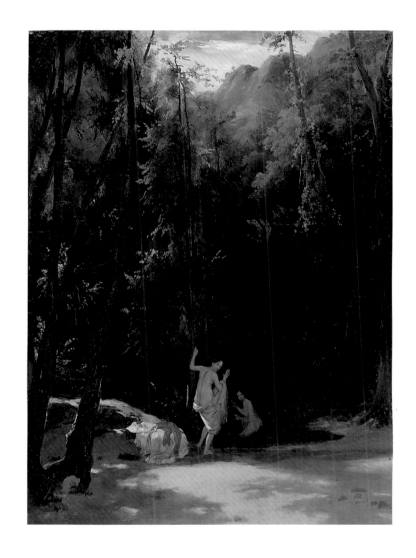

94. *In the Park at Terni*, 1828–1829
Oil on canvas
36 × 26 cm
Purchase; Inv. No. 1481

95. *Italian Landscape with Ancient Temple*, 1828–1829
Watercolor over traces of pencil on white paper
20.1 × 34.7 cm
Gift of the Von Kreibig Collection; Inv. No. C 70/1780

96. *Italian House,* c. 1829
Pencil and oil on waxed paper
24.9 × 36.4 cm
On loan from the Federal Republic of Germany; Inv. No. GL 1132

97. *Wooded Landscape,* c. 1835
Pen and traces of pencil on white paper
15.1 × 19.4 cm
Gift of the Von Kreibig Collection; Inv. No. C 70/1781

Johann Wilhelm Schirmer

Born 1807, Jülich; died 1863, Karlsruhe

Johann Wilhelm Schirmer was the son of a bookbinder and was briefly a bookbinder himself before joining the Düsseldorf Academy of Art in 1825 where he studied under Heinrich Christian Kolbe and in 1826 became a pupil of the Academy's new director, Wilhelm von Schadow. Schirmer founded the private Landscape Composition Society with Karl Friedrich Lessing and, beginning in 1827, they made many walking trips in the vicinity of Düsseldorf and the lower Rhine to draw from nature. In 1830 Schadow made Schirmer unofficially responsible for the Academy's landscape class and officially made him the professor of landscape painting in 1839. Throughout his life Schirmer traveled extensively, including trips to France and Italy where he continued to draw from nature. His most famous students from this Düsseldorf period were Arnold Böcklin, who studied with him in 1842–1843, and Anselm Feuerbach, who studied in Düsseldorf from 1845–1848. In 1854 he became the director of the newly founded Karlsruhe Kunstschule where he instructed Hans Thoma among others.

Mountain Landscape is representative of the naturalistic strains within Schirmer's diverse oeuvre that included literary and heroic landscapes, romantic landscapes, and biblical landscapes. This drawing depicts four mountain peaks receding in atmospheric perspective, giving particular attention to the details of the sheer cliffs and the clouds that roll past. Although the drawing is undated, the view is generally thought to be of the mountains in Tyrol and may have been drawn during Schirmer's trip to Switzerland in 1851.

J. B.-L.

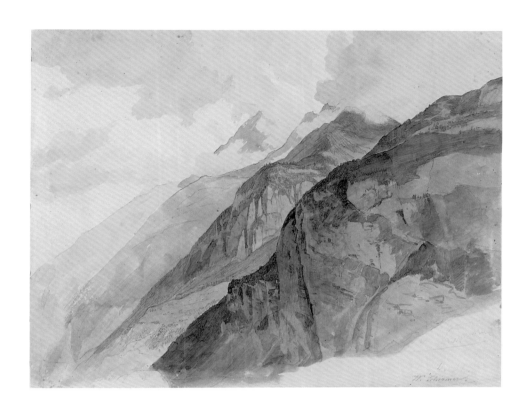

98. *Mountain Landscape,* no date
Pencil and watercolor on paper
37 × 46.7 cm
Inv. No. C 22/22

Adolph von Menzel
Born 1815, Breslau; died 1905, Berlin

Adolph von Menzel's initial training as an artist consisted in learning the lithography craft and trade carried out by his father. His father's early death in 1832 forced Menzel to take over the family business. He studied briefly at the Berlin Academy in 1833 but otherwise was self-taught as a painter.

If these beginnings were less than auspicious, Menzel quickly compensated. In 1842 he published 400 woodcuts for Franz Kugler's *Life of Frederick the Great*—an achievement that brought him considerable fame. Menzel also began to make paintings related to his illustrations as well as portraits, landscapes, and interiors. In 1845 he saw a Berlin exhibition of landscapes by John Constable, which may account for an increased interest in effects of light and atmosphere as well as a broadening of Menzel's style. His landscapes increasingly examined the newly industrialized Berlin suburbs. In 1853 Menzel was made a member of the Berlin Academy, and in the years that followed he received a succession of honors, including recognition in London and Paris, that culminated in the award of hereditary nobility to his family in 1898.

While Menzel is generally classified as a realist or naturalist, *Masked Supper,* 1855, reveals that he could also display the historical fancy of a romantic. Acquainted with the Rococo through his numerous illustrations of the age of Frederick the Great, Menzel imagines here a masked supper in an elegant eighteenth-century setting. The glittering scene, with its suggestions of sensual pleasure and intrigue, is carried out in a loose, informal manner worthy of Fragonard.

An extraordinary draftsman, Menzel can be compared to Degas in the originality of his compositions and the acuity of his observation. Drawings like *Frauenkirche in Dresden,* 1880, reveal the sureness with which Menzel frequently masses his forms to one side of the paper sheet, often cropping the image. *Portrait of a Woman,* 1889, contrasts the few swift strokes that define the sitter's garment with the soft handling that sensitively describes her face. She is surmounted by a tangle of hair, energized by sharp contrasts of light and dark.

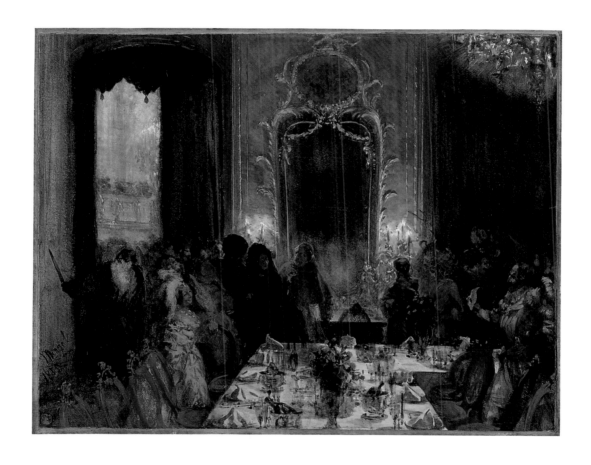

99. *Masked Supper,* 1855
Watercolor and highlights on paper
33 × 41.2 cm
Purchase; Inv. No. 1118

100. *Frauenkirche in Dresden,* 1880
Pencil on ivory paper
20.8 × 12.9 cm
Inv. No. C 84/3338

101. *The Piazza d'Erbe in Verona, 1882*
Pencil on white vellum
42.1 × 28.7 cm
Kornfeld and Klipstein, Bern; Inv. No. GVL 198

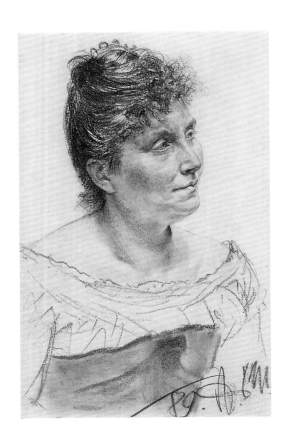

102. *Portrait of a Woman*, 1889
Pencil on white paper
20.5 × 12.8 cm
Inv. No. GVL 207

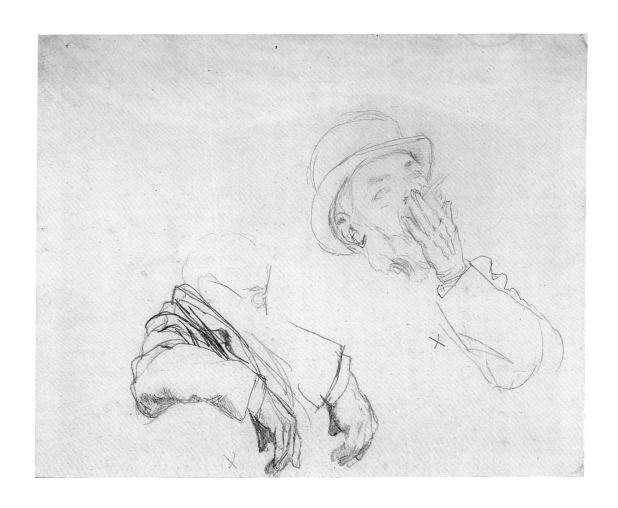

103. *Cigarrette Smoker, Hand and Arm Study,* no date
Pencil on white paper
26 × 31.2 cm
On loan from the Federal Republic of Germany; Inv. No. GL 1131

Hans Thoma

Born 1839, Bernua, Black Forest; died 1924, Karlsruhe

Hans Thoma entered the Karlsruhe Kunstschule in 1859, where he studied with the painter of religious subjects Ludwig des Coudres, the history and genre painter Hans Canon, and the landscape painter Johann Wilhelm Schirmer. In 1868 he traveled to Paris, where he encountered the work of Gustave Courbet. From 1870 to 1873 he resided in Munich, forming friendships with Arnold Böcklin as well as with the principal members of the Leibl Circle. Although he was patronized by two English collectors in the 1870s and 1880s, he had his first true success in an exhibition at the Munich Kunstverein in 1890. He was appointed Director of the Kunsthalle in Karlsruhe and Professor of the Academy of Fine Arts in Karlsruhe in 1899; in 1909 he saw the dedication of the Thoma Museum within the Kunsthalle Karlsruhe. Tremendously popular during his later years, Thoma was held by many to be the greatest German artist of his time.

While Thoma's early work bears the mark of Courbet's influence and his contact with the Leibl Circle, in his later career Thoma largely abandoned realism in favor of an allegorical style closer to that of the Deutsch-Römer painters Arnold Böcklin, Hans von Marées, and Anselm Feuerbach. *Landscape on the Rhine*, 1888, shows Thoma somewhere between those two poles. Thoma painted this Säckingen countryside many times. The details of the landscape, as well as the figures, are handled in a realist manner, with plain, direct brushwork and opaque colors. Through the swirling masses of vegetation and the use of occasional bright colors, however, Thoma manages to impart to this scene an almost otherworldly intensity and a distinct air of allegory.

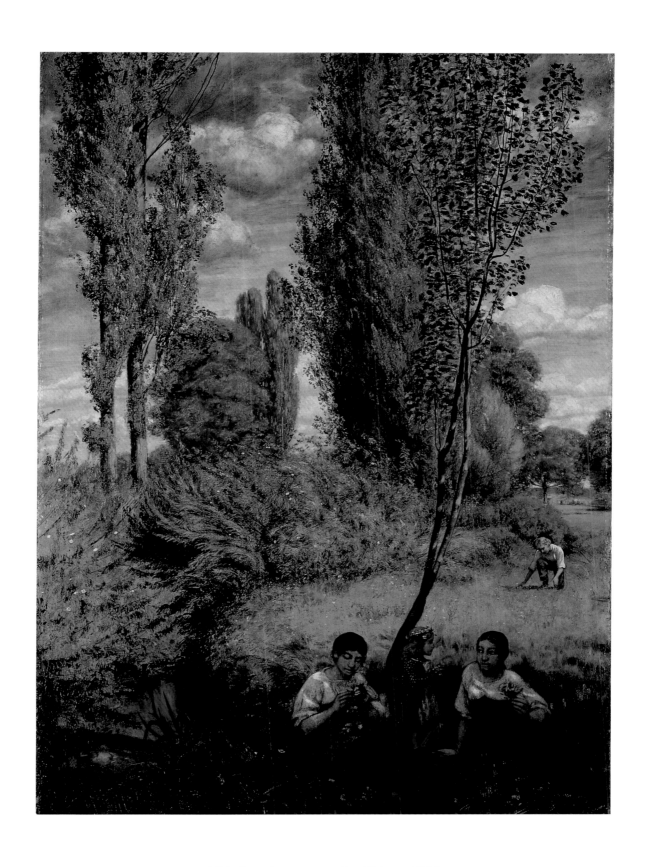

104. *Landscape on the Rhine*, 1888
Oil on canvas
160.5 × 115.5 cm
Purchase; Inv. No. 1039

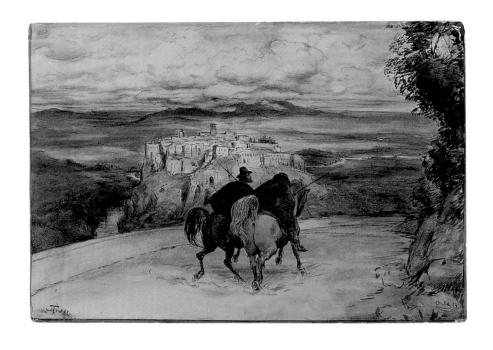

Hans Thoma
105. *Remembrance of Orte,* 1887
Pen and watercolor on paper, mounted on cardboard
38.3 × 54.2 cm
Gift of Erich von Kreibig; Inv. No. GVL 202

Friedrich Salzer

Born 1827, Heilbronn; died 1876, Heilbronn

Little is known of Friedrich Salzer's life beyond the fact that he was a landscape painter and that he painted the background landscapes in Alexander von Kotzebue's battle scenes. Nonetheless, the undated watercolor *Landscape with Path* is characteristic of changes in German art in the mid-nineteenth century. At the time Salzer reached artistic maturity around 1850, German romanticism had been criticized for nearly two decades as an empty emulation of an imperfect past and a flight from the realities of modern life into the world of fairy tales and myths. Although there were still strong centers of romantic art in Germany, above all in Munich, many German artists were seeking new paths to follow. The romantic art of Carl Philipp Fohr and the Olivier brothers also focused on landscape, but Salzer's interest in his *Landscape with Path* is of a different kind. Whereas the romantic artists often drew with crisp, clearly delineated lines, Salzer's drawing is more fluid and open, paying considerably more attention to atmospheric effects and shading.

J. B.-L.

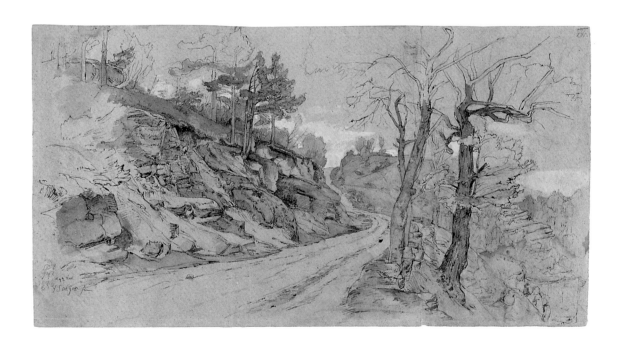

106. *Landscape with Path,* no date
Watercolor on gray paper
34.9 × 61.9 cm
Gift of R. Jentsch; Inv. No. C 68/1567

Louis Eysen

Born 1843, Manchester, England; died 1899, Munich

Although born in England, Eysen was the son of a Frankfurt merchant, and his family returned to that city in 1850. Beginning in 1861 he studied art at Frankfurt's Städelschen Kunstinstitut. In 1869–1870 he traveled to Paris, where he was exposed to the Barbizon School, the early work of the Impressionists and, above all, Gustave Courbet, whom he met in 1869. Following his return to Germany in 1870 he met Hans Thoma, with whom he remained in regular contact and who supported his work.

Eysen's *Fruit Garden,* painted around 1880, reveals Courbet's continued importance to Eysen, most especially in its dark green palette, heavy brushwork, and unromanticized view of its subject. Especially striking and original is Eysen's choice of view: seen from above, the relatively flat landscape seems to thrust upward, an effect accentuated by the cropping of the tree in the foreground.

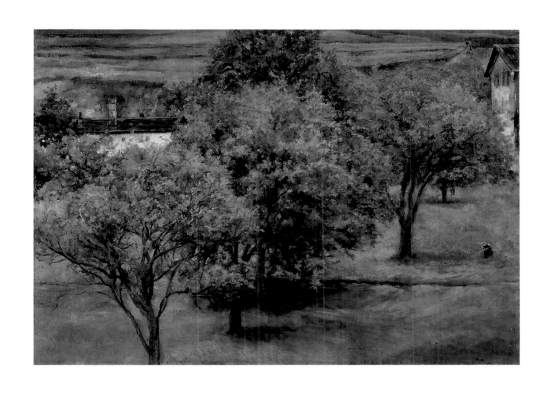

107. *Fruit Garden,* c. 1880
Oil on canvas
50 × 69.5 cm
Gift of Privy Councillor Ernst Seeger; Inv. No. 1111

Wilhelm Leibl

Born 1844, Cologne; died 1900, Würzburg

Leader of the so-called Leibl Circle of German realists that included Hans Thoma, Carl Schuch, and Wilhelm Trübner, Wilhelm Leibl trained at the Munich Academy with Hermann Anschütz, Arthur von Ramberg, and the history painter Karl Théodor von Piloty. His introduction to realism came at the 1869 International Exhibition in Munich, where he saw paintings by Courbet and Manet. Courbet, who attended that exhibition, admired Leibl's *Portrait of Frau Gedon* and invited the young German artist to Paris. Leibl stayed in Paris until the onset of the Franco-Prussian war in 1870, maintaining a friendship with Courbet and meeting Manet.

Once back in Munich, Leibl quickly gathered about him like-minded artists who held a similar interest in French realism. He was soon disillusioned by the Munich art world, especially by criticism directed against him, and moved to the country in 1872. There his subject matter shifted from portraits of the middle class to images of peasants and rural life. He sought to represent the purity and dignity of his subjects by portraying them directly, without anecdote or condescension. His attitude is summed up in his frequently quoted statement: "I paint people as they are; their soul is present anyway."

That attitude is evident in Leibl's *Head of an Old Farmer,* c. 1895. The subject, painted many times by Leibl, was Joseph Holzmaier, a small landowner from the village of Vachenhof bei Berbling, who was called "old stick" by the villagers. He is presented as complex and intelligent, neither a caricature of the peasant nor a "type." A similar effort to present his subjects as they are, without reference to stereotype, is apparent in Leibl's forthright, energetic drawing *Head of a Country Lad,* 1889, as well as in the drawing *Young Woman with a Hat, Sitting by a Window,* 1900. This pensive and removed image is related to the last portrait Leibl painted, his *Portrait of Frau Rossner-Heine,* 1900 (Bremen, Kunsthalle).

108. *Head of an Old Farmer*, c. 1895
Oil on canvas
42 × 32 cm
Purchase; Inv. No. 979

109. *Head of a Country Lad,* 1889
Pen and brush over pencil on paper
33.9 × 21.5 cm
Gift of Von Ess Collection; Inv. No. C 71/2087

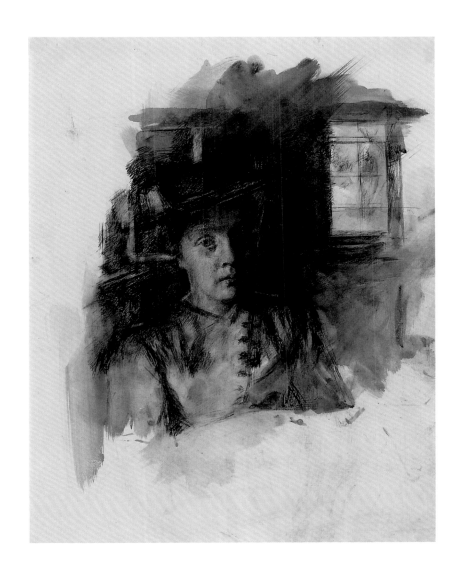

110. *Young Woman with a Hat, Sitting by a Window,* 1900
Pen and brush on ivory laid paper
32.9 × 25.9 cm
Von Ess Collection; Inv. No. C 71/2088

Carl Schuch

Born 1846, Vienna; died 1903, Vienna

Carl Schuch never exhibited and during his lifetime only sold one of his works. Soon after his death, however, he was hailed as one of the most important German painters of his time. His initial studies from 1865 to 1868 were carried out at the Vienna Academy; they were followed by a two-year trip to Italy. In 1870 he settled in Munich, where he joined the Leibl Circle and began a friendship with Wilhelm Trübner. In 1872 he began an extended period of travel, visiting cities in Belgium and Holland, and ending up in Venice, where he lived from 1876 to 1882. From Venice, Schuch moved to Paris where he lived until his return to his native Vienna in 1894.

Like the art of his colleagues in the Leibl Circle, Schuch's realist painting was deeply influenced by Courbet. Schuch's *Still Life with Cheese, Apples, and Bottles,* c. 1890, painted while he was in Paris, exhibits this affinity in its simple subject, solid forms, and heavy application of paint. In Paris, Schuch mostly painted still lifes, and he often used the same objects repeatedly in different paintings, treating those objects as compositional elements rather than as carriers of symbolic meaning.

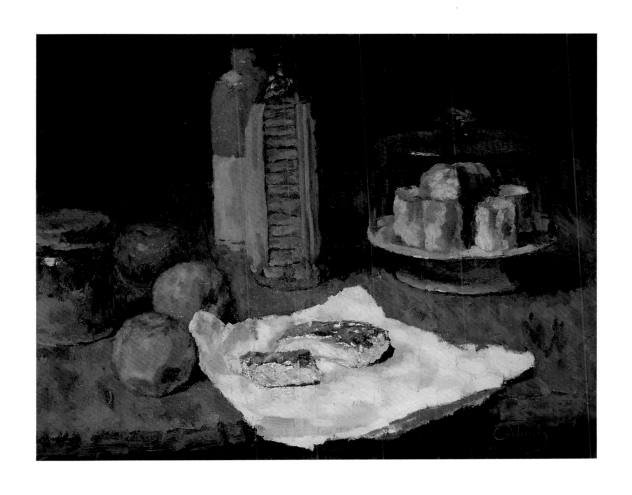

111. *Still Life with Cheese, Apples, and Bottles,* c. 1890
Oil on canvas
60.5 × 72.5 cm
Purchase; Inv. No. 1153

Wilhelm Trübner

Born 1851, Heidelberg; died 1917, Karlsruhe

Wilhelm Trübner began to study art at the urging of Anselm Feuerbach, whom he met in 1867. Trübner studied at the Karlsruhe Kunstschule from 1867 to 1868, then at the Munich Academy. At the 1869 International Exhibition in Munich he saw paintings by Wilhelm Leibl and Gustave Courbet, which proved a crucial influence. From 1869 to 1870 he studied history and genre painting in Stuttgart, then returned to the Munich Academy where he formed friendships with members of the Leibl Circle. During the early 1870s he traveled in Italy, Belgium, and Holland but returned to Munich in 1875 and remained there until 1896. From 1896 to 1903 he taught at the Städelsches Kunstinstitut in Frankfurt and thereafter served as Professor at the Karlsruhe Academy.

Boy at the Cupboard, 1872, is among Trübner's most important early paintings. He and his studio-mate Carl Schuch both painted images of a young boy caught in the act of uncorking a bottle. Trübner initially titled his version *At the Source* and also *The First Try,* perhaps hoping to capitalize upon the current popularity of comic themes (a popularity evident in the contemporary success of Carl Spitzweg). Whatever his motivation, *Boy at the Cupboard* was well received at the Munich Kunstverein, effectively launching Trübner's career.

Despite the comic overtones of its subject, *Boy at the Cupboard* is treated in a serious manner far removed from the gentle caricature of Spitzweg. Limiting the spirit of narrative or anecdote, Trübner restricts the details of his setting and emphasizes the structural interplay of horizontal and vertical elements. The painting seems as carefully composed as a still life, and as quiet.

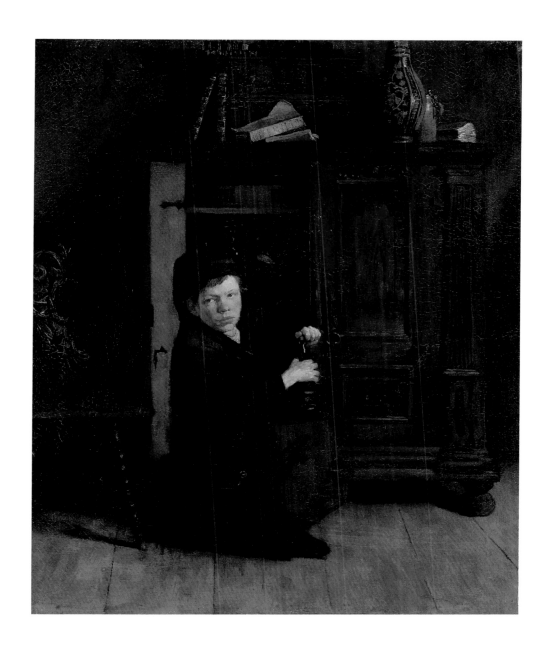

112. *Boy at the Cupboard*, 1872
Oil on canvas
55.5 × 46.6 cm
Purchase; Inv. No. 982

German Impressionism and
the Art of the Secessions

Fritz von Uhde

Born 1848, Wolkenberg/Saxony; died 1911, Munich

Fritz von Uhde's early career was divided between painting and military service. He studied at the Dresden Academy from 1866 to 1867, then joined the military. He moved to Munich in 1877, where he studied the Dutch masters, and joined the Reserves in 1878. From 1879 to 1880 he worked in Paris with the Hungarian artist Mihály Munkácsy, a successful painter of folk life and religious subjects. Returning to Munich in 1880, Uhde befriended Max Liebermann who introduced him to open-air painting. In 1884, he began to paint New Testament subjects but treated them in novel fashion: abandoning historical settings and costume, he treated his subjects as modern drama, set within the milieu of the contemporary poor. Deeply controversial, these paintings unleashed a storm of protest. Uhde co-founded the Munich Secession in 1892 and in 1899 was appointed its President.

At the time he turned to religious subject matter, Uhde also began to paint images of children. Some of these images then entered his religious paintings, as is the case with his *Three Models,* which was incorporated into the 1884 painting of *Suffer the Little Children to Come unto Me* (Museum der bildenden Künste, Leipzig). Despite its relation to that latter painting, the large *Three Models* cannot properly be considered a study. These three children of the poor are treated as monumental figures, each possessed of a distinct personality and psychological awareness. Although Uhde studied with academic history painters, the clear tones and emphasis upon natural light in this painting reveal the influence of Liebermann.

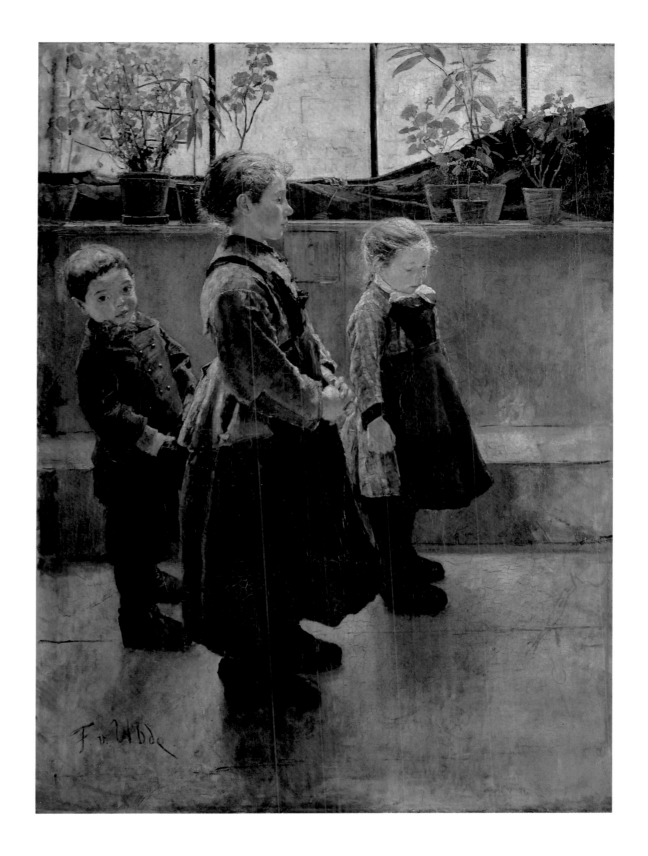

113. *Three Models*, c. 1884
Oil on canvas
137 × 102.5 cm
Purchase; Inv. No. 1175

Max Liebermann

Born 1847, Berlin; died 1935, Berlin

The so-called "triumvirate of German impressionism" was formed by Max Liebermann, Lovis Corinth, and Max Slevogt. Liebermann was the eldest of this group, and if he is best-known for his impressionist paintings, his realist work is of equal quality and significance. Liebermann took drawing lessons as a teenager before enrolling at Berlin University. He entered the Weimar Kunstschule in 1868, studying for five years with the Belgian history painters Ferdinand Pauwels and Charles Verlat. He began to make regular trips to Holland in 1871, where he was particularly influenced by the work of Frans Hals and the contemporary Dutch painter of portraits and marines Josef Israëls.

In 1872 Liebermann traveled to Paris, where he saw works by Gustave Courbet and by members of the Barbizon school. He resided in Paris from 1873 to 1878 and was closest to the Hungarian painter of folk life and religious scenes, Mihály Munkácsy. Liebermann moved to Munich in 1878, where he remained until 1884, forming friendships with members of the Leibl Circle. In 1884 he returned to his native Berlin, residing there for the rest of his life, apart from frequent travels. Through the mid-1880s his style shifted, becoming increasingly impressionist. He was elected President of the Berlin Secession in 1889, and in 1920 was appointed President of the Prussian Academy of Art. After 1933 his art was labeled "degenerate" by the Nazi government. He was stripped of his honors, and exhibition of his work was banned.

Old-Age Home for Men in Amsterdam, 1880, was executed in the period just before Liebermann began to turn toward impressionism. The artist painted several versions of this Catholic old-age home. He was, perhaps, drawn by his liberal ideals to depict this example of social welfare. In this version, however, Liebermann seems especially interested in the tunnel-like setting of the arcade, its sharp perspective, and the dramatic contrasts of light and dark. Although Liebermann's brushwork and color are not yet impressionist, his informally cropped composition, as well as his subject, are distinctly modern.

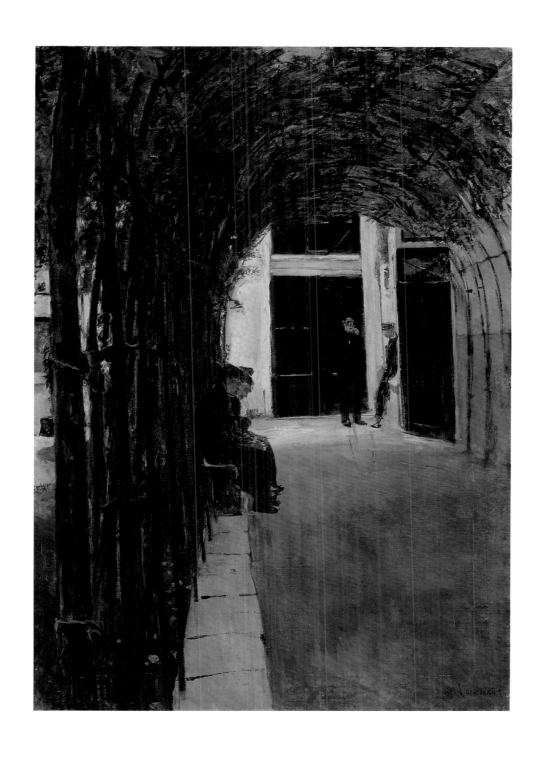

114. *Old-Age Home for Men in Amsterdam,* 1880
Oil on canvas
87.5 × 61.4 cm
Purchase; Inv. No. 2421

Lovis Corinth

Born 1858, Tapiau, East Prussia; died 1925, Zandvoort, Holland

An artist of prodigious energy and output, Lovis Corinth's greatest fame results from his impressionist paintings. Nevertheless, Corinth's work makes reference to most of the major German artistic movements of the late nineteenth and early twentieth centuries, including realism, Jugendstil and, in his late work, expressionism.

In 1876 Corinth began attending the Art Academy in Königsberg. Entering the Munich Academy of Art in 1880, he made the acquaintance of the realist painters Wilhelm Trübner and Wilhelm Leibl. He spent the years from 1884 to 1886 in Paris, studying at the Académie Julian with the academic painters William Bougereau and Robert Fleury and was able to view the paintings of the French Impressionists. Corinth lived in Berlin and Königsberg from 1887 to 1891, and then in Munich until 1899. Following the rejection of his painting *Salome with the Head of John the Baptist* by the Munich Secession in 1899 and its acceptance by the Berlin Secession, he moved to Berlin. In 1901 he opened a painting school for women there, and in 1911 he was elected head of the Berlin Secession. He was appointed Professor at the Berlin Academy of Art in 1918, and was later made an honorary member of the Munich Academy. He died while on a trip to Holland to study the work of Rubens, Rembrandt, and Hals.

Among Corinth's most remarkable works are his so-called "friendship portraits," paintings of close friends or relations that reveal a depth of psychological understanding. One such portrait, *Hermann Struck,* 1914, depicts the painter, printmaker, and author who was a fellow member of the Berlin Secession. Corinth veils his sitter behind a thick atmosphere of cigar smoke, which helps define the pensive, somewhat distant mood of the painting.

By contrast, in his *Self-Portrait with Palette,* 1923, Corinth thrusts himself forward in a pose that seems to challenge the viewer with the exaggerated details of his age-worn features. Each year from 1900 on, Corinth painted a self-portrait, usually on his birthday. The decision to present a record of his changing features clearly refers to the example of Rembrandt, as does the artist's determination to represent those features honestly, without idealization.

Most of Corinth's landscapes were painted after 1918, when the artist acquired a house on the Walchensee, a lake in southern Germany. *Walchensee, Country House with Laundry* is one of more than 60 paintings that Corinth made of the Walchensee and one in which the expressionist cast that he gave to his impressionist technique is particularly evident. Corinth was said to have painted these scenes in an excited, almost ecstatic condition. That condition is consistent with the heavy, rapid brushwork of the painting and in the curiously angled composition, which gives to what could be an unremarkable scene a vivid intensity.

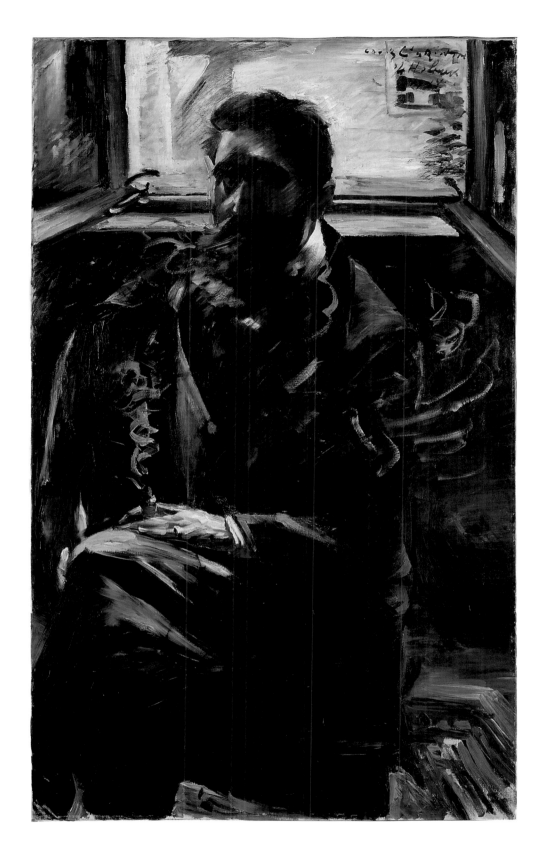

115. *Hermann Struck,* 1914
Oil on canvas
150 × 90.6 cm
Purchase; Inv. No. 2806

116. *Walchensee, Country House with Laundry,* after 1918
Oil on canvas
100 × 80 cm
Purchase; Inv. No. 2730

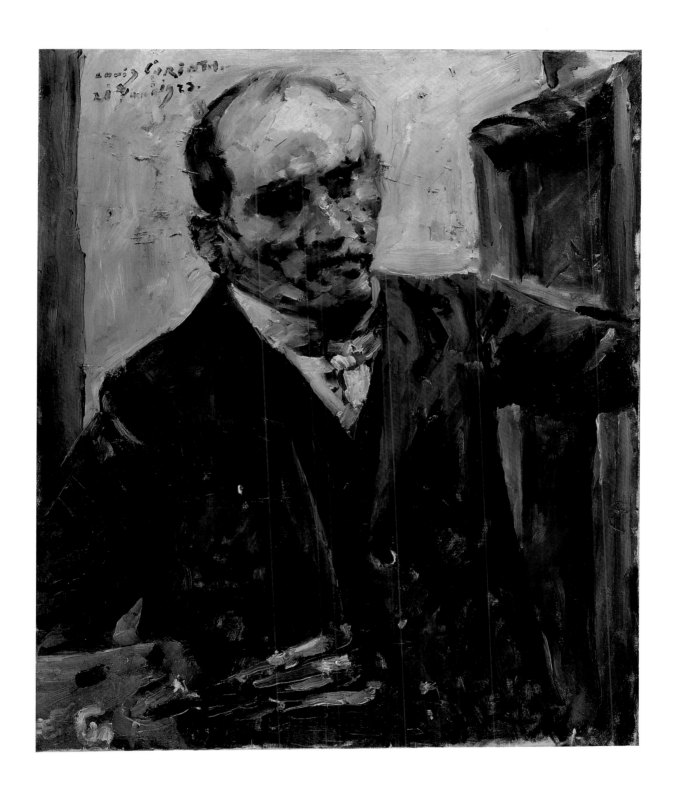

117. *Self-Portrait with Palette*, 1923
Oil on canvas
90.2 × 75.5 cm
Purchase; Inv. No. 2457

Max Slevogt

Born 1868, Landshut; died 1932, Neukastel

Like his fellow German impressionists Max Liebermann and Lovis Corinth, Max Slevogt came relatively late to an impressionist style. From 1884 to 1887 he studied at the Munich Academy. He took one semester at the Académie Julian in Paris in 1889, where he had his first contact with French impressionism, and returned to the Munich Academy that same year to study with Wilhelm von Diez, a painter of history and of humorous subjects. He met Wilhelm Trübner in 1890, and in 1892 became a founding member of the Munich Secession. During the 1890s he tended to paint in a dark palette, reflecting the influence of Diez. Following trips to Paris in 1899 and 1900, during which he studied the work of Manet and the French impressionists, his technique grew broader and freer, and his palette became bright. He joined the Berlin Academy in 1904 and the Dresden Academy in 1915. He was named honorary president of the German artist's group Deutscher Künstlerbundes in 1929. Over his long career Slevogt painted in virtually every genre. He also produced set and costume designs and was an active illustrator.

The Champagne Song, 1902, is one of Slevogt's most famous works. Painted with a bright palette and broad technique, the painting conveys the immediacy of a sketch, even though it was the result of a lengthy process of studies and is one of several versions of the subject. Slevogt was a friend of the Portuguese singer Francisco d'Andrade who was celebrated for his interpretation of the title role in Mozart's *Don Giovanni.* The artist chose to portray his friend singing the champagne aria, the strongest expression of the frivolity as well as the irresistibility of Don Giovanni's character. Slevogt expresses those qualities through the verve of his brushwork and the dominance of light, gay color.

Slevogt's portraits of Frida Fuchs and Eduard Fuchs, painted in 1904 and 1905 respectively, show the artist adapting the brilliant technique of *The Champagne Song* to more pensive subjects. Eduard Fuchs, a friend of the artist since 1893, was the son of an industrialist but became an anarchist, later a radical Social Democrat, and finally a founding member of the German Communist Party. He was a historian of art and culture and a passionate art collector, particularly of Honoré Daumier, Max Liebermann, and Slevogt. In his unusually narrow portrait of Eduard Fuchs, Slevogt shows his subject in motion, addressing the viewer and drawing a piece of paper from his briefcase as he passes by. He captures the quick, impatient mind of Fuchs and conveys his intensity. Frida Fuchs, who was married to Eduard from 1896 to 1915, is portrayed in a somewhat more reserved fashion, even though Slevogt employs a lighter palette. The broad freedom with which Slevogt depicts the background and the sitter's dress draws attention to her more tightly depicted head and her introspective.

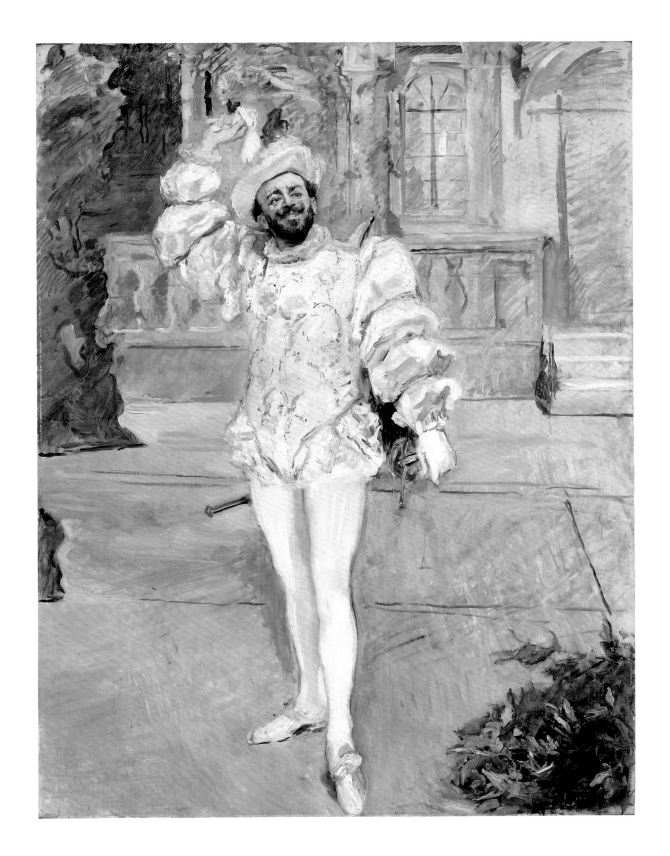

118. *The Champagne Song*, 1902
Oil on canvas
215 × 160 cm
Purchased from the Artist; Inv. No. 1123

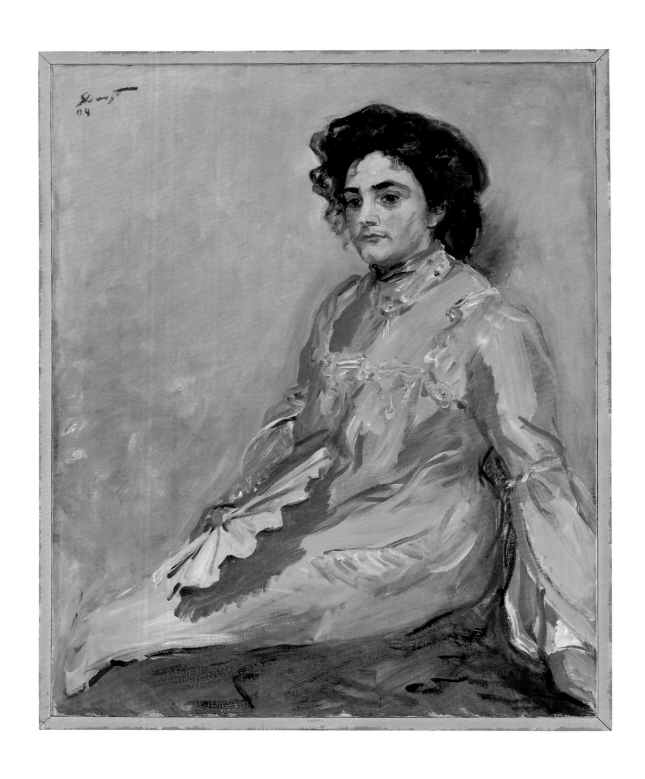

119. *Frida Fuchs,* 1904
Oil on canvas
92 × 74 cm
Gift of Theodor Fuchs; Inv. No. 2578

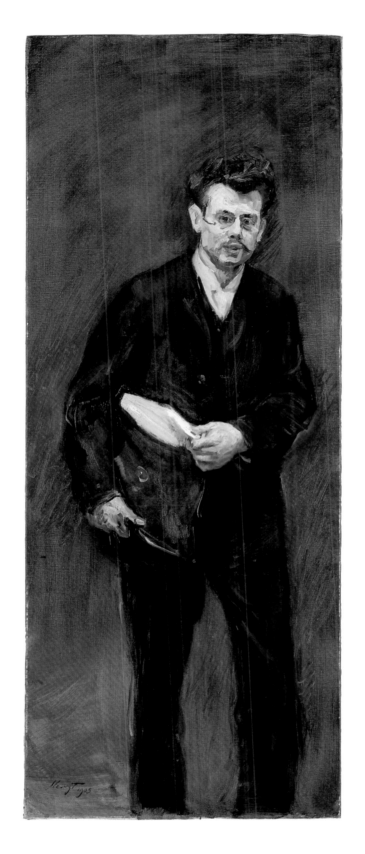

120. *Eduard Fuchs,* 1905
Oil on canvas
180.2 × 70.3 cm
Gift of Theodor Fuchs; Inv. No. 2576

Ferdinand Hodler

Born 1853, Bern; died 1918, Geneva

Of the major Swiss artists of the late nineteenth and early twentieth centuries, it is Ferdinand Hodler whose art and career are most firmly tied to the emerging Swiss national identity, even as his work is closely linked to the progress of European symbolism. Hodler began his career in 1869 serving as an apprentice to the landscape painter Ferdinand Sommer. He moved to Geneva in 1872 and began to study under Barthélemy Menn at the School of Fine Arts. In 1877 he undertook a series of travels to Paris, Madrid, and Munich and entered his work regularly in competitions in Switzerland. From the mid-1880s he stood at the center of a circle of symbolist writers and painters. He had his first one-man show in Geneva in 1885 and began exhibiting in Paris in 1892. Through the last decade of the nineteenth century and the first decade of the twentieth, he received numerous honors in a number of European capitals. In 1914 he signed a letter protesting the German bombardment of Reims Cathedral and was consequently expelled from all of the German artistic societies to which he belonged. Although he continued to be honored in Switzerland, his international career was effectively ended.

Self-Portrait, 1900, is the first of Hodler's 113 self-portraits in which the artist chose to depict himself in a full frontal view. Hodler had successfully completed a controversial fresco project for the Swiss National Museum in Zurich and had received a gold medal at the Paris World's Fair. The frontal pose reflects the artist's newly achieved confidence and sense of maturity. By its frontality, perfect symmetry, and placement of the figure against a blank background, all of which lend to the painting an extraordinarily focused intensity, *Self-Portrait* also suggests Hodler's belief in the spiritual mission of his art.

Hodler invested a similar intensity in his landscapes, which today may be the most popular portion of his oeuvre. *Lake Geneva with the Savoy Alps,* 1906, is typical of Hodler's later landscapes, with its combinations of surprising colors and contrasts of flattened abstract shapes with forms depicted in high relief. As in many of his landscapes, Hodler here places the viewer's vantage high above the panorama that stretches out before us. From this lofty position we witness a spectacle that seems as celestial as it does worldly.

In his last years Hodler created a number of allegorical compositions in which female figures stage a slow, rhythmical dance. *Study for a View of Infinity,* 1915, is a preparatory study for one such monumental composition and represents the apogee of Hodler's symbolism. Silhouetted against a colored ground, the dancer appears as a timeless, otherworldly embodiment, even as the forceful modeling of her forms gives her a strong physical presence.

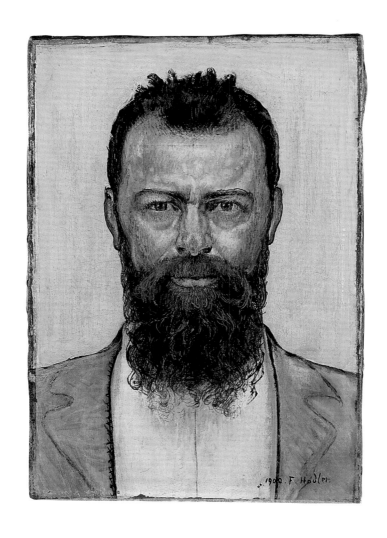

121. *Self-Portrait,* 1900
Oil on canvas
41 × 26.6 cm
Purchased from the Artist; Inv. No. 1193

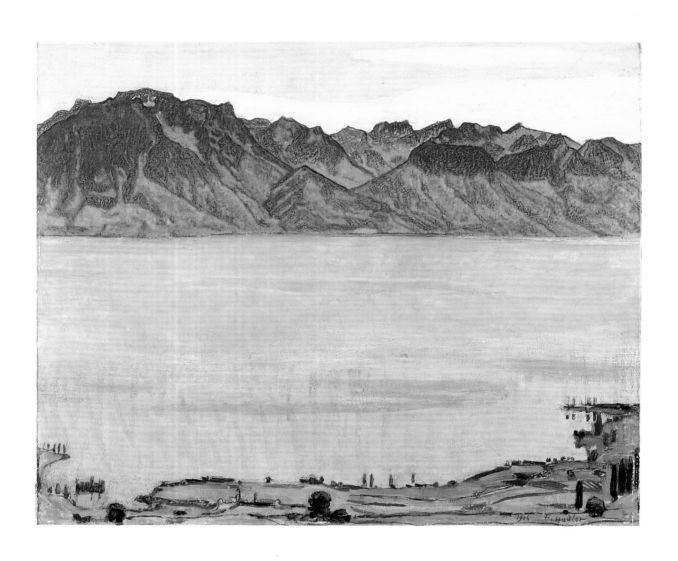

122. *Lake Geneva with the Savoy Alps,* 1906
Oil on canvas
67.5 × 80 cm
On loan from the Stuttgart Galerieverein; Inv. No. GVL 13

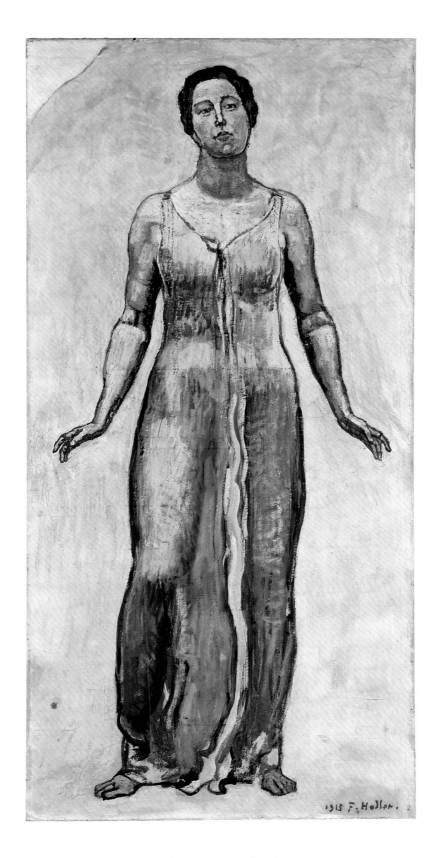

123. *Study for a View of Infinity,* 1915
Oil on canvas
124.5 × 60 cm
Purchase; Inv. No. 2818

Bibliography

Achenbach, Sigrid and Matthias Eberle. *Max Liebermann in seiner Zeit.* (Munich: Prestel Verlag, 1979).

Andrews, Keith. *The Nazarenes: A Brotherhood of German Painters in Rome.* (Oxford: Clarendon Press, 1964).

Bernhard, Marianne. *Deutsche Romantik Handzeichnungen.* 2 vol. (Munich: Rogner & Bernhard, 1974).

Börsch-Supan, Helmut. *Die Deutsche Malerei von Anton Graff bis Hans von Marées 1760–1870.* (Munich: Deutscher Kunstverlag, 1988).

Börsch-Supan, Helmut. *Caspar David Friedrich.* (Munich: Prestel Verlag, 1990).

Christ, Dorothea, ed. *Arnold Böcklin 1827–1901: Gemälde, Zeichnungen, Plastiken.* (Stuttgart: Schwabe & Co. Verlag, 1977).

Christ, Dorothea and Christian Geelhaar. *Arnold Böcklin: Die Gemälde im Kunstmuseum Basel.* (Basel: Eidolon, 1990).

Dressler, Walter. *Spitzweg, Schwind, Schleich.* (Karlsruhe: Städtische Galerie im Prinz-Max-Palais, 1984).

Düchting, Hajo and Karin Sagner-Düchting. *Die Malerei des deutschen Impressionismus.* (Cologne: DuMont Buchverlag, 1993).

Eitner, Lorenz, ed. *Neoclassicism and Romanticism 1750–1850. 2 vols./Sources and Documents in the History of Art* (Englewood Cliffs, New Jersey: Prentice-Hall, Inc., 1970).

Forster-Hahn, Françoise. "Adolph Menzel's 'Daguerreotypical' Image of Frederick the Great: A Liberal-Bourgeois Interpretation of German History." *Art Bulletin.* vol. 59, no. 2 (June 1977), pp. 242–261.

Forster-Hahn, Françoise. "Authenticity into Ambivalence: The Evolution of Menzel's Drawings," *Master Drawings.* vol. 16, no. 5 (1978), pp. 255–283.

Forster-Hahn, Françoise, ed. *Imagining Modern German Culture 1889–1910/Studies in the History of Art* (Washington, D.C.: National Gallery of Art, forthcoming).

Froitzheim, Eva-Marina. *Hans Thoma (1839–1924): Ein Begleiter durch die Hans-Thoma-Sammlung in der Staatlichen Kunsthalle Karlsruhe.* (Karlsruhe: Staatliche Kunsthalle Karlsruhe, 1993).

Gallwitz, Klaus, ed. *Die Nazarener in Rom: Ein deutscher Künstlerbund der Romantik.* (Munich: Prestel-Verlag, 1981).

Gauss, Ulrike. *Meisterwerke aus der Graphischen Sammlung: Zeichnungen des 19. und 20. Jahrhunderts.* (Stuttgart-Bad Cannstatt: Dr. Cantz'sche Druckerei, 1984).

Grisebach, Lucius, ed. *Adolf Menzel: Zeichnungen, Druckgraphik und illustrierte Bücher.* (Berlin: Staatliche Museen Preußischer Kulturbesitz, 1984).

Grote, Ludwig. *Die Brüder Olivier und die deutsche Romantik.* (Berlin: Rembrandt-Verlag, 1938).

Güse, Ernst-Gerhard, Hans-Jürgen Imiela, and Berthold Roland. *Max Slevogt: Gemälde, Aquarelle, Zeichnungen.* (Stuttgart: Verlag Gerd Hatje, 1992).

Hederer, Oswald. *Leo von Klenze: Persönlichkeit und Werk.* (Munich: Verlag Georg D. W. Callwey, 1964).

Heilmann, Christoph. *'In uns selbst liegt Italien' Die Kunst der Deutsch-Römer.* (Munich: Hirmer Verlag, 1987).

Hofmann, Werner, ed. *Runge in seiner Zeit.* (Munich: Prestel Verlag, 1977).

Hofmann, Werner. *Menzel-Der Beobachter.* (Munich: Prestel-Verlag, 1982).

Koerner, Joseph Leo. *Caspar David Friedrich and the Subject of Landscape.* (New Haven: Yale University Press, 1990).

Lammel, Gisold. *Deutsche Malerei des Klassizismus.* (Leipzig: VEB E. A. Seemann Verlag, 1986).

Lenz, Christian, ed. *Hans von Marées.* (Munich: Prestel-Verlag, 1987).

Mai, Ekkehard and Götz Czymmek, eds. *Heroismus und Idylle Formen der Landschaft um 1800 bei Jacob Phillip Hackert, Joseph Anton Koch und Johann Christian Reinhart.* (Cologne: Wallraf-Richartz-Museum, 1984).

Makela, Maria. *The Munich Secession: Art and Artists in Turn-of-the-Century Munich.* (Princeton: Princeton University Press, 1990).

Meier-Graefe, Julius. *Entwicklungs Geschichte der Modernen Kunst: Vergeleichende Betrachtung der Bildenden Künste, als Beitrag zu einer neuen Aesthetik.* (Stuttgart: Verlag Jul Hoffmann, 1904).

Mitchell, Timothy F. "Johann Christian Reinhart and the Transformation of Heroic Landscape, 1790–1800," *Art Bulletin 71* (December 1989), pp. 646–659.

Moffett, Kenworth. *Meier-Graefe as Art Critic/ Studien zur Kunst des neunzehnten Jahrhunderts.* vol. 19. Forschungsunternehmen der Fritz Thyssen Stiftung Arbeitskreis Kunstgeschichte (Munich: Prestel Verlag, 1973).

Neidhardt, Hans Joachim. *Die Malerei der Romantic in Dresden.* (Leipzig: VEB E. A. Seemann Verlag, 1976).

Nochlin, Linda, ed. *Realism and Tradition in Art 1848–1900/Sources and Documents in the History of Art* (Englewood Cliffs, New Jersey: Prentice-Hall, Inc., 1966).

Novotny, Fritz. *Painting and Sculpture in Europe 1780–1880.* (Baltimore, Maryland: Penguin Books, 1960).

Paret, Peter. *The Berlin Secession: Modernism and its Enemies in Imperial Germany* (Cambridge, Massachusetts: Harvard University Press, 1980).

Petzet, Michael, ed. *Wilhelm Leibl und sein Kreis.* (Munich: Prestel-Verlag, 1974).

Rosenblum, Robert. *Modern Painting and the Northern Romantic Tradition: Friedrich to Rothko* (New York: Harper and Row, 1975).

Ruhmer, Eberhard. *Der Leibl-Kreis und die Reine Malerei.* (Rosenheim: Rosenheimer Verlagsahaus, 1984).

Ruthenberg, Vera-Maria, ed. *Adolf Menzel.* (Rostock: Ostsee-Druck, 1908).

Schadendorf, Wulf. *Ferdinand Georg Waldmüller: Gemälde aus der Sammlung Georg Schäfer Schweinfurt.* (Schweinfurt: Sammlung Georg Schäfer, 1978).

Schiff, Gert, Stephan Waetzoldt, et al. *German Masters of the Nineteenth Century: Paintings and Drawings from the Federal Republic of Germany.* (New York: Harry N. Abrams, Inc., 1981).

Schröder, Klaus Albrecht, ed. *Lovis Corinth.* (Munich: Prestel Verlag, 1992).

Schuster, Peter-Klaus, ed. *Carl Blechen: Zwischen Romantik und Realismus.* (Berlin: Nationalgalerie Berlin, 1990).

Simon, Karl. *Gottleib Schick: Ein Beitrag zur Geschichte der deutschen Malerei um 1800.* (Leipzig: Verlag von Klinkhardt & Biermann, 1914).

Simon, Karl. *Spitzweg, Schwind, Schleich: Biedermeier und Vormärz, Gesichter einer Epoche.* (Karlsruhe: Städtische Galerie im Prinz-Max-Palais, 1984).

Traeger, Jörg. *Philipp Otto Runge und sein Werk: Monographie und kritischer Katalog.* (Munich: Prestel-Verlag, 1975).

Uhde-Bernays, Hermann. *Carl Spitzweg: Des Meisters Leben und Werk Seine Bedeutung in der Geschichte der Münchner Kunst.* 7th ed. (Munich: Delphin Verlag, 1921).

Uhr, Horst. *Lovis Corinth* (Berkeley: University of California Press, 1990).

Vaughan, William. *German Romantic Paintings.* (New Haven: Yale University Press, 1980).

von Holst, Christian, ed. *Malerei und Plastik des 19. Jahrhunderts.* (Stuttgart: Staatsgalerie Stuttgart, 1982).

von Holst, Christian. *Johann Heinrich Dannecker: Der Bildhauer.* 2 vols. (Stuttgart-Bad Cannstadt: Dr. Cantz'sche Druckerei, 1987).

von Holst, Christian. *Joseph Anton Koch 1768–1839: Ansichten der Natur.* (Stuttgart-Bad Cannstadt: Dr. Cantz'sche Druckerei, 1989).

von Holst, Christian and Ulrike Gauss, eds. *Gottlieb Schick: Ein Maler des Klassizismus.* (Stuttgart-Bad Cannstadt: Dr. Cantz'sche Druckerei, 1976).

von Holst, Christian and Ulrike Gauss, eds. *Schwäbisches Klassizismus: zwischen Ideal und Wirklichkeit 1770–1830.* 2 vols. (Stuttgart: Staatsgalerie Stuttgart, 1993).

von Kalnein, Wend, ed. *Die Düsseldorfer Malerschule.* (Mainz: Verlag Philipp von Zabern, 1979).

Wirth, Irmgard. *Eduard Gaertner: Der Berliner Architekturmaler.* (Frankfurt am Main: Propyläen Verlag, 1979).

Zimmerman, Werner. *Anselm Feuerbach: Gemälde und Zeichnungen.* (Karlsruhe: Staatliche Kunsthalle Karlsruhe, 1989).

Suggested Readings

Andrews, Keith. *The Nazarenes: A Brotherhood of German Painters in Rome.* (Oxford: Clarendon Press, 1964).

Champa, Kermit with Kate H. Champa. *German Painting of the 19th Century.* Yale University Art Gallery, 1970.

Eitner, Lorenz, ed. *Neoclassicism and Romanticism 1750–1850, 2 vols./Sources and Documents in the History of Art* (Englewood Cliffs, New Jersey: Prentice-Hall, Inc., 1970).

Farmer, John David, et. al. *German Master Drawings of the Nineteenth-Century.* Busch-Reisinger Museum, Harvard University, 1972.

Finke, Ulrich. *German Painting: From Romanticism to Expressionism.* (London: Thames and Hudson, 1974).

Forster-Hahn, Françoise. "Adolph Menzel's 'Daguerreotypical' Image of Frederick the Great: A Liberal-Bourgeois Interpretation of German History," *Art Bulletin.* vol. 59, no. 2 (June 1977), pp. 242–261.

Forster-Hahn, Françoise. "Authenticity into Ambivalence: The Evolution of Menzel's Drawings," *Master Drawings.* vol. 16, no. 5 (1978), pp. 255–283.

Forster-Hahn, Françoise, ed. *Imagining Modern German Culture 1889–1910/Studies in the History of Art* (Washington, D.C.: National Gallery of Art, forthcoming).

Jensen, Robert. *Marketing Modernism in fin-de-siecle Europe.* (Princeton: Princeton University Press, 1994).

Koerner, Joseph Leo. *Caspar David Friedrich and the Subject of Landscape.* (New Haven: Yale University Press, 1990).

Makela, Maria. *The Munich Secession: Art and Artists in Turn-of-the-Century Munich.* (Princeton: Princeton University Press, 1990).

Mitchell, Timothy F. *Art and Science in German Landscape Painting 1770–1840.* (Oxford: Clarendon Press, 1993).

Mitchell, Timothy F. "Johann Christian Reinhart and the Transformation of Heroic Landscape, 1790–1800," *Art Bulletin 71* (December 1989): pp. 646–659.

Moffett, Kenworth. *Meier-Graefe as Art Critic/ Studien zur Kunst des neunzehnten Jahrhunderts.* vol. 19, Forschungsunternehmen der Fritz Thyssen Stiftung Arbeitskreis Kunstgeschichte (Munich: Prestel Verlag, 1973).

Nochlin, Linda, ed. *Realism and Tradition in Art 1848–1900/Sources and Documents in the History of Art* (Englewood Cliffs, New Jersey: Prentice-Hall, Inc., 1966).

Novotny, Fritz. *Painting and Sculpture in Europe 1780–1880.* (Baltimore, Maryland: Penguin Books, 1960).

Paret, Peter. *The Berlin Secession: Modernism and its Enemies in Imperial Germany* (Cambridge, Massachusetts: Harvard University Press, 1980).

Paret, Peter. *The Romantic Spirit in German Art 1790–1990.* Scottish National Gallery of Modern Art, Edinburgh, and Hayward Gallery, London, with Nationalgalerie, Berlin, 1994.

Rosen, Charles and Henri Zerner. *Romanticism and Realism: The Mythology of Nineteenth-Century Art.* (New York: Viking Press, 1984).

Rosenblum, Robert. *Modern Painting and the Northern Romantic Tradition: Friedrich to Rothko* (New York: Harper and Row, 1975).

Rosenblum, Robert and H.W. Janson. *19th-Century Art* (New York: Harry N. Abrams, 1984).

Schiff, Gert, Stephan Waetzoldt, et al. *German Masters of the Nineteenth Century: Paintings and Drawings from the Federal Republic of Germany.* (New York: Harry N. Abrams, Inc., 1981).

Vaughan, William. *German Romantic Paintings.* (New Haven: Yale University Press, 1980).

Wegmann, Peter, ed. *Caspar David Friedrich to Ferdinand Hodler: Nineteenth Century Paintings and Drawings from the Oskar Reinhart Foundation, Winterthur.* (Frankfurt am Main: Insel Verlag, 1990).

Index of Artists